GUSTAV KLIMT

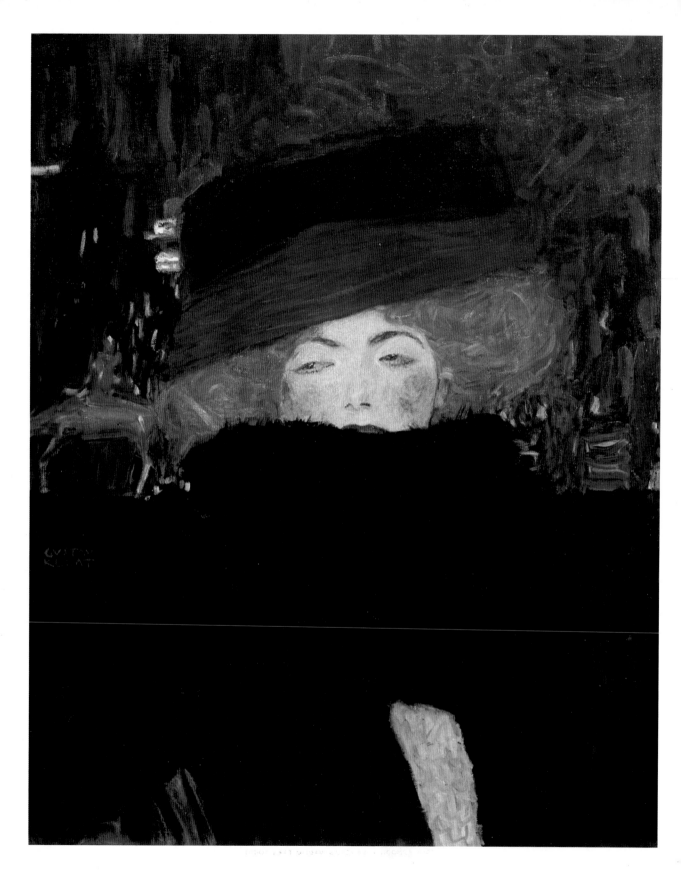

Gottfried Fliedl

GUSTAV KLIMT

1862–1918

The World in Female Form

TASCHEN

KÖLN LONDON LOS ANGELES MADRID PARIS TOKYO

COVER:
The Virgin (detail), 1913
Die Jungfrau
Oil on canvas, 190 x 200 cm
Národní Gallery, Prague
Photo: © Jochen Remmer – Artothek

ILLUSTRATION PAGE 2:
Lady with Hat and Feather Boa, 1909
Dame mit Hut und Federboa
Oil on canvas, 69 x 55 cm
Österreichische Galerie, Vienna

© 2003 TASCHEN GmbH
Hohenzollernring 53, D–50672 Köln
www.taschen.com

Original edition: © 1990 Benedikt Taschen Verlag GmbH
Cover design: Angelika Taschen, Claudia Frey, Cologne
English translation: Hugh Beyer

Printed in Italy
ISBN 3–8228–2919–6

Contents

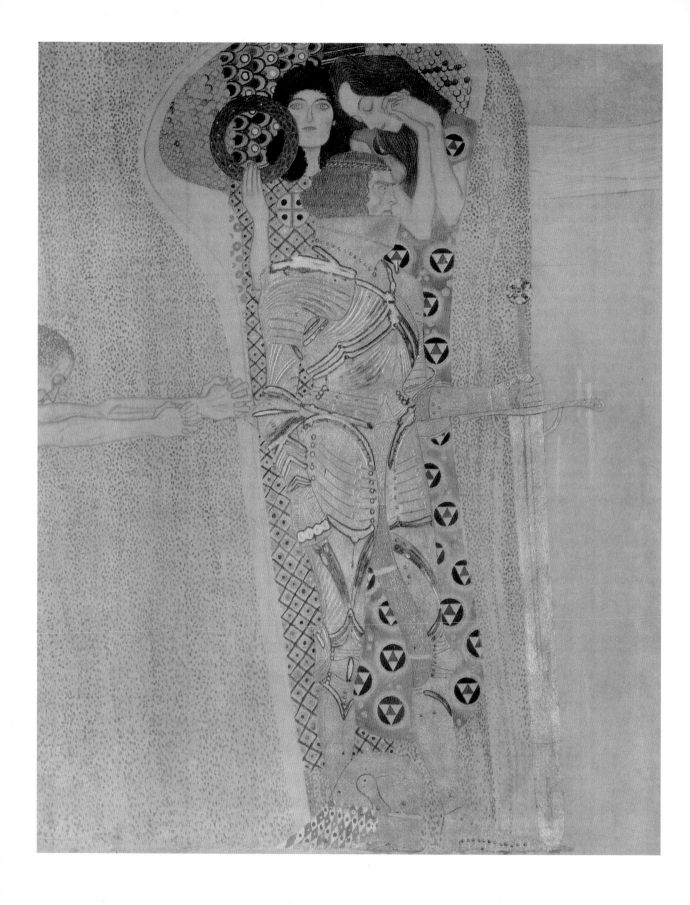

Introduction – Klimt's Popularity

Summer 1977. A rail journey from Athens to Vienna. With all the usual delays, it will take the train about forty hours to reach Vienna. I am sharing a compartment with a young Japanese lecturer at some art college, who is travelling to the same place. He is one of those typical Far Eastern travellers who perfectly fits the standard cliché. He is going to do Europe in six days, with ten hours for Vienna – after an uninterrupted rail journey of two days and one night. He only has two aims in Vienna: to see Otto Wagner's architecture and – Gustav Klimt's paintings.

Klimt's worldwide popularity could be illustrated with many similar episodes. It can be seen in the undivided appreciation of a very broad international public as well as those with an academic interest in art and social history. It is likely that no other Modernist artist has ever enjoyed such broad and lasting popularity. (For the time being, we shall refrain from giving a precise definition of the term 'Modernism' and how far it can be applied to Klimt's work).

Many of his works have been shown so frequently in the mass media that not even Dalí, Beuys, Picasso or Warhol – to name but a few – can compete with Klimt for media coverage. None of these artists is currently being used so many thousands of times as an advertising vehicle or an object of advertising. The never-ending fascination of Klimt's art can be seen in the innumerable uses to which his works are put. In Austria, in particular, they can be found in the most unexpected contexts. If you wish, you can have your bathroom decorated with Klimt tiles, or you can adorn your sitting-room with some hand-made Klimt embroidery, which is of course also available as a ready-made *petit point* picture. Klimt's major works can easily be taken home in the form of posters, stained glass or postcards. Art Nouveau's discovery of the female body and nudity as an advertising medium can still be felt today. The eroticism and preciousness of Klimt's work is an inexhaustible source for advertisers.

Austria's most widely read tabloid paper, for example, has used Klimt's art to advertise for a series on Austrian love life. For the New Year concert of the Vienna Philharmonic, which is always televised worldwide, Klimt's painting *The Kiss* (p. 117) was re-enacted as a 'live painting'. A popular publishing house may want to use Klimt's art to enhance the visual appeal of its latest book. And posters of his paintings even serve to advertise the financial reliability of a bank. Again and again, motifs from Klimt's works are used. His art, which has been

Naked Lovers, Standing, around 1908
Pencil, 55 x 35 cm
Historical Museum, Vienna

The Beethoven Frieze (detail), 1902
Der Beethoven-Fries
Casein paint on plaster, 220 cm high
Austrian Gallery, Vienna

duplicated and modified many times by the mass media, has been well able to cross social barriers. Paintings like *The Kiss* can be found as elegant decorations in typical middle-class sitting-rooms and also in the form of cheap posters in students' bedsitters.

The Austrian Ministry of Education has always taken a great interest in Klimt's oeuvre as well. The purchase of his *Beethoven Frieze* (pp. 104f.) by the state and the long and costly restoration of the painting by the *Bundesdenkmalamt* – the Federal Office for the Preservation of Historical Monuments – clearly show that Klimt is officially recognized as a great Austrian artist. Austria's former chancellor Bruno Kreisky specifically urged the restoration and public presentation of this mural, which had originally been created for the Viennese Secession. Using his personal influence in speeches and essays, he emphasized that the frieze was the work of an artist who had hardly been recognized at all at the time and who was finally being honoured as a genius.

While it was being restored, the frieze was also copied to scale, for the purpose of various exhibitions. This procedure meant that the original became a self-contained monument. Initially it had only served as part of a larger exhibition that was planned as a work of art in itself. After the Secession exhibition it would simply have been discarded, so it was produced very cheaply. Since then, however, it has become a lasting artistic monument and has returned to its original place, the Secession building. However, it is no longer in the main hall, which is still used for special exhibitions of the Secession, but has been given a separate room in the basement.

All this evidence of Klimt's popularity makes it seem doubtful whether he should really be counted among the ranks of the great Modernists whom he probably surpasses as far as the omnipresence of his paintings goes. Names like Duchamp, Malevich, Mondrian and Magritte stand for epoch-making changes and exemplary developments in Modernist art. It is difficult to say if the same is true for Klimt and whether his art, too, contains new, pioneering artistic options with new, critical insights into reality.

When Hans Hollein staged his spectacular exhibition *Dream and Reality* (Vienna 1986), Klimt's main works provided some of its focal points and *The Kiss* was almost displayed like an object of worship. However, in the context of this tense contrast of *Dream* and *Reality*, nobody would have wanted to see Klimt's art as part of *Reality*. Although he witnessed the disastrous breakdown of an empire and the end-of-the-world experiment of an entire culture, his work is far more the ecstatic reflection of fin-de-siècle society than a critical, clear-sighted discussion of social reality at the time of the disintegrating Habsburg monarchy. Even during his lifetime he was simply regarded as *decadent* – a typical representative of the decay and decline that prevailed at the turn of the century. With the renewed interest in the culture of the declining Habsburg monarchy, this assessment of Klimt has disappeared almost altogether.

However, when we enquire into Klimt's position as an artist, we should add a further question: does Klimt fit into 20th-century art

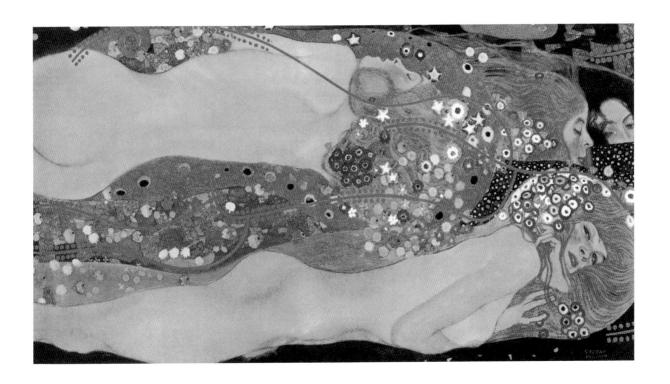

Water Serpents II, 1904-1907
Wasserschlangen II
Oil on canvas, 80 x 145 cm
Private collection, Vienna

history at all? There can be no doubt that most of his important works were painted in this century. But his training, the beginning of his career and thus the crucial factors that influenced his later development as an artist reach far back into the 19th century – the heyday of bourgeois liberalism in the 1870s and 1880s. Moreover, considering that his art claimed to go against historicism and the tide of rapid industrialization, does it not somehow hark back to a cultural period that disappeared altogether with the decline of the Habsburg monarchy?

Art historians, of course, see Klimt mainly as a member and sponsor of the Secession, which rebelled against antiquated ideas in the world of art and decisively influenced the breakthrough of Modernism in Vienna. He is seen as a painter and graphic artist who opened up new artistic possibilities and who identified – both politically and as a painter – with the young, rebellious generation of artists. This is sometimes reflected in an almost propaganda-like quality of his works, e.g. his Secession exhibition poster. All this, together with his occasional practical involvement as the head, organizer and - albeit rather taciturn – spokesman of the group, makes him one of the pioneers of Modernism.

Klimt has even been called an avant-garde artist. If we define the avant-garde as artistic, social and at the same time political rebellion, then at first sight it does indeed seem to apply to an artist like Klimt. In a major article, the American cultural historian Carl Schorske has interpreted Klimt's life and work as a protest, a revolt against his father's generation and their art. Schorske sees the accompanying

conflicts as a 'crisis of the liberal ego', a personality crisis which left deep traces in Klimt's work. However, we will see that the alliance of Secessionist artists and state politics – which only lasted a few years anyway – was politically conservative, mixed with a mood of artistic change, so that it cannot be viewed as progressive in character except in a very limited sense. It was part of the paradoxical situation in Vienna at the time that the state was convinced that art as a medium was still unadulterated by all political antagonisms. However, this soon turned out to be a mistake. The Austrian minister of education, in particular, was convinced that art could express the concept of the state – its unity and that of the nations – in an unbroken form, irrespective of all social and ethnic crises. Many artists did indeed identify with patriotic cultural and artistic endeavours and allowed themselves and even their future ambitions to become subservient to this concept of the state and, occasionally, also to the monarchy.

Apparently, then, there was considerable antagonism between commitment to aesthetic rebellion and a truce with the ruling culture, between *avant-gardists* and *décadence* artists, who had once been in disgrace and were now admired and widely sponsored. The former had found their organizational backing in the Secession and – later – in other associations. Such antagonism poses a number of questions which will be discussed in the following chapters. Questions about Klimt's fascination, popularity and topicality lead to these very artistic and cultural problems, which are expressed in his work. They have survived and are still regarded with keen interest.

Klimt's fame is still growing. Art historians have developed increasingly accurate research methods to analyse important aspects of his work, and reproduction techniques are becoming yet more perfect, thus enhancing the sensory fascination of his paintings. Large-scale exhibitons in Venice, Vienna, Paris and New York, devoted entirely to the history of art and culture under the Habsburg monarchy at the turn of the century, have kindled a renewed interest in Klimt's work. To a large extent, his popular appeal has always been due to the art market. In the same year that he died a large exhibition of Klimt's drawings was organized at Gustav Nebehay's gallery, and even today's great art dealers enthusiastically continue to display his work everywhere in the world. [1]

In 1908, with the *Kunstschau* exhibition, Klimt was at the height of his career. The exhibition, which contained several of Klimt's works as its highlights, was described as a "festive garment" for the artist. The magazine *Die Fackel*, where Karl Kraus had written a number of sneeringly caustic remarks about him, also contained an article by Otto Stoessel, in which he said, "Despite his brilliant gifts and his most exquisite hyper-refinement of expertise, Klimt fell victim to this dreadful state of affairs called 'taste', thus sharing the fate of everything that is relative and passes away with time." [2] Hardly ever has a critic been so wrong.

"I'm not very good at the spoken or the written word, particularly not if I'm supposed to say something about myself or my work. (...) If anyone wants to find out anything about me as an artist who is worth considering as a person, then he should have a good look at my paintings and try to find out from them who I am and what my intentions are." Gustav Klimt

Klimt's Fame

In order to understand Klimt, we must bear in mind that he is still surrounded by a number of clichés which have tenaciously persisted in playing an important role and which started when he was still alive. One of them is that of the unappreciated, misunderstood – even persecuted – artist. "Gustav Klimt," wrote the former director the Albertina Graphics Collection in Vienna, "used to meet with bitter rejection in his time. Given the historical and socio-historical situation, this was inevitable. It was a world in which all academic teachings of beauty were gradually losing their credibility and people were holding on, with all their strength, to things that were familiar. This world was bound to express its aggression with vehemence. After all, it felt that not only its aesthetics were being threatened." [3] It remains to be seen how far the standard concept of an artist who was in opposition to his times actually fits Klimt. It certainly arose quite early, at the beginning of his career, when Klimt did indeed become a controversial topic in Vienna's cultural circles. In 1903 a book called *Gegen Klimt* ('Against Klimt') was published by Hermann Bahr, a card-carrying member of the Secession who frequently wrote for the association. The book consisted entirely of polemical outbursts against the painter, whom he labelled an "outlaw".

Bahr had already stylized Klimt as a persecuted artist as early as 1901. Klimt's sketches of his so-called *Faculty Paintings* (pp. 76f.) for the University of Vienna had given rise to some controversy, which prompted Bahr to depict the artist as an unrecognized, misunderstood genius who had to face a hostile public and whose only obligation was to his own art. "There is a young artist who is becoming known rapidly, who is given the respect of other artists, of connoisseurs and of laymen and who gets clients ... someone who is very likely, as they say, to 'make it' quickly. He has the most marvellous future in front of him, in a few years' time he will be a professor – and then he can probably settle down to a quiet life. But that does not appeal to him. He is dissatisfied. He feels he can do more. He feels that he has never really given himself and that he has only ever painted in a foreign language, as it were. He can't bear it any more. Only now does he realize what it is that makes an artist – the power to show his own unique inner world, which has never existed before him, nor will ever exist after him. So this is what he wants to do. He wants to be unique. He goes through a tremendous crisis until he has eradicated everything alien, has acquired all his means of expression and has finally

Nude Woman, Standing and Leaning on Her Elbows, from the Left, around 1900
Red chalk, 32 x 45 cm
Historical Museum, Vienna

become his own artist … But suddenly something unexpected happens: not only is he misunderstood – no, ignorance runs out into the streets and rants and raves against him. People turn against him, using the crudest means of political agitation. He is personally denounced, suspected, slandered, and all the instincts of the common crowd are stirred up against him …" [4]

Bahr's speech was immediately printed and publicized in the form of a pamphlet. It cleverly promoted the idea of a lonely artist pitted against society, an autonomous, creative individual, not tied to traditions, independent of any influences, who necessarily has to face hostility because of his rebellious art, which is the very embodiment of progress. The idea of an artist who has to pay for his mission with social ostracism is a stereotype with which the 19th century, in particular, tried to determine the role of an artist in an ambiguous way. It is amazing that it should have survived so powerfully until the present day. Klimt was a prominent member of the Secession and, from time to time, its chairman. And although this artists' association systematically rejected all traditional forms of art, it enjoyed the highest possible favour. A contemporary painting shows an audience of the Secession artists with Kaiser Franz Joseph I: Klimt is seen introducing the members of the artists' association to the ruler, in particular the ancient Rudolf von Alt. The value of this picture is more than anecdotal, for it illustrates the political recognition of the Secession. Although some members of the Imperial family completely rejected it, this audience proved the national and political significance of the association, a status which it enjoyed for several years, mainly because of the patronage that was given to it by the minister of education, Hartel.

When the Habsburg monarchy had reached the height of its crisis and when social, national and economic problems seemed to have become intricately connected and therefore unsolvable, it was felt that art – and culture in general – was a force which could create harmony between all the disparate groups within society. The artists' association was therefore given considerable support by the state. The picture of the audience may seem insignificant, but it is a pictorial document of this political hope as well as the attempt to combine political conservatism and aesthetic progress. This alliance was very much in agreement with the "mission" that the Secession had given itself: it was their aim to achieve both the aesthetic enhancement of life and the popularization of art.

As for Klimt himself, he certainly enjoyed public recognition both personally and as an artist. The failure of a large-scale project such as his *Allegories of Faculties* for the University of Vienna is insufficient to prove that he was an unrecognized, "sub-cultural" artist. This extremely prestigious commission did of course trigger off a quarrel that was preceded by many other arguments about large public buildings on Vienna's Ringstrasse. Indeed, it finally resulted in the complete cessation of work for the Austrian state. However, after 1900, Klimt still had no difficulties in attracting the support of patrons, leading art critics and journalists. Access to the upper echelons of society was open to him ever since his brother had married Helene

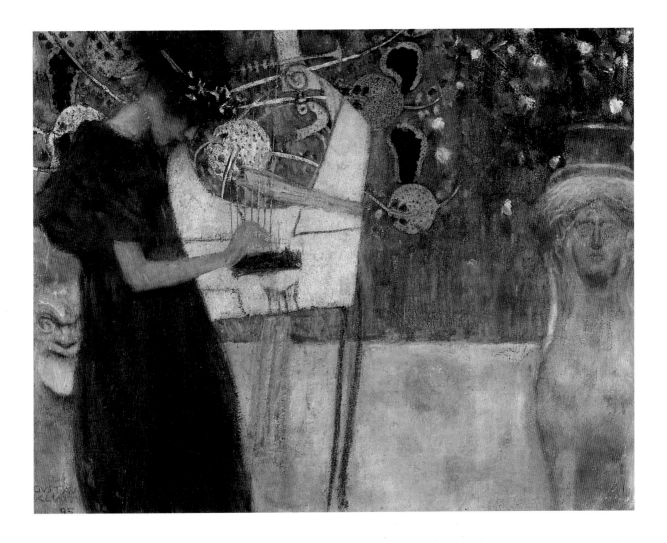

Music I, 1895
Die Musik I
Oil on canvas, 37 x 45 cm
Bavarian State Collection of Paintings,
Neue Pinakothek, Munich

Flöge, and, most importantly, Klimt continually received important commissions, so that he never had to suffer material hardship.

In 1900 Klimt was awarded a gold medal at the Paris World Fair, a year later the Bavarian State Collection of Paintings bought his painting *Music* (1895; p. 13), and in 1902 his first drawings were purchased by the celebrated Albertina Graphic Collection in Vienna. The 18th exhibition of the Secession (1903) was devoted entirely to Klimt, and in 1908 the Kunstschau exhibition celebrated his art by giving him an entire hall. In 1905, he was given the Villa Romana Award of the German Artists' Association. In 1906 he became honorary member of the Royal Bavarian Academy of Fine Arts, and, shortly before his death, of the Academy of Fine Arts in Vienna, although the latter never awarded him a professorship during his lifetime.

The real reason why Klimt was stylized as an unrecognized artist who did not receive fame until much later was, among other things, the continuing public apathy towards his most significant works and a lack of enthusiasm for showing them in museums. The proud rediscovery of the artist, which accompanied, for example, the restoration

Lovers, from the Right, 1914
Pencil, 37 x 56 cm
Owner unknown

and display of his *Beethoven Frieze* (pp. 104f.) reflected not only the
endeavour of politicians to boost their popularity with cultural
achievements, but also their desire to make amends in a special way.
Until twenty years ago nobody saw anything problematic in the fact
that Klimt's *Beethoven Frieze* lay in ruins at a depot, where it was
gradually decaying, and even in 1960 the city of Linz decided against
spending 300,000 Austrian schillings on a portrait of Margarethe Ston-
borough-Wittgenstein (p. 217), which had been on loan to the Aust-
rian Gallery. [5]

Literary and academic interest in the artist started while he was
still alive, with the first monograph published in 1920. In the 1960s this
culminated in an extensive rediscovery of Klimt, and since then nearly
every aspect of the artist's work has been covered. Also, a whole wave
of exhibitions on fin-de-siècle Vienna meant that Klimt was given a
degree of appreciation hitherto unknown. When Hans Hollein staged
his *Dream and Reality* exhibition, a Klimt cult hit Paris and New York,
comparable only to the 1908 Kunstschau.

However, the most important element of his fame is his reputation
as a master of eroticism. Nike Wagner has described him as the
"greatest erotic painter of his period" [6], Carl Schorske calls him the
"psychological painter of women" and "joyful discoverer of Eros" [7].
Alessandra Comini speaks of him as a *grand voyeur* and says that his
entire work is dominated by an obsession with the erotic [8]. "Klimt was
a master of eroticism – not just among other things, but with such an
intensity that the erotic element seems to exclude everything else,"
writes Gert Mattenklott. 'Whatever he perceived showed itself to him
in this perspective." [9] Finally, Jacques Le Rider comments that
"Klimt's entire oeuvre is a homage to the matriarchal principle which
dominates Modernism." [10]

One of the consequences of this assessment is that in the literature

on Klimt, both during his lifetime and later, there have always been examples of an eroticizing language which aims to recreate his art or even go beyond it. Other authors have pointed out that the erotic could be regarded as a socio-political and culturally progressive force. Thus, Klimt is seen as an artist who contributed considerably to the emancipation of women and the rediscovery of the lost power of the erotic element, an artist who was critical of his time and its outmoded cultural morality. "Klimt's permanent achievement," wrote Hans Bisanz in 1984, "is that he liberated the artistic depiction of human beings from the fetters of morality and opportunism and that he made visible, by means of his style, the basic mental images of man's inner life, images that point to the timeless element in the course of a person's individual destiny." [11] And finally, as the quoted passage seems to indicate, Klimt can be seen as a psychologist, as someone who analysed psychological phenomena and who pursued similar aims to those of his great contemporary, Sigmund Freud.

Carl Schorske goes even further in his essay and virtually equates the artist's intentions and those of the Secession with the scientific, medical and therapeutic aims of Freud, both in relation to cultural research and studying his own ego: "Klimt was a seeker and always viewed critically the things that were questionable and problematic in his own experience and in a given culture. Like Freud, he wanted to find the answer to his bewilderment by delving into the depths of his own soul and he often gave the answer much more readily to others by revealing himself ... Just as Freud had a passion for ancient culture and archaeological excavations, Klimt used the symbols of antiquity as metaphorical bridges and as a means of excavating one's instincts, particularly the erotic ones. Having started as a high-society theatre painter, he became a psychological painter of women ... Klimt turned to women as sensual creatures and drew everything out of them in terms of lust, pain, life and death. In an unending stream of drawings, Klimt tried to gain a sense of femininity." [12]

It is very tempting, of course, to link the idea of the misunderstood and despised artist and that of erotic obsession. However, it is certainly not true that Klimt was ever rejected because of his liberally erotic depictions. The only known case of prosecution concerned a male nude – a Secession poster – which Klimt then changed by covering the man's genitals with a thin little tree. On another occasion, it was explicitly emphasized by the law court that artistic freedom should take precedence over the demands of censorship in the Secession magazine *Ver Sacrum*. And although, in connection with his ceiling paintings for the University of Vienna, indignation was partly also directed at his nudes, most of the protest and eventually also the rejection of his work was based on the contradiction between Klimt's world view and the rational understanding of progress on the part of the bourgeosie, as well as their faith in science.

Klimt's Vienna – Then and Now

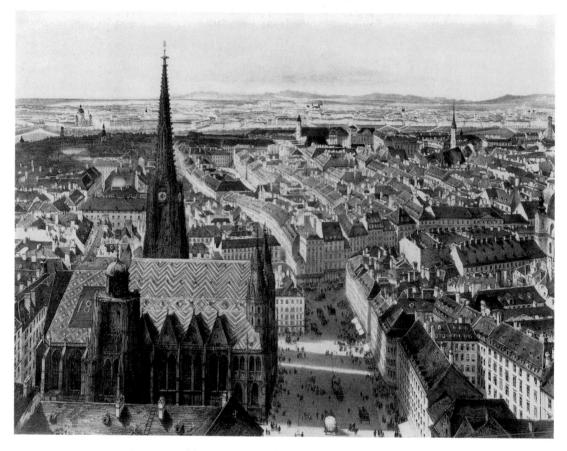

Above:
Part of Vienna, with St. Stephen's Cathedral in the Foreground, around 1860
Water colour by Jakob Alt,
reproduced lithographically by Franz Sandmann
Photographic Archives of the Austrian National Library, Vienna

Opposite, top and bottom:
Vienna, street scene, around 1900
Historical Museum, Vienna

Opposite, middle:
Sachergarten Café with contemporary Austrian society,
Photographic Archives of the Austrian National Library, Vienna

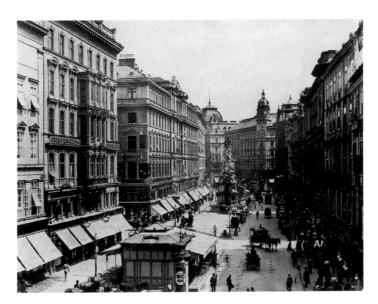

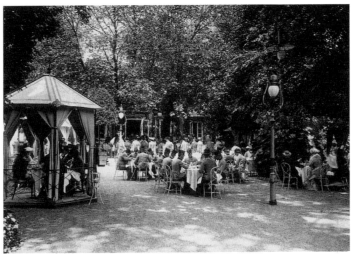

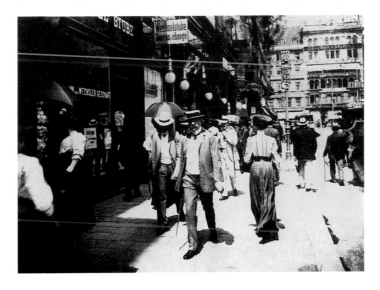

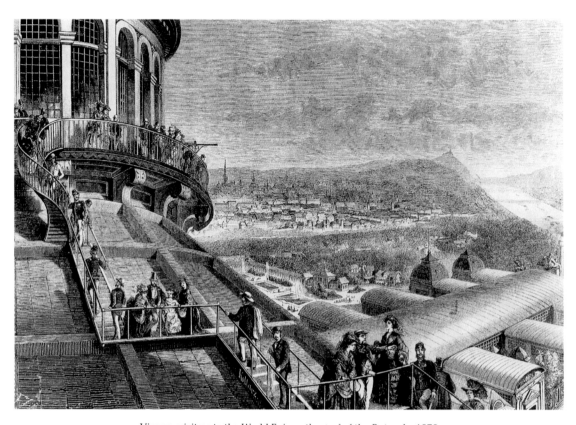

Vienna, visitors to the World Fair on the roof of the Rotunda, 1873
Photographic Archives of the Austrian National Library, Vienna

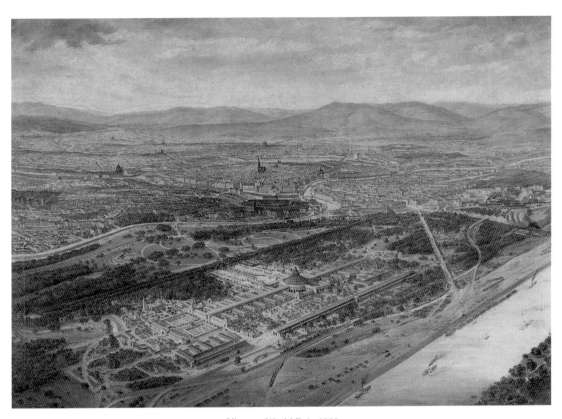

Vienna, World Fair, 1893
Historical Museum, Vienna

Otto Wagner, *Danube Canal Regulation. New Aspern and Ferdinand Bridge*, 1897
Pencil, Indian ink, watercolour, 98 x 72 cm
Historical Museum, Vienna

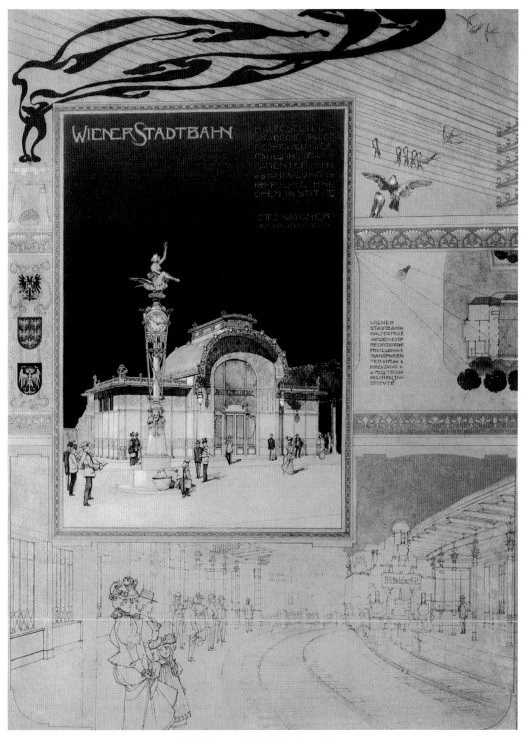

Otto Wagner, *Karlsplatz Tram Stop*,
view with perspective, 1898,
Pencil, Indian ink, watercolour, 65 x 46 cm
Historical Museum, Vienna

Kaiser Franz Josef Memorial, Burggarten

Roof figure on Majolica House,
Linke Wienzeile, Vienna

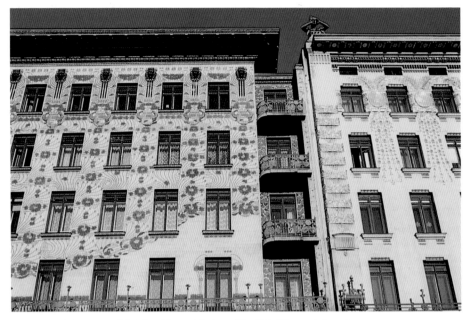

Majolica House (designed by Otto Wagner), façade

Ornamental decorations on Majolica House

Burgtheater, 1874-1888 (designed by Gottfried Semper and Carl Hasenauer)

Roof figures on the Burgtheater

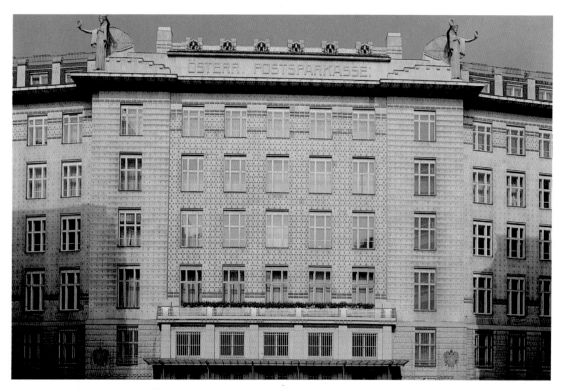

Austrian Post Office Savings Bank (designed by Otto Wagner), 1904-1906

Roof figure on the Post Office Savings Bank building

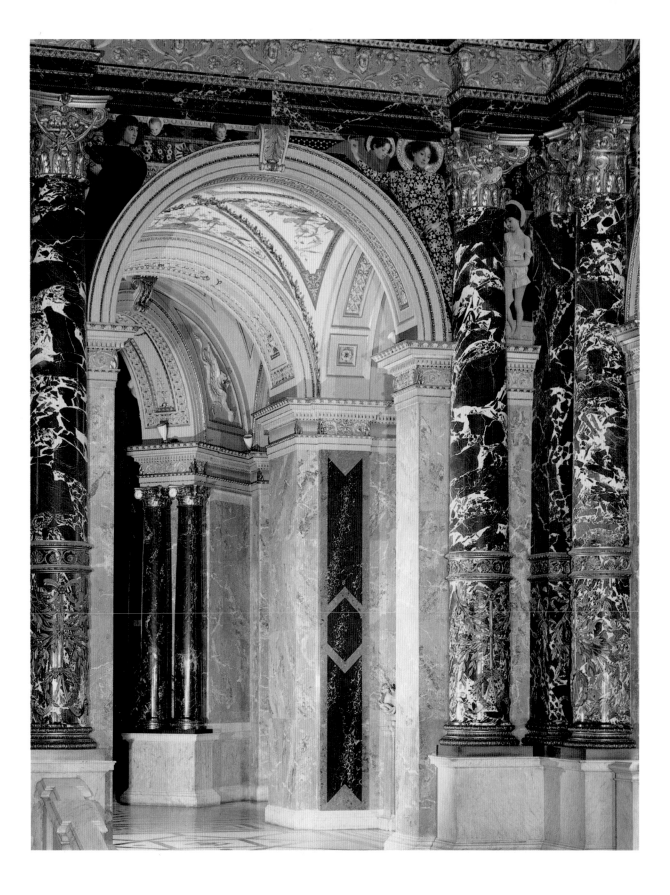

Years of Training

Klimt – who was the second child among seven – was born in Baumgarten, a suburb of Vienna, on 14 July 1862. His father, Ernst Klimt (1834-1892) was an engraver and came from a peasant family in Bohemia who had moved to Vienna when he was eight. His mother, Anna Klimt (née Finster, 1836-1915), was from Vienna.

After eight years of schooling at the local *Volks- und Bürgerschule* in the 7th Administrative District of Vienna, Klimt joined the School of Applied Art in 1867, at the age of 14. The college was attached to the Royal and Imperial Austrian Museum for Art and Industry. Both institutions had been founded at the height of liberal politics and culture in the 1860s. After the South Kensington Museum in London, it was the first continental European museum of applied art and the first modern institute in Vienna which was based on middle-class educational philosophy. It was meant to do more than display exhibits to a broad public. It aimed to provide, first and foremost, visual aids and teaching for craft and industry. The most important educational aim of the museum - to raise the "level of taste" in all areas of quality manufacturing – was further promoted and strengthened with the opening of the School of Applied Art. It was to supplement the direct visual teaching on the development of art and applied art at the museum as well as its opportunities for studying artistic forms and techniques. It aimed to teach practical skills and knowledge, with a view to combining forms of industrial craftsmanship and artistic work.

These two "cultural and industrial" institutions were to affect the production, invention and "aesthetic refinement" – to use the language of the time – of handmade and industrial products. It was hoped that this would also entail an economic advantage, as an aesthetically well-designed product was expected to sell better and be more competitive on the international market. As, however, the highly specialized degree of artistic craftsmanship made the production process rather expensive, these hopes were not met. The school and the museum never had a significant and lasting influence on production.

However, the growing interest in applied art was not merely a result of the newly-founded school and the systematic training which it offered. In the 1860s the political role of the liberally-minded middle classes had become considerably strengthened and thus increased their cultural assurance. An increasing number of private and public buildings and works of art were commissioned by middle-class clients. Both the museum and the school served the study and development of

Italian Renaissance, 1890/91
(detail on the right: child with Dante bust)
Intercolumniation painting at the Kunsthistorisches Museum, Vienna
Oil on plaster, ca. 230 x 40 cm

Italian Renaissance, 1890/91
Spandrel and intercolumniation paintings
at the Kunsthistorisches Museum, Vienna
Each spandrel painting, ca. 230 x 230 cm

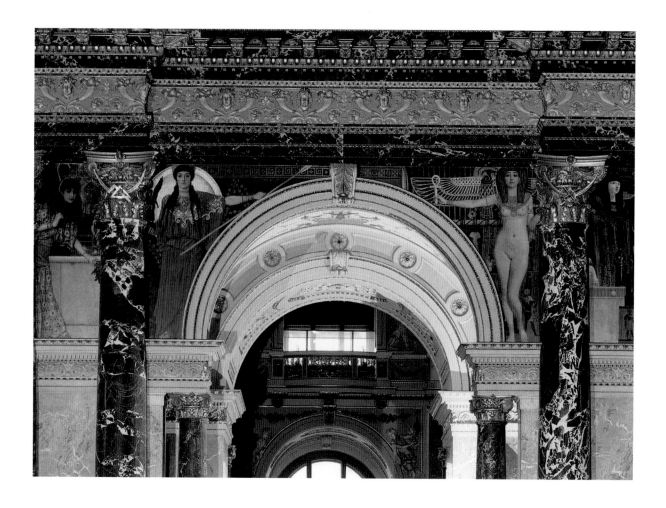

functional art forms by offering the relevant specialized range of training facilities. The great public and private Ringstrasse building projects, with their innumerable and extensive decoration jobs, offered a wide field of activities to an entire generation of artists. Indeed Vienna's period of rapid industrial expansion was called "The Ringstrasse Era". Many teachers and artists of the School of Applied Art were involved in important Ringstrasse projects. In their teaching and theory they represented the artistic ideals of "eclectic" historicism which made use of a variety of historical styles – although Vienna was dominated by the Italian Renaissance style during the 1870s and 80s. Together with other impressive governmental and educational institutions, the School and Museum of Applied Art were also situated on the Ringstrasse.

At first, Klimt attended the obligatory preparatory classes of the School of Applied Art, where he was taught by Michael Rieser, Ludwig Minnigerode and Karl Hrachowina. He practised ornamental drawing, copying three-dimensional and flat ornaments as well as commercial objets d'art. He also drew human figures from plaster casts and paintings. Practical lessons were accompanied by lectures on projection technique, perspective, style and other subjects. Subse-

Egyptian Art I and II,
Greek Antiquity I and II, 1890/91
Spandrel and intercolumniation paintings
at the Kunsthistorisches Museum, Vienna
Oil on plaster,
Each spandrel painting ca. 230 x 230 cm
each intercolumniation painting,
ca. 230 x 80 cm

Roman and Venetian Quattrocento,
1890/91
Spandrel and intercolumniation
paintings
at the Kunsthistorisches Museum,
Vienna
Oil on plaster,
Each spandrel painting ca. 230 x 230 cm

quently Klimt was promoted to the specialized painters' class under
Ferdinand Laufberger and, after his death in 1881, under Julius Victor
Berger, an artist working along similar lines to Hans Makart.

Klimt's brothers Ernst and Georg, who sculpted and chiselled
numerous frames for his brother Gustav's paintings, were also trained
at the School of Applied Art. Interestingly, in the course of the general
drive for modernization at the turn of the century, many of the artists
who advocated free and unfettered artistic creativity were either close
to the school, had been trained there or were even on the teaching staff
at a later stage. Until the educational reform under the Secessionist
Baron Felician von Myrbach, it was considered a most important
stronghold of the artistic doctrine of historicism. Teaching was domi-
nated by the disciplined copying of originals, often involving methods
of slavish Naturalism (sometimes even using photographs!), and
Klimt's entrance examination consisted of making a drawing of an
ancient female head from a plaster cast. Doubts about the school's
teaching methods gradually increased during the first two decades of
its existence until they peaked in massive criticism. It was said that the
school was a mere drawing school, that it did not prepare students
sufficiently for their real jobs, that it failed to achieve its artistic and

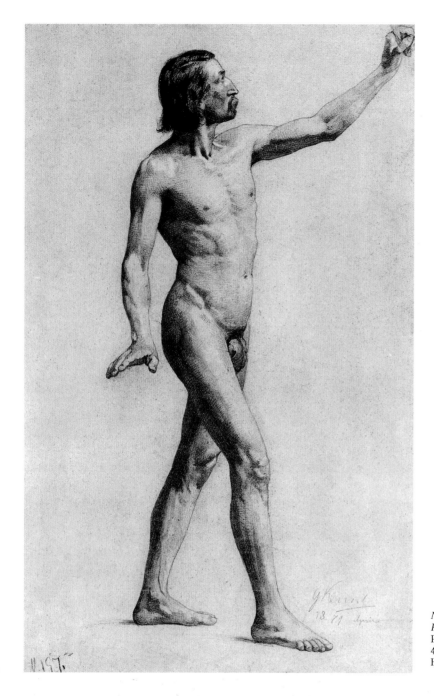

Male Nude in Walking Posture, from the Right , 1877-1879
Pencil, heightened with white,
43 x 27 cm
Historical Museum, Vienna

economic mission of "raising the level of good taste" and that it
therefore did not produce an aesthetically mature culture that could
create competitive products for the national and international market.
Even at that time, there were critical voices about the aesthetic con-
cept of historicism in general: "We are inundated by an unchanging
monotony of inane objects ... menus, labels from bottles, matchboxes,
paper cigarette ends and all kinds of debris and rubbish, inevitably in
the form of hackneyed puttos, sphinxes, griffins and acanthius leaves

Austrian Museum of Art and Industry
Photographic Archives of the Austrian
National Library, Vienna

... sloppy work by people who have never seen or studied an original and who only very superficially handle whatever formal nonsense happens to be fashionable at the time." [13]

Attempts to achieve a reform, even while Klimt was at the School of Applied Art, do not seem to have borne fruit. Practical reforms could not be introduced until the school was firmly in the hands of the Secessionists, who emphasized autonomous artistic creativity rather than copying historical examples. Its representatives turned vehemently and angrily against the eclecticism of artistic production during the period of industrial expansion and against the educational methods that served it – methods that were marked by a lack of freedom and by mindless copying. Whatever one may think of this criticism, it certainly lost sight of the beneficial elements that were involved in learning through copying. Klimt's earlier works, in particular, show that his strict training, oriented towards historical patterns and examples, as well as his vast gamut of artistic methods provided a basis for his later development and indeed opened up a career that was at first completely dominated by the historicist culture of the *Ringstrasse Era*. Klimt's style was marked by a characteristic contrast between excellent Modernist craftsmanship and abstract stylization, between decorative surface patterning and a confident development of space, both in the statuary proportioning of figures and in many of his drawings. Undoubtedly, this originated in the broad spectrum of "applied art" as it was taught by the School of Applied Art of the Royal and Imperial Austrian Museum for Art and Industry, even though its aim had been quite different at the time.

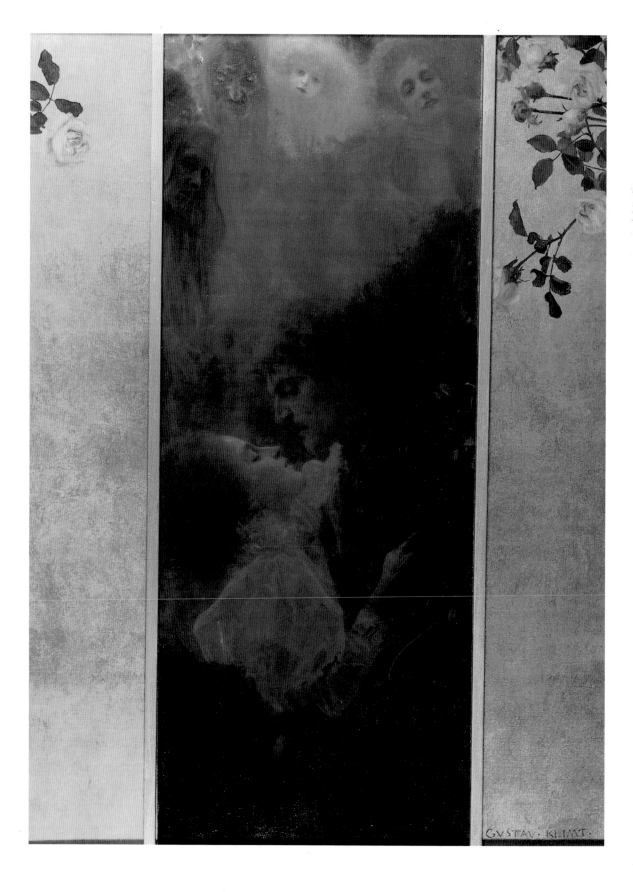

Early Works and the Beginning
of a Career

Klimt was the only student at the School of Applied Art whose education launched him on a great artistic career before the 19th century was out. Both his teachers and Rudolf von Eitelberger, the principal and founder of the School, helped to promote his career. Together with his fellow-student Franz Matsch and his brother Ernst, Klimt was asked by his teacher Michael Rieser to work with him on the stained glass windows in the Votivkirche (Votive Church), the first large building on the Ringstrasse. Thus, Rieser and Von Eitelberger supported Klimt in becoming a painter. [14]

Klimt, his brothers and Franz Matsch (1861-1942) combined to form an artists' association which they called the *Künstlercompagnie*, which subsequently profited from the building boom of the late Ringstrasse Era. At first, this was limited mainly to the more provincial parts of the Habsburg Empire. All three found employment with a company called Fellner & Hellmer, which specialized in building theatres, and were involved, among other thing, in decorating theatres in Fiume, Reichenberg and Karlsbad (now Liberec and Karlovy Vary, Czechoslovakia) and Bucharest.

Even after their training, all three kept up their contact with the School of Applied Art and the head of the museum, who was highly influential on the cultural scene. A letter, written by the three artists to von Eitelberger in 1884, shows very clearly their attempt to establish themselves on the Historicist art market. Diplomatically, they mentioned their faithful adherence to traditions and their efficiency as a collective which even enabled them to take on larger commissions at inexpensive prices. "Only now," they wrote among other things, "after we have succeeded in establishing a studio ... do we take the liberty, Your Honour, to submit to you, dear Herr Hofrath, a programme of our association in as brief a version as possible ... The instructions of our teachers [i.e. Laufberger and Berger] were of such a wholesome and universal kind that we deem ourselves fortunate to have enjoyed them. In view of the fact that we were students of the same masters and that each of us endeavours to uphold their inestimable teachings, we believe that we have embarked upon the right path, although we will of course continue to cooperate with one another and seek to promote this path by means of mutual correction. ... our corporate activity is of considerable advantage ..., as our greater creative capacity enables us to deal with commissions swiftly and the sum of our experience is constantly growing. Until now, our

Finished Drawing for the Allegory
Junius, 1896
Black chalk, washed pencil, gold,
heightened 42 x 31 cm
Historical Museum, Vienna

Love, 1895
Liebe
Oil on canvas, 60 x 44 cm
Historical Museum, Vienna

activity ... has mainly been directed at the provinces and abroad; it is therefore our dearest desire to carry out more extensive work in our native city, and it may be that an opportunity exists at this very moment, as Vienna's new monumental buildings are approaching completion and decorative artwork in these buildings is probably only accorded to their most significant parts, so that the most excellent artists are fully occupied ..." [15]

Their "dearest desire" – to be involved in the great building tasks on the Ringstrasse – was fulfilled. From 1886 to 1888 they worked on the ceiling paintings of the two staircases at the *Burgtheater*. There Klimt also painted his *Thespian Cart*, *The Globe Theatre in London*, *The Altar of Dionysius*, *Theatre in Taormina* and *The Altar of Venus* . The *Künstlercompagnie* also helped decorate the staircase of the Court Museum of Art History, where Klimt had already been asked for assistance with sgraffito work by his teacher Laufberger. The decoration of the huge staircase at the museum was meant to glorify the Imperial court by showing the generosity of Imperial patronage, while at the same time serving as a self-representation of the bourgeoisie. Originally the work was to be carried out by Hans Makart, but his untimely death prevented the completion of his work. The *Künstlercompagnie* was asked to paint the spandrels and intercolumniation, i.e. the area between the columns (pp. 28f.), in accordance with a programme designed by Albert Ilg, the principal of the applied art collection of the museum. At the same time, they were to keep very strictly to the spirit of historicism, to follow historical examples in all their details and to study the exhibits of the museum.

Both jobs confronted Klimt and the other two painters with the optimism and faith in progress of middle-class liberalism. The three-dimensional decorations on the façades of the two museums as well as the cycles of paintings which Klimt helped to create served to glorify

Fable, 1883
Fabel
Oil on canvas, 85 x 117 cm
Historical Museum, Vienna

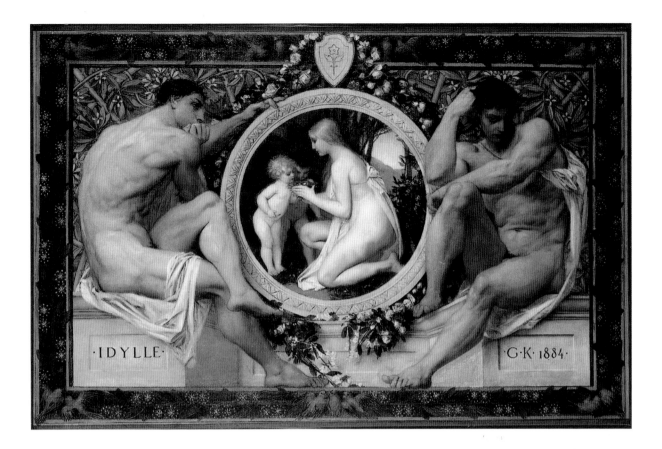

Idyll, 1884
Idylle
Oil on canvas, 50 x 74 cm
Historical Museum, Vienna

the "triumphal march" of cultural progress by celebrating several outstanding historical stages of development. The most appropriate art form for this conception of one's own position was that of historical genre paintings. In many true-to-life and historically accurate details (costumes, interior design, ornaments, etc.), they recalled the past "as it was" so that the viewer could identify with it. Thus, the middle classes could understand themselves and "their" century as the heir and climax of epoch-making cultural achievements of the past. The theatre and the world of the stage, for example, could be seen as the worthy successor of Graeco-Roman and Shakespearean drama.

Significantly, Klimt not only helped to decorate the theatre, but one of his commissions also involved portraying the audience of the (old) Burgtheater, which he did in the spirit and with the insistence on form that characterized the 19th-century middle classes. In 1887 the Viennese City Council commissioned Klimt and Matsch to paint a view of the interior of the old theatre, which was scheduled for demolition and where the last performance was to take place in 1888. His painting *Audience at the Old Burgtheater* (p. 40), which provides photographic details of Viennese society rather than the actual stage, not only documents Klimt's identification with liberal middle-class culture [16], but also formed the basis of his own fame when he was given the Imperial Award. Although his painting was competing with photography, which was more suited for portrait studies, it was of a much

Upper Part of a Recumbent Girl, from the Right, and Two Studies of Hands, 1886-1888
Black chalk, washed and highlighted in white, 45 x 32 cm
Albertina, Vienna

Half-Length Portrait with Three-Quarter View of an Older Man, from the Left. (ceiling painting at the Burgtheater in Vienna), 1886-1888
Black chalk, highlighted in white, 43 x 29 cm
Albertina, Vienna

*Head of a Recumbent Man, Supporting
Himself* (ceiling painting at the Burg-
theater in Vienna), 1886-1888,
Black chalk, highlighted in white,
28 x 43 cm,
Albertina, Vienna

higher quality. It is said that Klimt produced several replicas for per-
sonalities depicted among the audience. In this collective portrait the
audience stages its own social and historical role, thus acting its own
part. By watching the stage, instead of being mere spectators, its
members become the real subjects of history, which is being staged
before their very eyes.

The photographic Naturalism of this "society painting" as well as
the desire of many personalities to be included in it and thus acknow-
ledged and appreciated betray something of its function: the depicted
persons were to recognize themselves and be identified by others as
members of that cultural elite which, shortly before the turn of the
century, regarded itself as the true force behind material and cultural
progress – and enjoyed being celebrated in this role.

The painting was significant for Klimt in that it helped him obtain
recognition among Vienna's high society, and even though this
appreciation was not shared by everyone, it was nevertheless wide
enough to help him through all later conflicts. His recognition showed
itself in the high award for the painting, after the artist had already
obtained the Golden Cross of Merit for his work on the *Burgtheater*
staircases. Public acclaim, however, did not lure Klimt into unqualified
adherence to the cultural optimism of the liberal middle classes. With
his *Faculty Paintings* (pp. 76f.), at the latest, he refused to follow the
dominant self-image of the middle classes, which by then had already

become rather shaky. With this refusal he questioned both his own identity as an artist and the ideals of artistic monumentalism during the time of greatest imperial confidence.

When a publisher commissioned Klimt to submit samples for a "sumptuous work" of allegories and emblems, Klimt came into contact with the artistic – though this time allegorical – treatment of typically historicist themes. The keynote of the painting was already aiming at that allegorical "overall context" of natural and social life which Klimt was to depict later, for example in his *Faculty Paintings*. For his first portfolio (1882-84) Klimt drew, among other things, sketches for *The Folk Tale, Daily Papers, Realms of Nature* and *Opera*, as well as producing a number of painted sketches for *Fable* (p. 36) and *Idyll* (p. 37). For his second portfolio, which was published from 1895 onwards, he created, among other things, the two drawings *Sculpture* (pp. 44 and 69) and *Tragedy (p. 45)* as well as the painting *Love* (p. 34).

The painted version of *Love* (1895) already shows us the mature formal and thematic idiosyncrasies of Klimt's art. It was a theme which was to occupy him again and again. The two lovers are supplemented by secondary figures which are meant to put them in a wider allegorical context and extend the thematic limits of this genre painting to that of a cosmological depiction of mankind. Youth, old age and the "hostile" forces depicted in the form of female figures, which were to become characteristic of his major works later, point to a variety of threats to human life and happiness as well as their transitoriness. His

Profile and Back View of a Gentleman with Opera Glasses, Sketch of His Right Hand, 1888-1889
Black chalk, highlighted in white,
43 x 28 cm
Albertina, Vienna

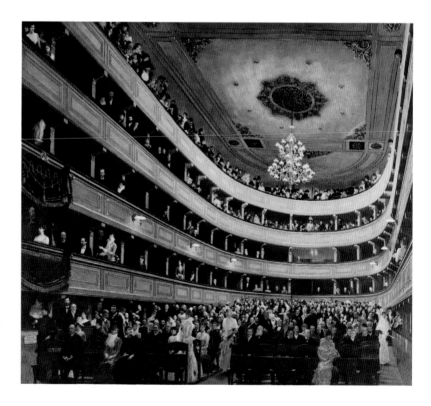

Auditorium of the old Burgtheater, 1888
gouache on paper, 82 x 92 cm
Historical Museum, Vienna

*Study Sheet for an Allegory of the
Theatre, Movement and Costume Study,*
1895
Drawing pen, with watercolour and
highlighted in white, 39 x 26 cm
Historical Museum, Vienna

Hofburg Actor Lewinsky as Carlos (p. 50) – a portrait which was
painted in the same year as *Love* and is comparable in its formal
technique – also includes an allegory (the art of theatrical presenta-
tion). To avoid disturbing the dignity of the portrait, it has been
banned to the frame, where it shows two aspects of old age and
femininity – ugliness and beauty as well as aggressiveness and har-
mony.

The wide, painted frame of *Love* produces a formal tension be-
tween the empty space and the densely painted surface. It affords us,
as it were, a glimpse of the painting itself. The allegorical secondary
figures are observing the two lovers like spectators looking at a stage.
In his *Allegory of Sculpture* (p. 44) a number of busts – representing

the different stages in the development of art – are in fact lined up like spectators above a stone balustrade. They mirror our own glances as we concentrate on the metamorphoses of femininity. Fending off male glances with its dead eyes, the Graeco-Roman sculptural allegory is – just like a sphinx – a "counter-image" to the observing figures that seem to have been changed back from sculptures to living beings again.

When Klimt was given a private commission in 1898/99, this posed completely different thematic and formal demands from the official commissions for the large Ringstrasse buildings. The industrialist Nikolaus Dumba left the architectural work and interior design of

Finished Drawing for *Youth*, 1882
Drawing pen, with watercolour and highlighted in white, 38 x 26 cm
Historical Museum, Vienna

Organist, 1885
(Draft for the *Allegories of Music* at
Bucharest National Theatre)
Oil on canvas, 38 x 50 cm
Austrian Gallery, Vienna

three rooms in his stately home on the Park Ring to the painters Hans
Makart, Franz Matsch and Gustav Klimt. Klimt was responsible for the
music room, designed the wall decorations and painted two sop-
raporte paintings (i.e. paintings embedded in the panelling above the
doors), *Music II* and *Schubert at the Piano* (pp. 46 and 47). The interior
design and general artistic appearance of people's living space were
of central importance for art around the year 1900. One's living space
was seen as an area of privacy where a person could withdraw from
the life of society and which was reserved for the undisturbed
development of one's psychological sphere. "Atmosphere", the unity
of psychological and aesthetic well-being, was one of the key concepts
characterizing the requirements of interior design at the time. This
new concept of interior decorating gave artists the opportunity to try
out and put into practice – often in artists' circles – their ideas of a
"comprehensive work of art" and the "overall psychological effect" of
their notions of space. These also became characteristic of the Seces-
sion exhibitions. Rooms, series of rooms and indeed whole villas could
be subjected to a uniform artistic concept in which all the details were

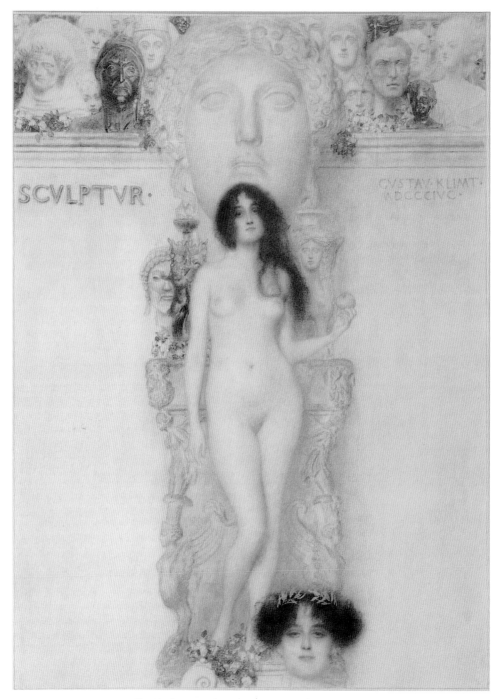

Finished Drawing for the Allegory *Sculpture*, 1896
Black chalk with pen, washed, gold, highlighted in white, 42 x 31 cm
Historical Museum, Vienna

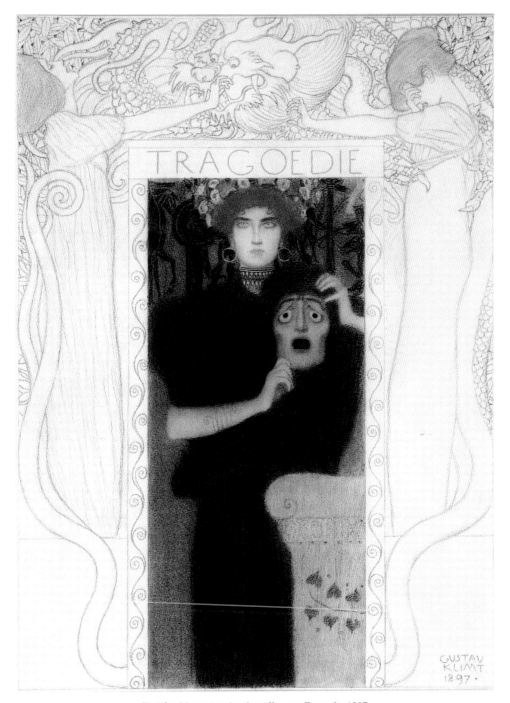

Finished Drawing for the Allegory *Tragedy*, 1897
Black chalk with pen, washed, gold, highlighted, 42 x 31 cm
Historical Museum, Vienna

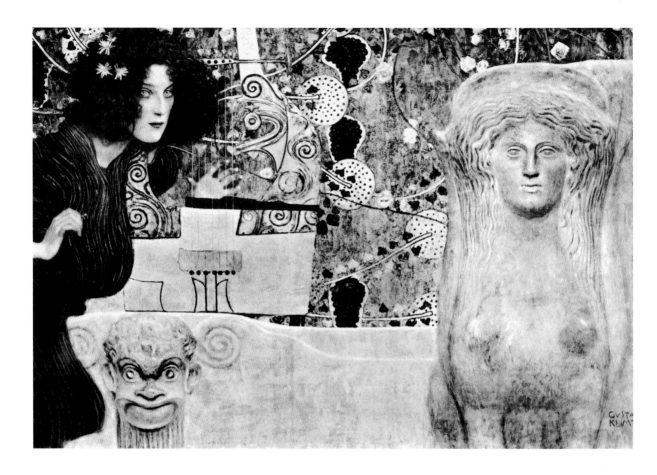

in harmony with one another, so that sometimes even the clothes of the inhabitants were subject to the uniform design of the whole.

In designing rooms full of atmosphere for Palais Dumba, the artists echoed the historic style of Biedermeier culture. With this style (between about 1815 and 1848), the middle classes had, for the first time, created an appropriate home décor for themselves. It was the expression of their self-image as well as their self-satisfaction, reflected particularly in its intimate character with its concentration on cosy snugness.

Klimt's sopraporte paintings for the music room form a transitition from his early historicist academic works to Secessionist paintings. His *Schubert* painting, in particular, shows that he no longer followed the academic tradition. Although it is a historical genre painting (which was probably inspired by Biedermeier pictures of Schubert), Klimt completely abandoned the idea of accurate historical imitation. Even the clothes of the figures are contemporary, and the glimmering brightness of the candlelight gives the painting its Impressionist character. The sketch, incidentally, is far more closely in line with a certain decorative elegance than the final painting itself – that elegance which Klimt was to adopt to a much greater extent at a later stage. Forming a relic of historical realism, only the accurate portrayal of Schubert's features somehow seems to contradict the Impressionist

Music II, 1898
Die Musik II
(Sopraporte painting in the Music Room of Nikolaus Dumba Palace at Parkring 4, Vienna)
Oil on canvas, 150 x 200 cm
Destroyed by fire at Immendorf Palace in 1945

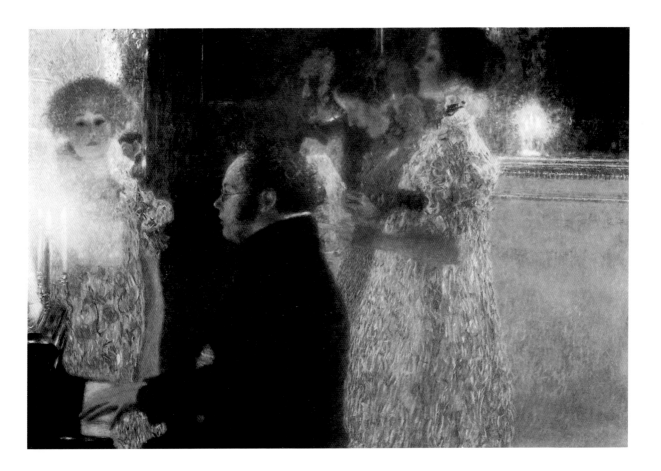

lighting effect that dissolves the tangibility of the rationally "touchable" space of the painting. [17] It is the first major work in which Klimt departed from the Naturalist rendering of space and light that characterized history paintings in which the figures had still occupied definite places within the depicted space.

The formal qualities of Klimt's later work, which dissolved the visual space in decorative two-dimensional patterns, can already be seen particularly in *Music II* , the pendant to his *Schubert* painting. The "vivid lifelessness" of the mask and sphinx makes them part of a frieze in the style of antiquity. However, his accuracy of detail does not serve the precise rendering of an ancient work of art, even though it is certain that Klimt spent a considerable amount of time studying works of art at the Court Museum of Art History. Unlike in Historicism, where the artist aimed to preserve the authenticity, truth and genuineness of historical tradition and experience as well as its exemplary character for the present, he is now no longer concerned with archaeological reconstruction. Instead, Klimt seemed to be interested in a connection between historical and atmospheric character, an animate liveliness which does not simply remind us of a fixed image of antiquity as a thing of the past, but aims to recreate it as an ideal, everlasting presence. [18]

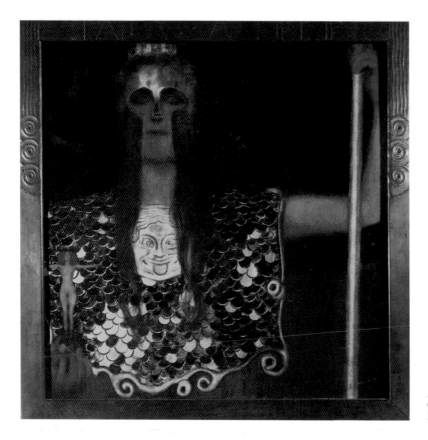

Pallas Athene, 1898
Oil on canvas, 75 x 75 cm
Historical Museum, Vienna

The same can be said for Biedermeier. Its historical treatment is reflected in the *Schubert* painting. Again, it was regarded not as a finished period which might have been exemplary, but as a different version of Modernism, a time comparable to the years around 1900 in displaying a modernness that was more than temporary. The two periods were therefore seen as closely related. Both paintings, *Schubert* and *Music II*, are attempts to turn the past into present. In the one painting it is antiquity, in the other the Biedermeier period which appears in the shape of a "different present".

19th century Historicism was based on a concept of time that saw history as an irreversible process logically developing towards the future. Each "element" within this time continuum, each cultural or artistic period, occupied an unalterable "position". It would never return, nor could it be recalled in any way. In referring to the past, for example when Vienna's liberal culture of the 1870s and 80s referred back to the Italian Renaissance, the relevant artistic period was seen as an irrevocably finished period. Its artistic achievements, ideals and norms could be kept alive for the present through the effort and mediation of institutions such as museums and educational establishments (e.g. the School of Applied Art), but only as a species of cultural property. Still within the framework of this basic understanding of history, Klimt's works were beginning to herald his departure from the thematic and formal ideals of Historicism. Klimt established a different concept of time and a different relationship between past and present.

Even the sensuous, menacing presence of *Pallas Athenae* (above), with her maternal yet punitive power, rather disturbs the thought of a calmly retrospective ideal of academic education. Historicist symbols such as Pallas Athenae – a monumental statue outside Vienna's Parliament – were literally imbued with life and acquired a sensuous presence which prompted superficial identification of the historical figures with the real beauty and seductiveness of the ladies in Viennese society. This can be seen in the way Klimt's painting *Judith* (p. 142) was interpreted at the time. Such seductiveness, in turn, revived ancient mythology again so that, indirectly, it gained a new lease on life. Just as the erotic fascination of *Judith* kept her mythical significance alive, the sensuousness of the *femme fatale* was able to give new life to the hallowed but now anaemic ideal of wisdom.

Even earlier, in his monumental paintings for the Ringstrasse buildings, Klimt had made use of the Modernist depiction of femininity – with his sister, among others, as a model – as well as female nudes. He wanted the sensuous eroticism of his female figures, rather than their historical significance, to make the viewer identify with his paintings. In some of his works this led to a deliberate confusion of different levels of reality. Nuda Veritas, for example, held in *Pallas Athenae*'s hands as if she were a small statue, is a flesh-and-blood nude in the style of Klimt's seductive red-headed femmes fatales. In the two *Music* paintings for the Dumba salon, the historical, iconographic character has been replaced by an atmosphere deliberately evoking the past.

There are two sides, though, to Klimt's thematic approach. Identification with the sensuous presence of femininity affords a new view of ancient themes, strengthens their relevance to the present and imbues them with life. At the same time, however, eroticism and sexuality in Klimt's works are endowed with an aura of basic, primaeval forcefulness. His recourse to ancient myths and his method of enlivening them in the form of images give the erotic element a kind of borrowed innocence and natural originality. Thus, Klimt's depictions of erotic antiquity or ancient eroticism are a critical comment on the Pharisaical morality of his time.

In works such as *Pallas Athenae* and the Secession poster (p. 70) Klimt used this singular dialectical approach to fan the flames of the current rebellion in art and the younger generations' rejection of liberal bourgeois culture.

After the death of his brother and father in 1892, Klimt received the commission for the *Faculty Paintings* (pp. 76f.). This was the first high point of his career as a decorative history painter. However, his fame was no guarantee of unbroken success. When, in December 1893, the Academy of Fine Arts proposed that Klimt should be appointed professor at the Master School of History Painting, the Kaiser appointed somebody else – Kasimir Pochwalsky. In 1901 Klimt's name was put forward for another professorship, but again, he did not receive it. His work on the *Faculty Paintings* in the late 1890s provoked a lengthy public controversy with considerable consequences for Klimt's life and work.

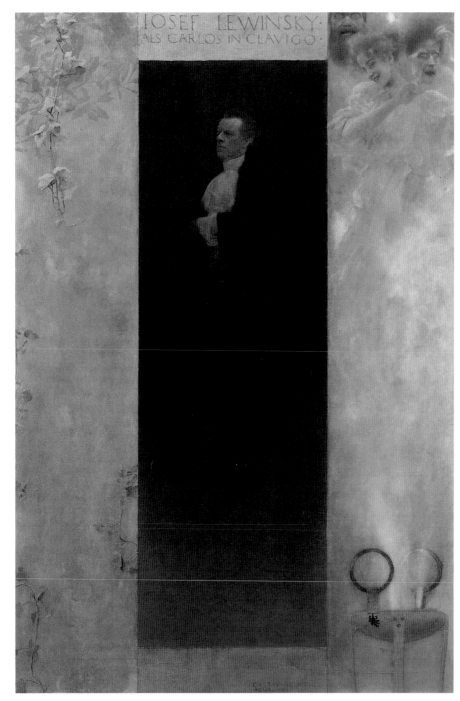

Hofburg Actor Josef Lewinsky as Carlos, 1895
Oil on canvas, 64 x 44 cm
Austrian Gallery, Vienna

Early Portraits

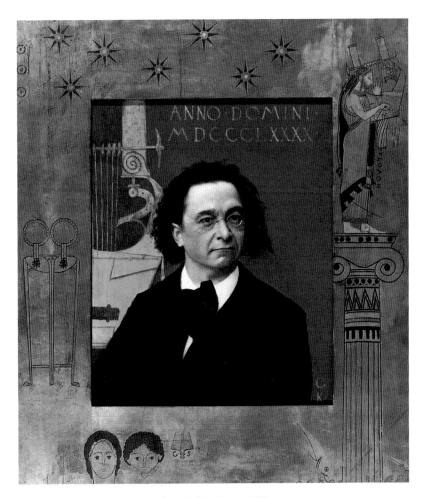

Joseph Pembauer, 1890
Bildnis des Pianisten und Klavierpädagogen Joseph Pembauer
Oil on canvas, 69 x 55 cm
Tyrolean State Museum Ferdinandeum, Innsbruck

Girl in the Open Air, 1896
Mädchen im Grünen
Oil on canvas, 32 x 24 cm
Private collection, Austria

Portrait of a Lady (Frau Heymann?), around 1894
Damenbildnis
Oil on wood, 39 x 23 cm
Historical Museum, Vienna

Lady at the Fireplace, around 1897/98
Dame am Kamin
Oil on canvas, 41 x 66 cm
Austrian Gallery, Vienna

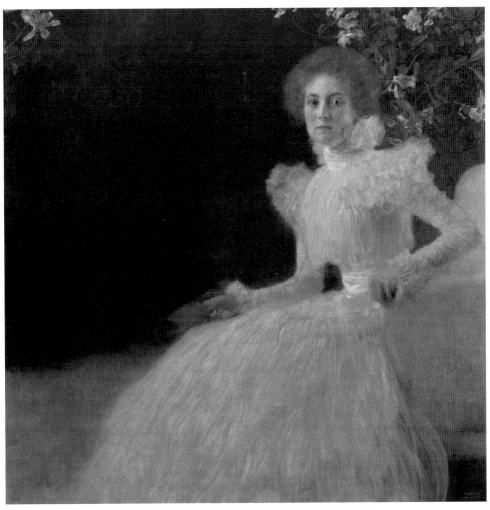

Portrait of Sonja Knips, 1898
Bildnis Sonja Knips
Oil on canvas, 145 x 145 cm
Austrian Gallery, Vienna

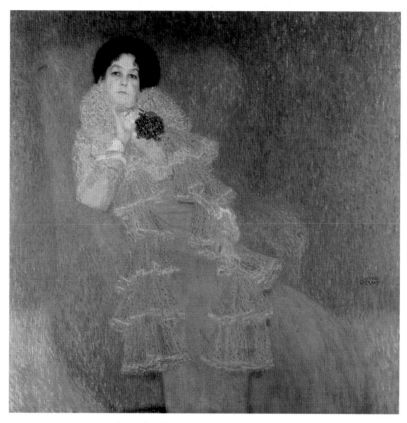

Portrait of Marie Henneberg, 1901/1902
Bildnis Marie Henneberg
Oil on canvas, 140 x 140 cm
Moritzburg State Gallery, Halle, Saale

Opposite:

Portrait of Serena Lederer, 1899
Bildnis Serena Lederer
Oil on canvas, 188 x 85.4 cm
The Metropolitan Museum of Art, New York, purchase,
Catharine Lorillard Wolfe Collection, bequest of Catharine
Lorillard Wolfe, by exchange, and Wolfe Fund;
and gift of Henry Walters, bequest of Collis P. Huntington,
Munsey and Rogers Funds, by exchange, 1980.

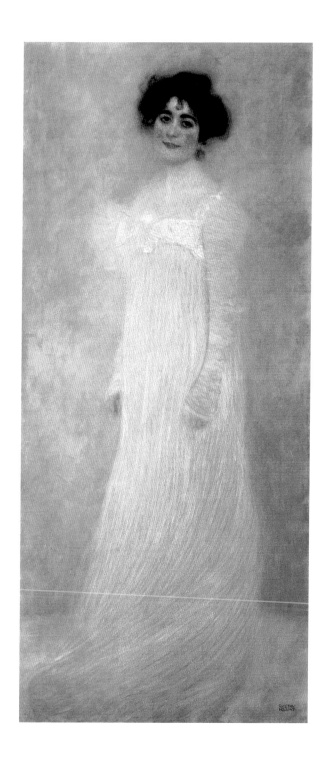

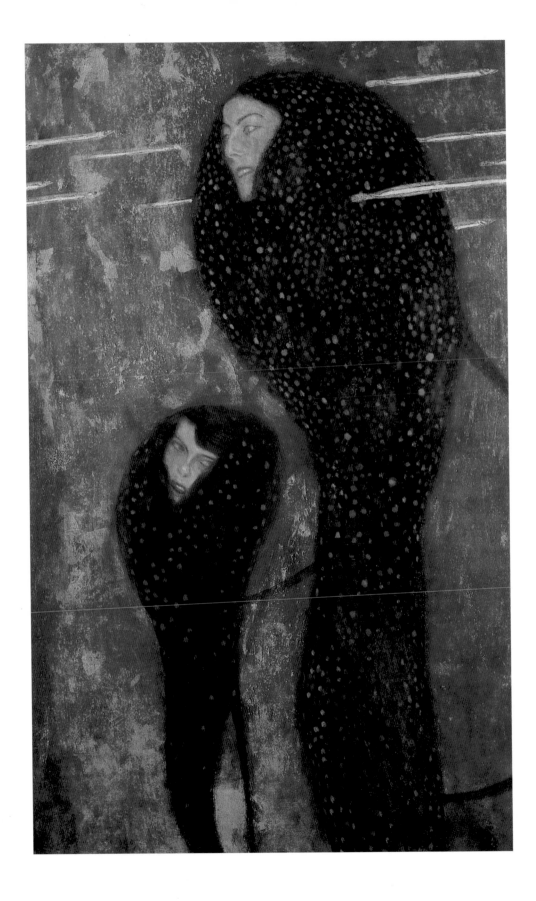

"Oedipal Revolt" – the Secession

Klimt's early works and his integration into society as an artist coincided with a crisis in liberalism and the liberal bourgeoisie. Cultural historian Carl Schorske has therefore interpreted Klimt's life and oeuvre entirely in terms of a "crisis of the liberal ego" – a crisis triggered by radical economic and political change affecting the artist and his work.

Vienna's art and culture around the year 1900 mainly owed its richness to the liberal Austrian bourgeoisie, a social class whose crisis was closely connected with the difficult and contradictory development of its political emancipation. Earlier, in 1848, the middle classes had failed to enforce their political demands, and their bourgeois "revolution" had been crushed by the military counter-revolution of the revived absolute monarchy. They then had to enter into considerable compromise with other social classes in order to have any political power at all. Sharing their power with the aristocracy and the ruling dynasty had an adverse effect on the economic progress and especially the industrialization of the Habsburg monarchy, so that Austria remained an agricultural country well into the nineteenth century.

Towards the end of the century, the middle classes found themselves falling between two stools. Not only did they have to maintain their identity towards the aristocracy and the Kaiser's dynastic politics; they now had to do the same in the face of modern social movements and the large-scale political parties which lent substance to such movements. Also, the structure of the state, which continued to be mainly agricultural, did not allow the middle classes to gain a real economic foothold as a capitalist force. Thus the "social question" developed into an existential crisis of the empire that was economic, philosophical and political. The problem was further aggravated by ethnic conflicts between the various nations of the Habsburg Empire, which was only kept together by force.

The failure of industrialization – and, with it, economic modernization – came to a climax in the 1873 crash, (in the very same month that Vienna was holding its world fair). As a result, the middle classes were barred from any share in political power, and no middle-class minister was appointed. In addition, towards the end of the century, the political scope of the middle classes was curtailed even further by the large political parties – the Christian Social Democrats and the Socialists. The political and social demands of the labour movement, in particular, could no longer be suppressed.

Two Studies of a Girl and Four Studies of Hands, 1897/98
Black chalk, highlighted in white,
47 x 33 cm
Historical Museum, Vienna

Mermaids (Whitefish), around 1899
Nixen (Silberfische)
Oil on canvas, 82 x 52 cm
Zentralsparkasse, Vienna

The increasing exclusion of the middle-class intelligentsia from political power and the resulting crisis, says Schorske, was counterbalanced to an extent by various cultural revolts. As the middle classes had very little or no influence on political and social change, they could only concentrate their activities on academic pursuits, science, literature and art. The literary circle *Jung Wien* (Young Vienna) was one of the first Secession groups who protested against traditionalist norms in art and ethics and who derived their identity as a group from this protest.

The actual Secession itself came into being in 1897. This group of young artists had formed within the *Künstlerhaus* (the Artists' House), a classical, traditional association of artists. They were now opposing the older generation of artists, and Klimt, who had been a *Künstlerhaus* member since 1893, was one of the first to leave the association. In 1897 he became the first chairman of the Secession. Only a year later it organized its first exhibition, opening its own exhibition premises, designed by Joseph Maria Olbrich.

This rebellion sought to emulate the ancient Roman *secessio*. However, Schorske does not interpret it as a revolt of artists excluded from the art scene. After all, the early Secessionists had originally belonged to the *Künstlerhaus*. Rather, he sees it as a generation conflict that was partly motivated psychologically – an "oedipal revolt" of the sons against their fathers and their traditions. [19] The mouthpiece of the Secession was a magazine called *Ver Sacrum*, after an ancient Roman initiation rite for young men in times of danger. It is worth noting that in choosing these names – *Secession* and *Ver Sacrum* – the young artists were deliberately distancing themselves from any historical recourse to the Middle Ages or the Renaissance. Instead, they were proclaiming a religious and cultic renewal not only of art but of society at large.

The Secession was founded after vehement arguments in the Co-Operative Society of Austrian Artists. This society, founded in 1861,

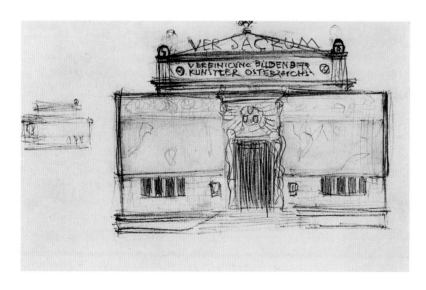

Sketch of the Secession Building, 1897
Black chalk, with watercolour,
11 x 18 cm
Historical Museum, Vienna

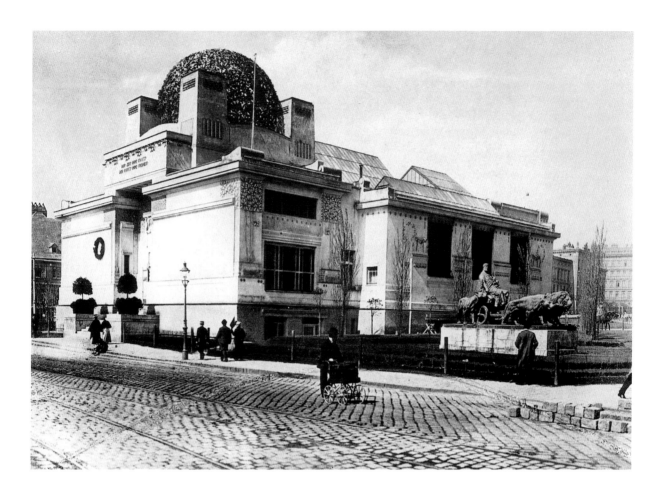

Secession Building (designed by Joseph Maria Olbrich), 1897-98, complete view diagonally from the right
Photographic Archives of the Austrian National Library, Vienna

represented the more orthodox – and mediocre – artistic and cultural forces of liberalism and acted as a professional trade union of sorts. It is not entirely clear why the younger generation of artists separated from the *Künstlerhaus*. Apart from the artistic conservatism of many members, they objected to the society's rejection of foreign Modernism – which was only introduced in Vienna in the large-scale exhibitions of the Secession – as well as its marked tendency towards commercialism. In 1894 the society even acted as host to the Munich Secession, which had been founded in 1892. When, in 1896, a progressive candidate for the position of chairman was defeated, the rift between retarding and progressive forces finally became visible, and a group of about forty artists – among them Gustav Klimt, Carl Moll, Koloman Moser and Alfred Roller – began to discuss the option of a new artists' association which was to remain under the aegis of the professional society. On 3 April 1897, the constituent assembly of a completely new and independent organization took place, the *Association of Austrian Artists*, though there was still no mention of a break with the Co-Operative Society. However, shortly afterwards, in May 1897 and after further arguments, this did indeed happen. [20]

The letter to the Co-Operative Society, signed by Klimt, in which the withdrawal of a "group of artists" was justified, was the first

Recumbent Female Nude with Study of Arms, 1898
Black chalk, 32 x 45 cm
Neue Galerie, Graz

written document of the group and gives a coherent picture of their understanding of themselves as well as their self-confidence. The letter was immediately made public, thus confirming the final breach, although the term *Secession* was avoided at first.

The following is an extract from the artist's letter: "As the governing body must be aware, a group of artists has been trying for years to bring their views on art to bear within the Co-Operative Society. These ideas have culminated in the realization that the artistic scene in Vienna must be brought more vigorously into line with the progressive development of art abroad, that exhibitions must have a non-commercial, purely artistic basis, that this must give rise in wide circles of society to a purified, modern view of art, and finally that official circles must be encouraged to cultivate art to a much greater extent. It has been the experience of this group of artists that, despite years of objective endeavours within the Co-Operative Society, they have not met with the right understanding and comprehension. ... The concentration of like-minded Austrian artists will aim above all at raising the level of artistic activity and interest in our city, and once it has achieved a broader, Austrian basis, within the entire realm." [21] Here, we can already see the central motivation of the new artists' association. Rather than being a mere interest group of a commercial kind, its members wanted to pursue an artistic mission that would affect society and the state.

The association soon started its own magazine - *Ver Sacrum* (1898). It was edited by Koloman Moser, Alfred Roller and Baron Felician von Myrbach, the head of the School of Applied Art which was attached to the Royal and Imperial Austrian Museum for Art and Industry. (He was later succeeded by Josef Hoffmann.) Not only did this magazine act as an organ to publicize Secession art, it also provided a mouthpiece for their artistic and political demands.

The statutes of the Association of Austrian Artists, which were subsequently published in the first edition of *Ver Sacrum*, summarized their objectives succinctly: "1: The Association of Austrian Artists has made it their task to promote purely artistic interests, especially the raising of the level of artistic sensitivity in Austria. – 2: They aim to achieve this by uniting Austrian artists both in Austria and abroad, by seeking fruitful contacts with leading foreign artists, initiating a non-commercial exhibition system in Austria, promoting Austrian art at exhibitions abroad, and by making use of the most significant artistic achievements of foreign countries both to stimulate art in our own country and to educate the Austrian public with regard to the general development of art." [22]

Very soon after the Secession had been founded, the artists began to make preparations for their own exhibition building. The architect was Joseph Maria Olbrich and the project, for which a rough sketch by Klimt still exists (p. 60), took only around six months to complete. In November 1898 the building opened with the Second Secession Exhibition. [23]

It was not until the first edition of the magazine *Ver Sacrum* that the term *Secession* was used with any claim to an entire programme. The intentions of the artists' circle as well as their recourse to the ancient Roman *secessio* were explained by Max Burckhardt in the introductory article: "Whenever the tensions caused by economic antagonism

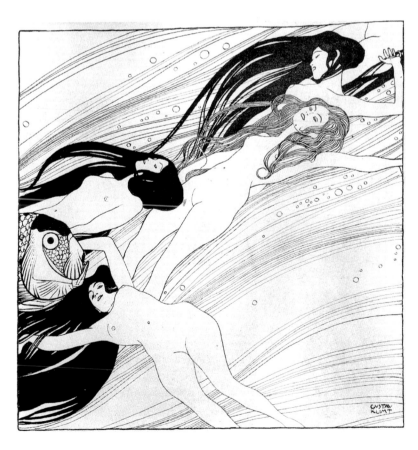

Fish Blood, 1898
Fischblut
Pen and ink,
dimensions and owner unknown

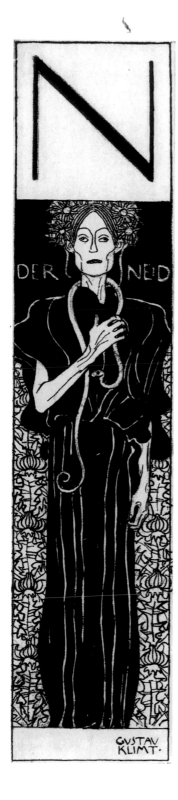

Finished Drawing for *Envy*, 1898
Black chalk, pencil, pen and brush in
Indian ink, 42 x 10 cm
Historical Museum, Vienna

had reached a climax in ancient Rome, part of the people would leave the city and move onto the Mons Sacer, the Aventinus or the Janiculum, threatening to found a second Rome right there, outside the ancient mother city and before the very noses of its dignified fathers, unless their wishes were fulfilled. This was known as *secessio plebis...* However, when the country was threatened by great danger, every living thing brought forth during the next spring was offered to the gods as a sacred spring offering – a *ver sacrum*. And when those born during a Sacred Spring reached adolescence, the youngsters – themselves a Sacred Spring – would move out of their home town to found a new community elsewhere, a community built by their own hands and geared to their own aims." [24]

The elitist self-confidence of the group is reflected in several allegorical works by Klimt, with direct reference to the founding of the group. Schorske interprets Klimt's *Poster* in this light, a poster which was designed for the *First Art Exhibition of the Association of Artists – Secession* (p. 70). This exhibition was still held on the premises of a horticultural society. Protected by Athena, Theseus is seen fighting against the Minotaur. Schorske suggests that this vehement struggle should be read as an act of artistic liberation and therefore a political act. However, this is probably no more than one aspect of the painting, and indeed only related to Vienna's *Jugendstil* (i.e. Art Nouveau) rebellion at the time.

The young male hero at the centre of a drama of salvation is a theme that also occurs in other great works by Klimt, particularly the *Beethoven Frieze* (pp. 104f.), thus showing that the analogy between art and reality must not be sought in the sphere of politics alone. Schorske interprets the struggle between Theseus and the Minotaur first and foremost as a revolt of the sons against the fathers. However, the painting contains not only a father – symbolized by a bull – but also a very forceful and protective mother image, fending off all fear with a Gorgon shield, and completing the oedipal triangle. She seems to be seconding her son's revolt against his father. The message, which is easy to understand, clearly expresses an entire programme and defines the role of the Secession as a culturally subversive and revolutionary movement. Its aim was to overcome the liberal art of the fathers.

Another painting which must be understood in this rebellious and revolutionary sense is Klimt's *Nuda Veritas* (p. 74) of 1899, especially if we interpret it in the light of the inscription added by the artist: "If you cannot please everyone with your art and your actions, you should satisfy a few. Pleasing many is a bad thing." Art is shown as a mirror of society, though society is not dependent on it. The Secession postulated artistic freedom precisely because it wanted to influence society. On the other hand, it cultivated an elitist image by stylizing the artist as a saviour and advocating the aesthetic treatment of conflict-laden social reality, though it could only be understood and enjoyed by a small select circle.

However, *Nuda Veritas* is not only interesting with regard to the politics of the art world. Compared with the Secession poster, the allegory has changed sex. While the poster begs interpretation as the

depiction of a male generation of artists revolting against the art of their fathers, *Nuda Veritas* presents a female figure with whom the viewer is meant to identify positively. Although allegories had always taken the form of women, particularly in 19th-century art, the woman does not just have the function of a mediator here. Just as, in his earlier works, Klimt had deliberately confused the levels of time and reality, he now cast woman as an allegorical vehicle by drawing into focus her feminine attributes. After all, the message of an allegory is always carried mainly by attributes. *Nuda Veritas* harbours a flesh-and-blood "truth", a truth that rests on seductive feminine eroticism and therefore constitutes more than just dry literary comment on the social function of art. For the first time in his work, Klimt showed the archetypal woman as the exclusive vehicle of identification. Not only does this figure communicate an allegory and thus a meaning that points beyond her, but she also exposes herself and her eroticism.

Never again did Klimt take such an explicit stance in art politics as in the two paintings. They expressed the assertive self-confidence of a new generation of artists. The same forceful image was apparent when Hermann Bahr defended Klimt against the first attacks on his *Faculty Paintings* (which will be discussed in more detail below). His plea for the artist, which was also printed and circulated as a manifesto, culminated in the categorical defence of the elitist principle of art and artists against the "mob". Going beyond the simple *Nuda Veritas* motto "Pleasing the majority is a bad thing", the pamphlet contemptuously went a step further: "so much the worse for the majority", thus expressing quite unambiguously the elitist side of Secessionist philosophy. "After all, there is a mob. However, it does not get dangerous until it has found its ringleaders … These are a certain brand of people who combine commonness with their own interest … Schopenhauer gave an unparalleled description of them … 'Apart from a lack of judgement, … fame and merit at a high level come face to face with envy; within every species, envy is at the core of all forces of mediocrity, forces that flourish everywhere. Quietly and without organizing themselves in a special way, they unite against the single unsurpassed individual'." Bahr then develops this thought even further: "It has always been the purpose of art and indeed its very origin and most important purpose to express the aesthetic feelings of a minority of pure, noble and more highly developed people. It expresses these feelings in enlightened compositions, and as the slow, dull populace gradually follows them, it serves to educate them in the ways of truth and beauty." [25]

Even before the completion of the Secession building, the association staged its first exhibition in the Horticultural Rooms, with 131 works by foreign artists and only 23 by Viennese painters. The exhibition was to offer "a new and higher standard for assessing Austrian art" [26], as well as initiating an exchange with the European centres of art, which had been so perilously neglected by the Co-Operative Society. The young artists' association received the highest official accolade when the first exhibition was visited by the Austrian Kaiser. [27]

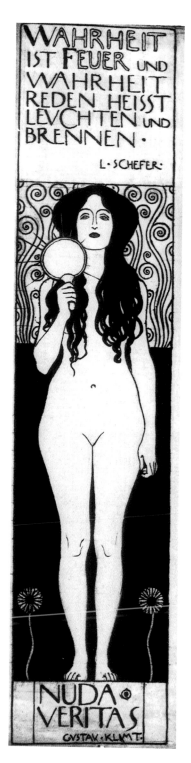

Finished Drawing for *Nuda Veritas*, 1898
Black chalk, pencil, pen and brush in Indian ink, 41 x 10 cm
Historical Museum, Vienna

*Female Nude Standing with Her Left
Arm Stretched Behind Her, around 1889*
Blue chalk, 40 x 26 cm
Albertina, Vienna

The Secession programme met with a political situation that was favourable to its endeavours. The formation of a civil servants' government in 1900 resulted in the final demise of the liberal heritage, while at the same time providing the political conditions for a cultural heyday, albeit rather a brief one. Faced with social and national tension, the cultural sphere seemed to be totally removed from all conflicts. It was hoped that, with the advent of Modernism, art could now serve the formation of a new political identity. Interestingly, the development of a cultural identity linked to statesmanship did not proceed with recourse to past traditions but in conjunction with the modern, innovative currents of the time.

With an exhibition policy aimed at pervading all spheres of art and life and realising a dream of "Austrian Beauty" (H. Bahr), the Secession presented an image which lent itself to being promoted as international and cosmopolitan in its political orientation. "Although every artistic development has its national roots," said the Minister of Education von Hartel, "the products of art nevertheless speak a common language, and as they enter into noble competition, they lead to mutual understanding and appreciation." These words were part of his speech to the Arts Council, which he had founded in 1899. Proclaiming the freedom of the arts, von Hartel's programmatic sentence was closely related to Secessionist philosophy. The extent to which the development of art was significantly influenced by this political philosophy can be gathered from the memoirs of Berta Zuckerkandl, an author and one of the fellow-combatants of the Secession: "Fascinated by the motto 'Give our age its art and art its freedom', I plunged into the battle. It was a matter of defending a purely Austrian culture which proudly professed its loyalty to the nations united under its flag ... Austria was proud of its diversity, which had crystallized into an inspired, unique whole." [28]

For several years the liberalization of Austrian art politics resulted in the systematic promotion of Modernism as well as state intervention in the cultural scene. (Indeed it was the very birth of cultural politics.) In 1903 the *Moderne Galerie* (Modernist Gallery) was founded, after it had already been advocated by Carl Moll at the first meeting of the Arts Council in 1899. Both the Arts Council and the Modernist Gallery were state institutions for the promotion of modern art. However, it was not long before the entire concept of the Gallery changed completely. Not just contemporary art but Austrian art of all periods was to be shown at a museum called the Royal and Imperial Austrian State Gallery. Indeed, it is interesting to note that state promotion of art in the first decade of the 20th century meant that it was brought more and more into line with the patriotic elements of statesmanship that prevailed in Austria at the time.

In the same year Secessionists succeeded in occupying key positions in cultural politics. Otto Wagner was an influential member of the Academy of Fine Arts and, together with Alfred Roller, belonged to the Arts Council. The School of Applied Art, too, was soon taken over by Secessionists in a *coup de main*. Extensive reforms were initiated under its principal, Baron Felician von Myrbach, and con-

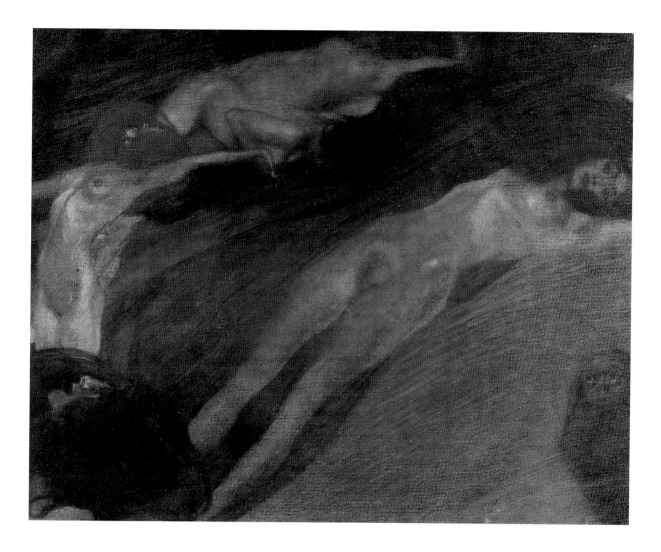

tinued under the stage designer of the Court Opera House, Alfred Roller. Secession members such as Josef Hoffmann, Koloman Moser and Arthur Strasser joined the School. As a result of these reforms, the School of Applied Art – and, cooperating closely with it, the Viennese Workshop – became the institutional basis for a "breakthrough of Modernism" in Vienna.

Flowing Water, 1889
Bewegtes Wasser
Oil on canvas, 52 x 65 cm
Private collection, by permission of the
St. Etienne Gallery, New York

Modernity

The new artists' circle exercised caution in withdrawing from Co-Operative Society. When the Secession was launched, they emphasized in their official letter that they intended to stay within the society, thus giving the impression that no separate organization was planned. However, by publicizing their separation in the press at this early stage, they did indeed offend, so the breach was only made all the more irreversible. They justified their actions by pointing out that the art scene had to open up towards modern artistic currents from abroad, that contemporary Austrian art should become publicly involved and that it should rid itself of commercialism (although Secession exhibitions were also aimed at selling the artists' works). Another element of the artists' self-image is revealed in the early documents by various pronouncements on a specifically Austrian art. Hermann Bahr, for example, wrote about a typically Viennese art, with a special Austrian flavour. However, hardly anything was said about the modernity of the language of art itself. This may be because the term "modernity" was not regarded as a description of a new period in art, but a totally new form of artistic activity and attitudes which were impossible to locate within the spectrum of stylistic developments.

For the first time in its history Vienna began to exhibit important artistic currents of European Modernism – a change of practice and policy which was a clear break with tradition. This was also reflected in the educational activities of Secession members at the School of Applied Art and the Viennese Workshop, where they deliberately renounced any aesthetic obligation to accept historical precedent. All these reforms also served as a practical criticism of art and the artistic environment in the late 19th century. However, artists did not derive their new self-image first and foremost from a critical attitude towards traditions but from the idea of a completely fresh start.

Hermann Bahr even rejected traditions to the point of describing them as irrelevant. With 19th century Historicism denied any artistic merit whatsoever (Berta Zuckerkandl also argued occasionally along such lines), innovation became tantamount to re-birth. "I learnt to understand at that time," wrote Hermann Bahr in the first edition of *Ver Sacrum* in January 1898, "what the duty of our young Viennese painters is and that their *Secessio* must be something quite different from the one in Munich or Paris. In Munich and Paris the Secession aimed at establishing a 'new' art alongside the 'old' …. it is different with us. We are not fighting for or against a tradition, because we have none anyway. It is not a struggle between the old art … and a new one … but for art itself … and for the right to be artistically creative." [29]

The term Modernism does not characterize a clearly delineated historical period but the awareness of a generation which brought forth an aesthetic approach in keeping with the time. It is in this sense that Max Burckhardt – in his programmatic introduction to the first

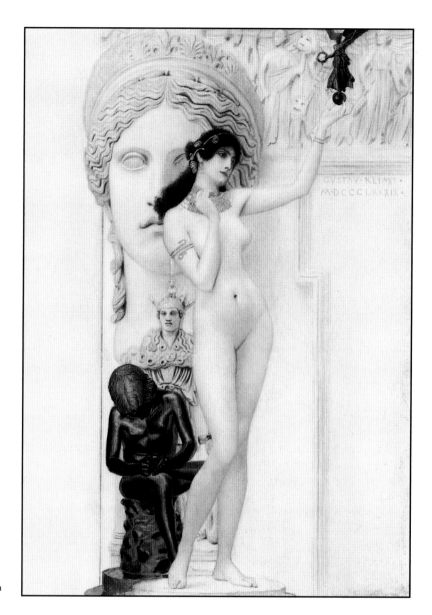

Allegory of „Sculpture", 1889
Allegorie der „Skulptur"
Pencil with watercolour, highlighted in
gold, on cardboard, 44 x 30 cm
Austrian Museum of Applied Art, Vienna

edition of *Ver Sacrum* – ascribed Modernity, i.e. Modernism, to the
Secession: "They [the artists' association] have gathered under the
banner of *Ver Sacrum*, feeling not that their own personal interests but
that the sacred cause of art itself was in danger. Thus, without wanting
to achieve anything but their own aims by their own efforts, they were
and always have been solemnly and enthusiastically prepared to
make any sacrifice for the sake of art. The spirit that united them was
the spirit of youth, the spirit of spring which makes the present ever
modern ..." [30] And it is in this sense – also as an allusion to the
contemporaneous nature of Modernity – that we must read the motto
above the entrance of the Secession building: "Give our time its art,
and art its freedom."

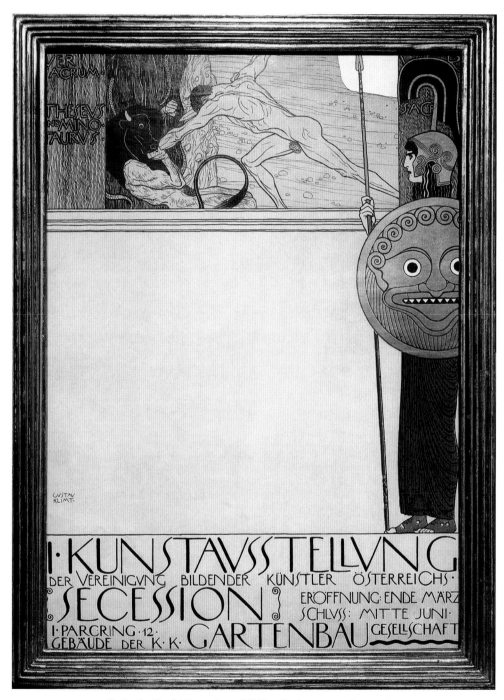

Poster for the *Ist Secession* exhibition (before censorship), 1898
Lithograph, 62 x 43 cm
Private collection, by permission of Barry Friedman Ltd., New York

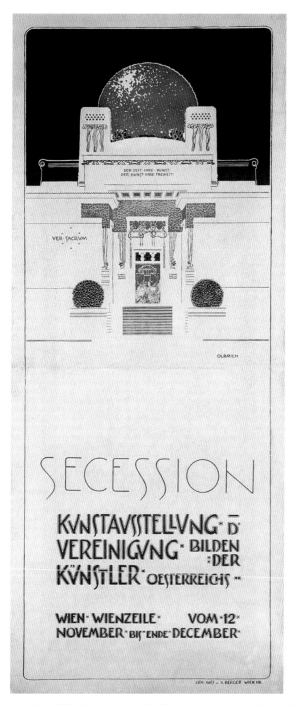

Joseph Maria Olbrich, poster for the *IInd Secession* exhibition, 1898
Lithograph, 86 x 51 cm
Mr. and Mrs. Leonard A. Lauder Collection

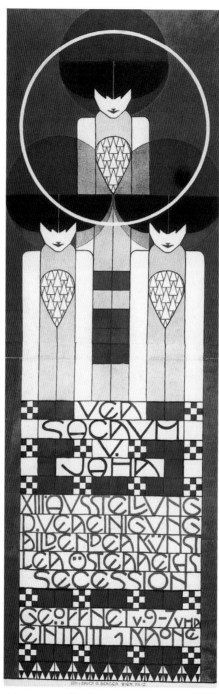

<u>Koloman Moser</u>, poster for the *XIIIth Secession* exhibition, 1902
Lithograph, 177 x 60 cm
Private collection, by permission of Barry Friedman Ltd., New York

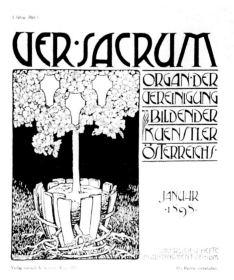

Alfred Roller, cover for *Ver Sacrum* , 1898
Lithograph, 30 x 29 cm
Collection, The Museum of Modern Art,
New York

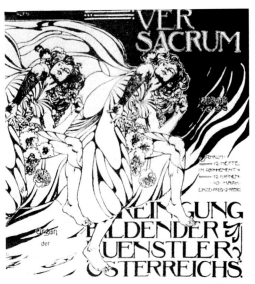

Koloman Moser, cover for *Ver Sacrum* , 1898
Lithograph, 30 x 29 cm
Collection, The Museum of Modern Art,
New York

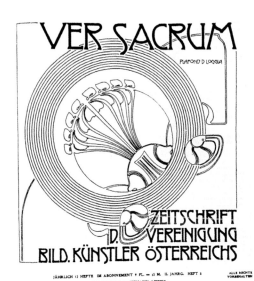

Otto Wagner, cover for *Ver Sacrum*, 1899
Lithograph, 30 x 29 cm
Collection, The Museum of Modern Art,
New York

Alfred Roller, cover for *Ver Sacrum* , 1898
Lithograph, 30 x 29 cm
Collection, The Museum of Modern Art,
New York

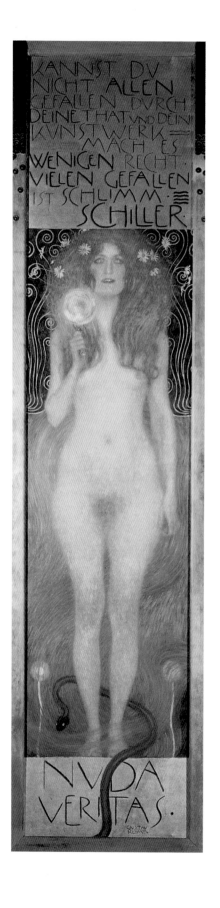

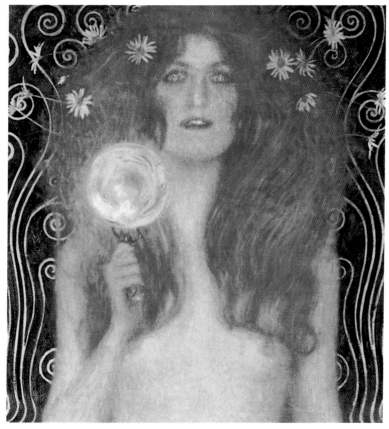

Nuda Veritas (detail), 1899

Opposite:
Nuda Veritas, 1899
Oil on canvas, 252 x 56 cm
Theatre Collection of the National Library, Vienna,
currently on loan to the Museum of the Twentieth Century

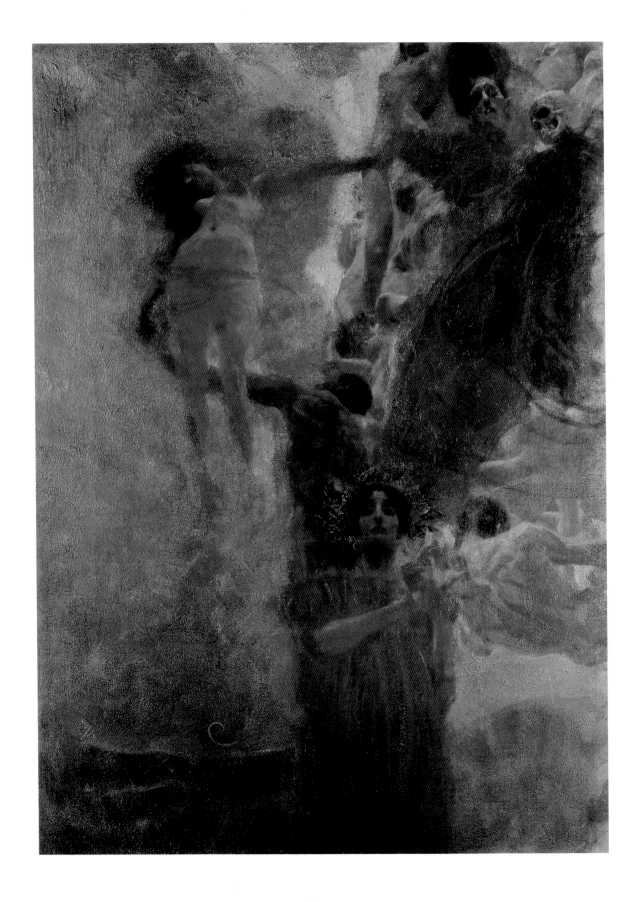

The Faculty Paintings

By 1894 Klimt had made a name for himself with the interior decorations of the large educational buildings on the Vienna Ringstrasse, and so he and Franz Matsch were commissioned by the Ministry of Education to make a number of ceiling paintings for the Great Hall, depicting the various faculties in allegorical form. This was the very time when the entire art scene was beginning to change and when the newly-founded Secession was beginning to establish itself. Even Klimt's sketches for the *Faculty Paintings*, which were gradually exhibited by the artists' association, triggered off a public controversy that went on for many years. Not only the attitude of the state was criticized – its promotion of Modernism and the Secession – but also Klimt himself, both as a person and as an artist. In his examination of Klimt, Carl Schorske has paid much attention to the "drama" around the artist's three ceiling paintings, analysing it as a "crisis of the artist's liberal ego" within the general crisis of liberalism. [31]

The theme of the *Faculty Paintings* was to be "The Victory of Light over Darkness", aiming at an apotheosis, a vindication and glorification of rational science and its usefulness to society. However, in the three paintings for which Klimt was commissioned - *Philosophy* (p. 80), *Medicine* (p. 83) and *Jurisprudence* (p. 89) – he emphatically refused to follow any rationalist world view. "In his *Philosophy* Klimt was still very much a child of the theatre culture, showing us the world as a traditional Baroque *theatrum mundi*, as if we were the audience looking at it from the stalls. However, whereas the Baroque *theatrum mundi* was clearly divided into zones of heaven, earth and hell, the earth seems to have dissolved in Klimt's painting and merged with the other two spheres. Entangled in knots, the suffering mass of humanity slowly drifts by, hovering aimlessly in a viscous void. The stars behind her, a heavy, sleeping sphinx emerges from the murky cosmos. She is completely blind and seems to be no more than the concentration of atomized space. Only the glowing face at the lower edge of the painting suggests the existence of an alert intelligence. 'Knowledge' ... has become the focal point of the theatre lighting, and it is as if a prompter had turned round to the audience, drawing us into the cosmic spectacle." [32]

The polarity between this mysterious, allegorical depiction and the official self-image of academic science was also pointed out by contemporary critics, who saw Klimt's *Philosophy* as nothing but "a dull, submissive, dreamlike mass, drifting indefinitely, for better or worse,

Two Studies of a Standing Nude, from the Left
Studies for the composition draft
Medicine, 1897/98
Pencil, 38 x 28 cm
Albertina, Vienna

Medicine (composition draft), 1897/98
Oil on canvas, 72 x 55 cm
Private collection, Vienna

in the service of eternal procreation from the first stirrings of existence to their feeble demise as they sink into the grave. This is briefly interrupted by an intoxicating moment of loving union followed by a painful process of drifting apart. Love has been a disappointment, bringing neither happiness nor knowledge. Fate, however, remains unchallenged. Far away from cold, clear knowledge and also from the eternally veiled cosmic mystery, the human species is forever struggling for happiness and knowledge, while remaining a tool in the hands of nature, a tool used for the unchangeable purpose of procreation." [33]

Indeed, nothing in the painting seems to suggest that philosophical and academic pursuit produces any rational, socially beneficial results. The composition is as blind, open and ambiguous as the various states of the individuals and couples. Neither do their actions and movements have any recognizable aim or identifiable time dimension. Unlike the history paintings which Klimt, among others, had produced a few years earlier, his *Philosophy* now displays a spatial and temporal diffusion that no longer allows a rational connection of the events with the present. Klimt was no longer concerned with communicating an experience grounded in history.

Not only did Klimt's *Philosophy* contradict the prevailing academic view of science, it also gave an accurate illustration of the most widespread idea at the end of the century. It was believed that the consistent and purposeful progress of history was ultimately governed by cyclical forces of nature inaccessible to human rational thought. The social impotence of the liberal middle classes was seen as embedded in a relentlessly regular cycle of nature in which the individual was relieved of the necessity to act, while at the same time becoming an observer of himself and the mysterious happenings of the world. Systematic "rational" influence did not seem possible.

This view of life as a theatre was an important feature of contemporary art and culture and had also been characteristic of Klimt's earliest works, when external circumstances actually focused his mind on the theatre. At the time, he was working for the theatre, making frescoes, stage curtains, designing the *Burgtheater* auditorium and also part of the decorations for the staircase at the Court Museum of Art History, built so that visitors could move around imagining they were on a stage. In fact, the "scenic architecture" of this huge staircase served a dual purpose: on the one hand, the Habsburg dynasty was able to celebrate its own role as an art patron in the form of paintings and statues, and on the other hand the middle-class public, as it were, were in a position to display themselves, thus firmly establishing their new social status through a public demonstration of their share in the country's culture.

Klimt's "image of humanity" (Werner Hofmann) in *Philosophy* no longer allows for an identification of history, social self-awareness and social role patterns. Although it contains various allegorical elements from some vague historical periods (such as ancient mythology), it does not generally allow any clear-cut space-time definition. Eliminating all the historical elements which provided reference points in 19th century Historicism, bourgeois ideology at the turn of the century

Seated Old Woman from the Left, Supporting Her Head, Study for Philosophy, 1900-1907
Black chalk, 45 x 34 cm
Albertina, Vienna

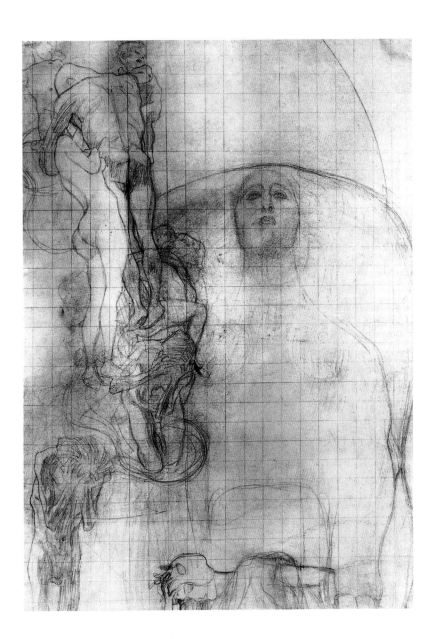

Transfer Sketch for *Philosophy*,
1900-1907
Black chalk, pencil, enlargement grid,
90 x 34 cm
Historical Museum, Vienna

replaced these by nature – a nature which was without history and brought only timeless cyclical change. This cycle of nature called forth moods, passions and emotions, but no longer knowledge or enlightenment, and thus no longer the idea of man's rational domination and subjugation of nature. As a result, the dynamism of fin de siècle society was undermined, because the domination of nature – furthered by technological developments and capitalist interests – lay at the very root of middle-class faith in progress.

Meanwhile, Klimt no longer had any intention of depicting or celebrating the social institutions and the rational, optimistic role of academic knowledge. "This was not how university professors saw and loved the world. Their view of the victory of light over darkness was different, and so was their idea of its depiction in their sacred

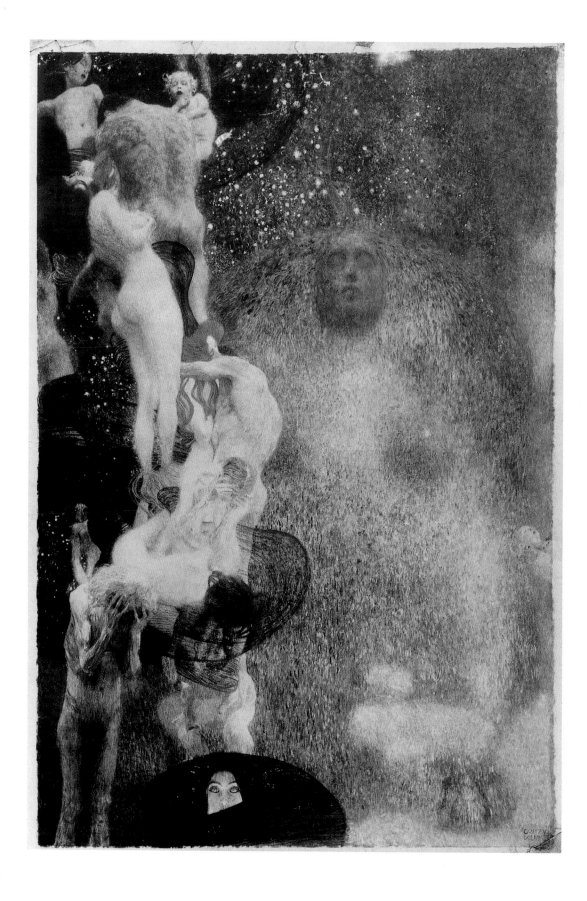

halls." [34] Eighty-seven faculty members protested against the murals, thus provoking a "sensational lawsuit" (Schorske) which was to develop from an artistic debate into a cultural conflict. At first the commissioning ministry ignored the protesting professors and the attacks of the conservative press, [35], but when a draft version of Klimt's second painting - *Medicine* – was exhibited, the argument broke out even more fiercely. The painting was shown at the 10th Secession Exhibition (1901), and Ernst Stöhr commented in *Ver Sacrum*: "Life takes place between birth and death, and on the way between these two points life creates that profound suffering for which Asclepius' daughter, Hygieia, has found a miraculous palliative and cure." [36]

Again, the painting radically offended the self-image of physicians. "Klimt did not make the slightest attempt to depict the science of medicine as doctors saw it ... With her hieratic posture and symbols borrowed from ancient Greek tradition, Klimt's Hygieia [the main figure in the painting] merely proclaims ambiguity par excellence ... Hygieia, who is herself a snake changed into human likeness, offers the serpent a bowl of the waters of Lethe, so that it can drink of that prototypal liquid. In this way Klimt proclaims the unity of life and death, the co-presence of man's vital and instinctive energy and the disintegration of the individual." [37] The two focal points of the paintings are formed by death and life - life as a solitary figure placed opposite and apart from the group of people. Death is a skeleton among the aimless movements of human bodies, and nothing in this painting indicates the role of medicine as the art and science of healing that reconciles the opposites of life and death. In this pessimistic view of eternal waxing and waning, Medicine (Hygieia) appears as a sphinx-like enigma.

The only links between the drifting bodies and the solitary female nude hovering in space are provided by the woman's extended arm and the arm of a male nude shown from the back, although they are neither touching nor directly related to one another. It is worth noting that the allegorical message in this painting is mainly personified by women. They represent the revolving movement of cyclical growth, showing pregnancy (top right-hand corner), motherhood (a mother with a child in her arm in the left-hand corner of the figures), embryonic childlikeness (above Hygieia) as well as old age and ugliness (far right of the centre and to the left of the skull). Here, the viewer is given reference points in the various stages of feminine metamorphosis, above all in the frontal figure of Hygieia, an austere and distant archetypal mother, the only figure who is clothed in the painting. Most of the male nudes have their backs partly turned to the viewer, some of them completely.

Not only are Klimt's monumental paintings shot through with the antagonism between rationalism and irrational nature, between liberal culture and the aesthetic rebellion of its "sons", but Klimt was also fascinated by the tension between patriarchal culture and chaos, for which he used femininity as an allegorical vehicle. It was both a rebellious world view, opposed to the things of the past, and a vision of the future, with a totally different, feminine culture.

Nude of an Old Man with His Hands before His Face, Study for *Philosophy,* 1900-1907
Akt eines Greises mit vorgehaltenen Händen
Black chalk, 46 x 32 cm
Private collection, Austria

Philosophy, final version, 1907
Philosophie
Oil on canvas, 430 x 300 cm
Destroyed by fire at Immendorf Palace in 1945

Transfer Sketch for *Medicine*, 1901-1907
Black chalk, pencil, enlargement grid,
86 x 62 cm
Albertina, Vienna

Medicine, final version, 1907
Medizin
Oil on canvas, 430 x 300 cm
Destroyed by fire at Immendorf Palace in
1945

Aside from this symbolism directed against the rational, optimistic self-image of medicine, Klimt's aesthetic devices also caused offence. His Modernist depiction of nudity gave rise to a great deal of contemptuous and indignant criticism – by Karl Kraus among others – and even led to the confiscation of a *Ver Sacrum* edition, in which a preliminary study of *Medicine* had been published. However, no lawsuit or conviction ensued, and the relevant authorities did not feel that the artistic depiction of nudity merited criminal prosecution. From the very beginning it was Klimt's allegories in particular that attracted scorn and ridicule, as in Karl Kraus's comments. He described *Medicine* as a painting "in which the chaotic confusion of decrepit bodies symbolizes the situation in a state hospital ..." [38]

When *Medicine* was shown to the public, it caused such violent reactions that the conflict over the *Faculty Paintings* even reached the upper house of the Austrian parliament. This made it impossible to use art as a medium for overcoming political barriers. The Minister of Education, von Hartel, who was one of the patrons of the Secession, came under pressure to justify himself. "Again and again the Ministry insinuated," said Klimt, "that I had become an embarrassment to them. Now, for an artist ... there can be nothing more distressing than working for and being paid by a client who does not whole-heartedly and with his entire understanding give his full support to the artist ... Ever since this unfortunate 'state job' [i.e. the *Faculty Paintings*] they have been blaming von Hartel, the Minister, for every one of my other works. And it seems as if the Minister of Education is now beginning to imagine that he really does bear such a responsibility ... In everything I have done, I have been a terrible embarrassment to the Minister ..." [39] As a result, Klimt's application for a lectureship at the Academy of Fine Arts failed.

The aggressiveness of Klimt's third university painting, *Jurisprudence* is seen by Schorske as the artist's response to the rejection and disdain that he had been suffering. Although there is virtually no corroborative evidence from Klimt, Schorske concludes – mainly from the formal changes that took place between the preliminary drafts and the final version – that Klimt must have undergone a profound personal crisis and period of re-orientation, which left its mark on his art. As in the two preceding works, the legal apparatus is not shown as a socially beneficial institution but as a punitive and vengeful power with sweeping sexual ambitions.

The centre of the painting is occupied by a nameless victim, an emaciated, naked, bent old man, held tightly in the grip of an octopus-like creature that almost devours him. This totally unearthly form of justice is administered by three Furies, serving as "prison officers" (Schorske), who have been sent by the three allegorical figures *Truth*, *Justice* and *Law*. These figures are enthroned high above and far away from the scene. It can hardly be denied that the painting is a reference to Klimt's own situation, and – compared with *Medicine* and *Philosophy* – its composition reflects the general message even more clearly. In *Philosophy* and particulary *Medicine* the artist solved the contradiction between a Modernist depiction of the bodies and an Impre-

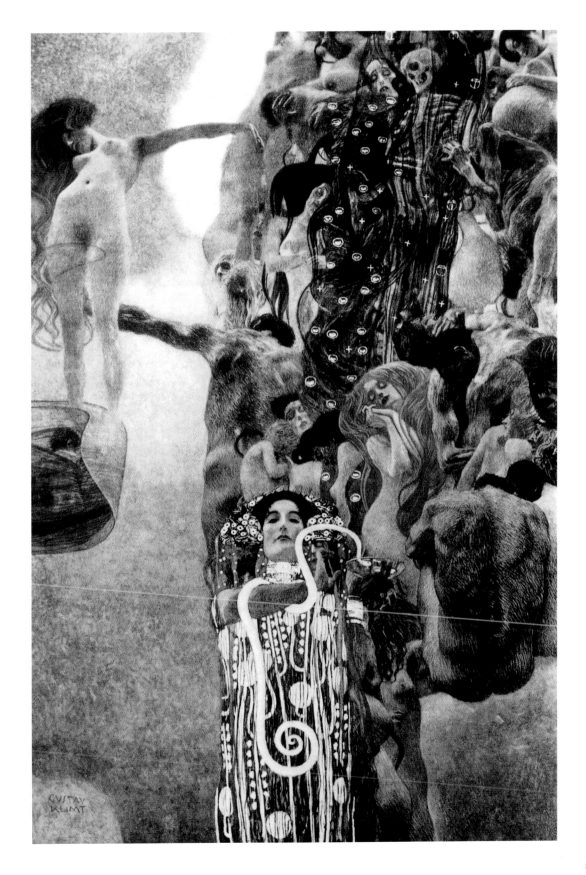

Two Pairs of Wrestlers, Study for
Medicine 1901-1907
Pencil 43 x 29 cm
Albertina, Vienna

Hygeia, detail from *Medicine*
1900-1907

ssionist atmosphere at the expense of an unambiguous message. In *Jurisprudence*, by contrast, he chose such a low perspective that the space seems extremely condensed and distorted while at the same time allowing arrangement of the figures. Although the representatives of the law are at the top of the painting, where they have the greatest importance within the hierarchy, our attention is initially attracted by the larger figures: the old man, the victim and thus the centre of this allegory, on the foremost level and the three "Furies of the Law" who – as the executives of justice and mythical instruments of revenge – seem more important than justice itself.

The scene is not one of diffuse space creating an atmosphere of indefinite, nebulous and unsatisfactory content; instead, the area is ornamentally segmented and fixes our attention on the brilliantly Modernist individuals (particularly the male nude) in the foreground.

Incidentally, none of the three *Faculty Paintings* takes account of the viewer's perspective of a ceiling painting. The idea was to create an illusion of "breaking through" the ceiling. Four separate paintings were to "open it up", as it were (the fourth one was to be painted by Franz Matsch).

However, Klimt had no intention of directing his criticism mainly or exclusively at the socio-political role of the law. Instead, he shifted his attack into a mythical realm of fabled creatures, while concentrating on the male fear of suppressed female vengefulness as well as delusions of punishment: "Klimt's painting is mainly dominated by a fear of castration: the male victim – passive, dejected and impotent – has been caught in a live noose, with an octopus surrounding him like a female womb. The Furies who are supervising the execution are, at once, femmes fatales of the fin de siècle and Greek Maenads. ... However, Klimt gave them the cruel, Gorgon-like expression of ancient Maenads ... Klimt's world of law is divided into two parts, with the three Graces of Justice at the top and their three Furies at the bottom. This is reminiscent of the powerful resolution in Aeschylus' *Oresteia*, in which Athena establishes the precedence of rational law and paternal power over the matriarchial law of blood vengeance. Once Athena has built her lawcourt – the Aeropagus – for the benefit of society, she persuades the Furies to become its patronesses. She then curbs their power by making them part of her own temple. Thus, reason and culture celebrate their triumph over instinct and barbarism. Klimt reversed this ancient symbolism by giving the furies their original power again and showing that the law has not succeeded in overcoming violence and cruelty but has merely concealed and legitimized them." [40]

Schorske points out that the main figure, which has often been interpreted as a self-portrait, also expresses guilt: "The phantasies of sexual punishment in Klimt's Furies fit perfectly into the context of the rebellious call for the liberation of Eros." [41] However, the theory that Klimt's attacks on the law for denying man's instincts might have instilled in the artist feelings of guilt is not entirely convincing, at least not without qualification. As there is no reference to the social relevance of the law, it seems that the "guilt" of the male victim of the law

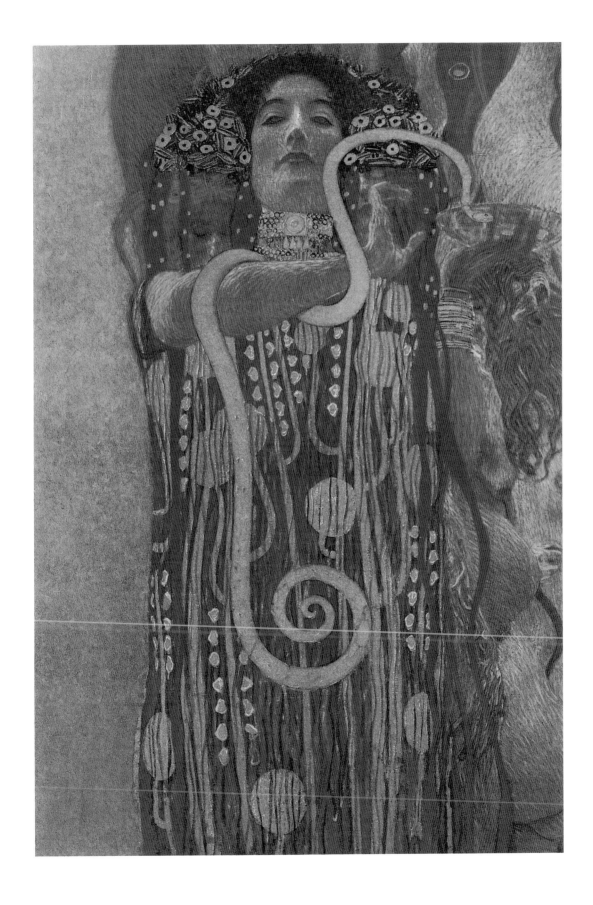

is far less related to the collision of the sexual revolution and social norms than to the process of suppression triggered by the aesthetic revolution itself. Instincts are not "liberated" by the nude male figure; their depiction here prompts fear. As in other allegories by Klimt, the central theme of his *Jurisprudence* is the conflict-ridden fate of a man. In all these paintings the idea of liberation remains highly ambiguous. In *Jurisprudence* Klimt shows the conflict between the artist and society as exclusively psycho-sexual. This can be seen clearly in the anxiety-laden depiction of a man threatened by female nature and its inherent instincts. The weakness of the painting lies in Klimt's attack on a powerful institution by showing the fate of an individual: "The accusation itself, with the emphasis on the individual sufferer, involves a change from public ethos to private pathos." [42]

The most vehement and indeed polemical criticism of Klimt's

Transfer sketch for *Jurisprudence*, 1903-1907
Black chalk, pencil, enlargement grid, 84 x 61 cm
Private collection, Austria

Painted composition draft for
Jurisprudence (detail), 1897/98
Oil on canvas, dimensions unknown
Destroyed by fire at Immendorf Palace in
1945

attack on the legal system – with its odd constellation of private and psychological rather than social and political grievances – came from Karl Kraus, who seems to have been the only person to see its wasted opportunities: "At the beginning of the twentieth century, when man is thinking twentieth-century thoughts, no symbol can hold richer associations for man than jurisprudence. Omnipresent in all forms of political, social and economic conflict, it mediates between those who hold the reins of power and those who want to seize them, between high and low, rich and poor, man and woman, capital and labour, manufacturer and consumer, – all that is jurisprudence ... But for Mr. Klimt all the concept of jurisprudence means is crime and punishment, and the administration of justice means 'Cop 'em and top 'em'." [43]

However, the dilemma of Klimt's allegories lies not just in their content but also in their artistic, i.e. aesthetic presentation. Klimt's most noticeable artistic device (also typical of applied art) was stylization, which frequently earned him both praise and criticism. Its effect was to cloak naked instincts and emotions in formal harmony, thus preventing them from coming across – and being consumed – as anything other than an "aesthetic placebo". "This device is consistent with an artistic intention that seeks to define art *entirely in terms of aesthetic behaviour as the only true basis for justifying the existence of the world.* However, it becomes a puppet of cultural falsehood as soon

as the critical conscience of the sceptics – such as Kraus, Loos and Kokoschka – ceases to support the alliance between truth and beauty." [44]

Klimt was not permitted to show *Jurisprudence* at the 1904 World Fair in St. Louis. When an attempt was made to prevent him from exhibiting his two paintings *Hope* and *Goldfish* (1901/2 – Klimt was going to provoke his critics by dedicating the latter to them), Klimt decided to annul his contract for the *Faculty Paintings* and even offered to repay any commissions he had already received. "If this job, which has taken years and years, is ever to be completed," he wrote in a widely publicized letter to the Ministry of Education, "I shall first of all have to muster my enthusiasm again, which I find totally impossible as long as I am working under the present conditions of state patronage." [45] And in an interview on the same subject Klimt questioned the entire new practice of state sponsorship of the arts, a practice which had, by and large, given the Secession its role in the politics of art: "I've had enough of censorship. I'm going to help myself now. I want to break free. I want to get rid of all those unpleasant trivialities holding up my work and regain my freedom. I reject all state support, I don't want any of it ... Above all, I want to take a stand against the way in which art is treated in the Austrian state and at the Ministry of Education. Whenever there's an opportunity, genuine art and genuine artists are under attack. The only thing that's ever protected is feebleness and falsehood. A lot of things have happened to serious artists which I don't wish to enumerate now, but I will sometime. One day I shall speak out for them and clarify a few points. A clean break is called for. The state should not seek to exercise dictatorial control over exhibitions and artistic statements; it should confine its role to that of mediator and commercial agent and should leave the artistic initiative entirely to the artists themselves ..." [46]

Klimt paid the advance commission back to the state, and the three drafts were acquired by Koloman Moser and Erich Lederer. *Medicine* eventually reached the Austrian Gallery. Later, under Nazi rule, Klimt's *Philosophy* and *Jurisprudence* were "aryanized", i.e. forcibly removed from their Jewish owners and made state property. In May 1945, all three paintings were destroyed at Schloss Immendorf, Lower Austria, when retreating SS troops burnt down the stately home.

Jurisprudence, final version, 1907
Jurisprudenz
Oil on canvas, 430 x 300 cm
Destroyed by fire at Immendorf Palace in 1945

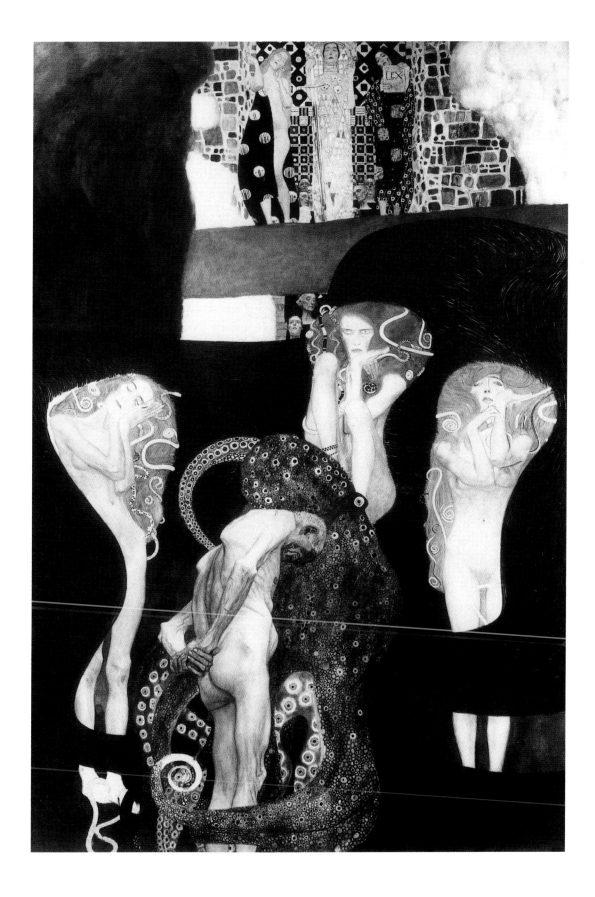

Orchard, around 1898
Obstgarten
Oil on cardboard, 39 x 28 cm
Private collection, Vienna

Early Landscapes

Farmhouse with Birch Trees, 1900
Bauernhaus mit Birken
Oil on canvas, 80 x 80 cm
Austrian Gallery, Vienna

Island in Lake Atter, around 1901
Insel im Attersee
Oil on canvas, 100 x 100 cm
Private collection, by permission of the St. Etienne
Gallery, New York

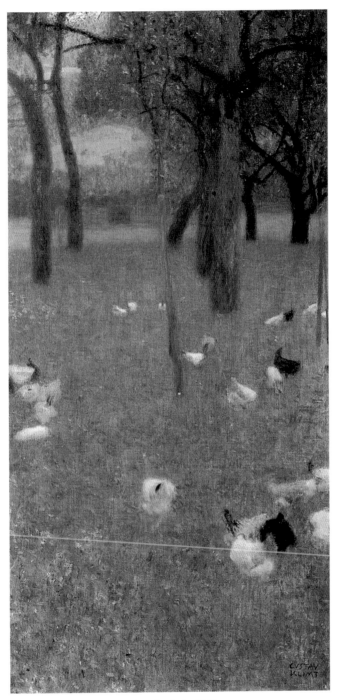

After the Rain, 1899
Nach dem Regen
Oil on canvas, 80 x 40 cm
Austrian Gallery, Vienna

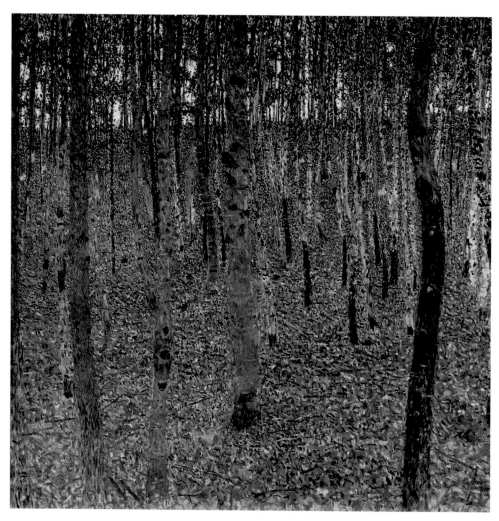

Beech Forest I, around 1902
Buchenwald
Oil on canvas, 100 x 100 cm
Modern Gallery, Dresden

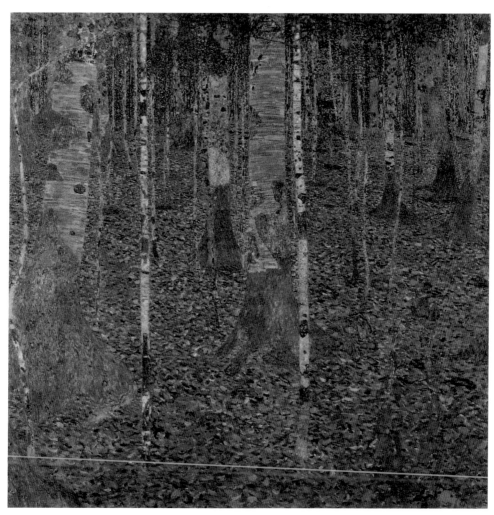

Birch Wood, 1903
Birkenwald
Oil on canvas, 110 x 110 cm
Austrian Gallery, Vienna

The Secession Building and its Exhibitions

The 14th Exhibition of the Viennese Secession in 1902 is still regarded as a climax in the history of the association. The twenty-one participating artists were all guided by a common idea, that of paying homage to art. The interior design of the exhibition rooms was by Josef Hoffmann. Together with special items – such as Klimt's *Beethoven Frieze* (pp. 104f.) – and the works of art around Max Klinger's Beethoven sculpture, they formed work of art in itself.

The Secession exhibitions – and this one, in particular – marked an important turning point in the history of exhibitions. For the first time, works of art were no longer arranged according to artists or subjects. Instead, they added up to an overall work of art in which each element constituted part of an overriding idea and aesthetic context. The interior design furnished a fitting backdrop for the works on display, underlining the overall idea and establishing connections which enabled the viewer to understand the message of each individual work. This made the Secession exhibitions forerunners of today's fashionable mise-en-scène exhibitions.

However, their aestheticism had yet another aim which was, in a way, diametrically opposed to the general idea: step by step, a spatial setting was developed which carefully ensured that each work of art with its unmistakable qualities came into its own. To a large extent, this eventually resulted in a neutral space, a "white cell" (Brian O'Doherty) – the gallery and museum room of today – which emphatically reinforces the autonomy of art and seems to state that it should not seek to be anything but art. The dilemma of a setting which individualized the different works was already registered in the Secession exhibitions: the overriding idea and the decorative setting of the interior design were geared to preventing the disintegration of exhibitions into collections of radically individualized works of art. And indeed it was only through such a so-called *Gesamtkunstwerk* with its overall impact that the Secessionist idea of art as a social force could be put into practice.

The Secession Building, incidentally, was designed as a kind of neutral framework which could be adapted to circumstances, thus revolutionizing the whole idea of exhibitions. For example, it used sliding walls which added considerable flexibility.

A year after Klimt's *Medicine* had been presented to the public, the scandal was still fresh in everybody's minds, and the controversy over his *Faculty Paintings* meant that the position of the entire Secession –

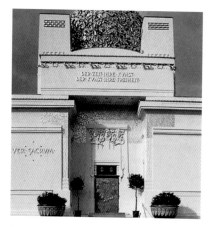

The Vienna Secession Building
(designed by Joseph Maria Olbrich),
1897-1898
Front view

The Vienna Secession Building
(designed by Joseph Maria Olbrich),
1897-1898
Side view

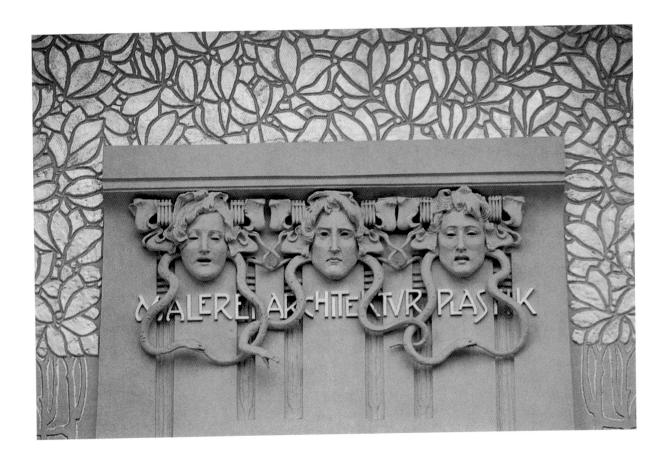

who fully supported Klimt – was called into question. So the development of a new, special type of exhibition can also be viewed as an attempt to present the Secession to the public by highlighting, in a clear and comprehensible manner, its artistic and political principles. Those principles were reflected both in the theme of the exhibition ("The Cult of the Artist") and its form and design ("Raumkunst" – the art of interior decorating). In his introduction to the catalogue Ernst Stöhr wrote: "Last summer the association decided to interrupt the customary cycle of art exhibitions with an event of a different kind. Until then we had provided a uniform link between the many diverse exhibitions, a harmonious connection between disparate elements, so that a general exhibition policy was made possible that was both artistic and modern. Now, however, its entire nature was to be changed. First of all, a uniform space was to be created, which was then to be decorated with paintings and sculptures, so that these became secondary to the general concept of space. The idea was to subordinate the individual parts to the overall effect and to do so under the given circumstances and within narrowly defined limits. This inexorable logic necessarily resulted in a deepening of the spacial character and a firm commitment to the guiding concept.

"All these requirements have to be met by any work of monumental art, and they lie at the root of the highest and best which man through the ages has been able to offer – temple art. The desire to

Golden laurel dome on the Secession Building

perform a great task and to go beyond the usual studies and paintings gave birth to the idea that we should venture a step which, by force of circumstance, the creative artist of our times is deried: the production of the coherent design of an interior ... The idea that guided us and which was to provide dignity and unity to our project lay in the hope that there would be a magnificent work of art at the centre of the exhibition. Max Klinger's Beethoven memorial was approaching completion. The thougt that we might provide a dignified framework for the earnest and splendid homage that Max Klinger was paying to the great Beethoven with his monument was enough to fire us with enthusiasm and instill in us a sense of dedication to the work at hand, even though we were aware that the result of our creative endeavours would be displayed for only a few days. Thus, an exhibition was born which was not to be branded by the transitoriness of its existence ... We wanted to experience the rewards of performing a task with both a purpose and an aim. We wanted to learn. All this was to take the form of an exhibition within the narrow confines of our building, where nothing permanent could be created because each exhibition was bound to extinguish the work of the preceding one. " [47]

Klinger's Beethoven memorial was in a central room at the very heart of the museum, but the exhibition was designed in such a way that visitors did not see it immediately. Their eyes were drawn first to the architecture of the church-like three-aisled interior with its muted

colours and subdued overhead lighting. Then they were guided into the "side aisle" on the left where they were prepared, as it were, for the climax of the exhibition by Klimt's *Beethoven Frieze*. The central room was accessible from the two side rooms, which were slightly elevated. There, the significance of the main work was further enhanced and the overall concept of the exhibition underpinned by two murals, Alfred Roller's *Daybreak* and Adolf Böhm's *Breaking Day*. Visitors left the exhibition through the right-hand "side aisle" which, as it were, echoed the hallowed atmosphere of the painstakingly celebrated, almost sacred occasion. It contained, among others, works by Ferdinand Andri *(Joy of Fighting)* and Josef Maria Auchentaller *(Joy, Thou Purest Spark Divine)*.

This kind of stage-setting for the aesthetic experience of an exhibition was by no means new. The reverent enshrinement of art had already started with the advent of middle-class museums in the late 18th century and was reflected in their classical and historicist interior design. The design of early 19th-century cultural buildings provided an appropriate framework for the "purifying" artistic experience. Karl Friedrich Schinkel's theatre and museum in Berlin are typical examples. Even at that time the act of entering or leaving a "temple of art", of changing from the humdrum sphere of everyday life to that of culture, was considered extremely significant.

XIVth Exhibition of the Viennese Secession (Beethoven), 1902, front wall with paintings by A. Böhm in the main hall
Photographic Archives of the Austrian National Library

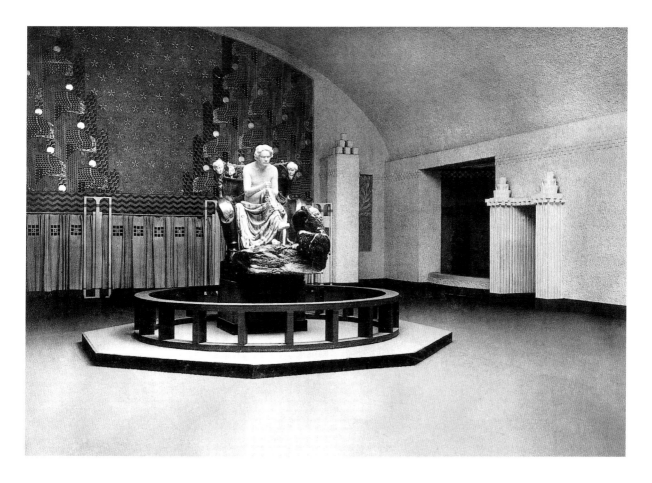

Particular attention was therefore given to the design of the doorways at the Secession exhibition, so that stepping from one room to another became an experience in itself. Designed by Josef Hoffmann, the exit door of the left "side aisle" was a completely abstract square relief, cut in mortar. It is regarded as one of the first abstract works in the history of art.

Klimt's frieze was intended as a decoration. Together with other exhibition elements, it was designed to illustrate and illuminate the overall concept of the show. But Klimt's task was radically different from that of earlier monumental decorators. In the past, both interior design and sculptural decorations formed a rigid framework into which the pictures were inserted like photographs in an album. Now Klimt was given the opportunity – indeed, the assignment – to produce compositional and stylistic elements as integral parts of an overall spacial and thematic concept. For Klimt, however, this also meant that within the general framework he could decide for himself how he wanted to paint his mural.

The *Gesamtkunstwerk* of the exhibition paid homage to Beethoven, the great composer, to Klinger, the great artist and to the idea of the Secession itself who set themselves the task of "saving" society through art. Thus, the artist himself became the saviour; art and the cultivation of it (the exhibition) the work of salvation. "If ever there has

been an example of collective narcissism, then this was it: the artists (of the Secession) were glorifying an artist (Klinger) who, in turn, glorified another hero of the arts (Beethoven)." [48] The response of the public – with 58,000 visitors, the Secession's greatest publicity success – no doubt derived from the 19th-century Beethoven cult.

Built by Joseph Maria Olbrich, the Secession building was intended as a place where art could be enjoyed in an atmosphere free from the cares of daily life. Herrmann Bahr, a supporter of the Secession whose publications helped pave the way for its creation wrote that the visitor was to "purge himself of his daily concerns, focus his mind on the eternal", and cast off "the mental and emotional stress of the workaday world". [49] The realm of art was to be experienced as separate from the rest of life, almost sacred and indeed created by the artist for these special conditions of perception and presentation. The architectural backdrop for conternporary art was no longer provided by public, monumental buildings, but by the more intimate and private surroundings of a short-term exhibition.

Klimt's frieze is a good example of a work of art that was no longer first and foremost a monument but a decorative element of an art interior. It was mainly marked by abstraction and simplicity of design, which enhanced the effect of the material and also each individual work of art. The simplicity of the material and its lack of ornament were aesthetic principles clearly distinct from the aesthetics of historicist art, where ornament was the prime vehicle of expression.

Later, at the 1908 Kunstschau exhibition, Klimt himself said in a lecture that, unfortunately, the Secession exhibitions had not always been successful. They should in fact have helped towards a breakthrough in "the continually increasing presence of art in every sphere of life" – a presence, he felt, by which the "progress of civilization" was measured. [50] Klimt admitted that the overall idea of the Secession had failed. It had been one of the aims of the Secession and their exhibition projects to abolish the dividing line between art and life.

The idea that art could change society had already been expressed in the 19th-century applied art movement. Both the Austrian Museum of Art and Industry and the School of Applied Art, which was attached to it in 1867 (the school where Klimt received his first training), had made it their avowed aim to reconcile cultural and economic progress. Craft, industry and art were to form a mutually beneficial whole. The artistic "refinement" of commercial and industrial products was to boost sales and profits, while at the same time serving the cultural education of society, an education which was aimed at bringing together artists, manufacturers, the intelligentsia and "the people" and which was to break down the barriers between classes.

After the economic and social crises of the late 19th century, the Secession could no longer cling unconditionally to the idea of the unity of art production and its reception. Foundations such as the Viennese Workshop (1903) and the School of Applied Art, which was reformed to provide more practical training, as well as the exhibitions of the Secession were attempts to apply a long-standing reform principle on a new level. However, the concept of the Secession, like that of the

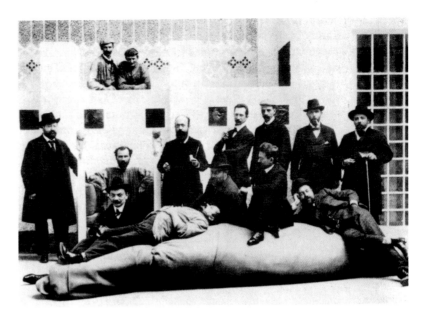

Members of the Viennese Secession at the Beethoven Exhibition. From left to right: Anton Stark, Gustav Klimt, Kolo Moser (in front of Klimt, with hat), Adolf Böhm, Maximilian Lenz (lying down), Ernst Stöhr (with hat), Wilhelm List, Emil Orlik (seated), Maximilian Kurzweil (with cap), Leopold Stolba, Carl Moll (reclining), Rudolf Bacher

Viennese Workshop – which set out to produce exquisite luxury products for a small circle of wealthy people (an attempt which ended in financial failure) – were elitist. The Secession changed the public educational function of the museum into an aesthetic mission, supported entirely by artists and aimed at an elite.

The art critic Rudolph Lothar commented on an exhibition in 1898: "A place has been created where you can converse in surroundings far removed from everyday life and the noise outside and where you can talk about art and paintings. Instead of demanding absolute silence, this new art challenges you to speak your mind, to respond and to react. It derives its impetus from the conflict between differing views ... And if we accept the invitation of art and escape life outside, we find ourselves drawn all the more into life's web – though in a different way ... The highest aim of art is not to be enjoyed but to teach enjoyment. This makes art an excellent educator of mankind." [51] Until then, the middle-class concept of a museum was based on the mind-broadening, humanizing and educative function of art and art contact. But now it was replaced by one based on the enjoyment of art by the museum-going public, the "guests". This enjoyment, however, was not accessible to everyone, but only those "... who ... are able to appreciate the feelings which the artist experienced during his creative act; only they are worthy to stand in front of it [the work of art]." After all, "the Secession is – and aims to be – an art of the soul ... That is its youth, its strength and significance! ... it addresses all those who labour under the burden of everyday life. And it aims to turn them all into aristocrats! The aristocratization of the masses – that is the mission of art. And the Secession sets about its accomplishment with new and powerful methods, methods which are personal and speak from one person to another. It really ought to open the gates of its house to the people, wider and wider. The people will understand its language." [52]

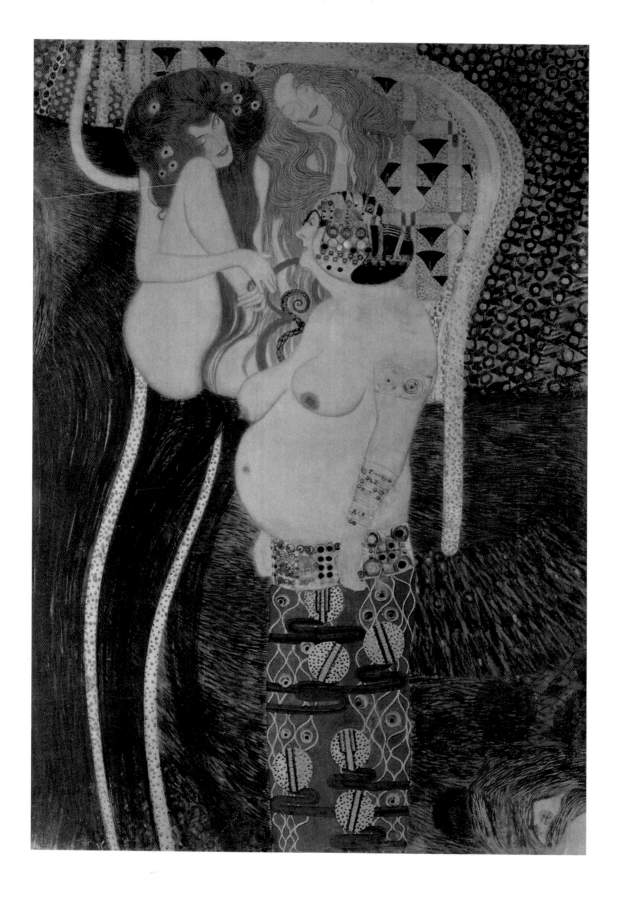

The Beethoven Frieze

Originally it was planned that Klimt's frieze should be removed after the exhibition. For this reason, only the cheapest material was used (which was to lead to great problems in restoring the frieze): Klimt had painted it on a plastered wooden lattice, held in place with reeds. To achieve certain effects, he used – among other things – tin tacks, fragments of mirrors, buttons and costume jewellery made of coloured cut glass. Nevertheless, the frieze outlived all the other works of art in the exhibition. [53] Indeed, it has become the principal memento of the most famous of all Secession exhibitions. In 1970 the frieze was bought by the Austrian state, whereupon it was restored in a long and costly process [54]. At the same time an exact copy was made for exhibition purposes, which was shown to the public for the first time in Venice in 1984, at an exhibition called *Vienna 1870-1930 – Dream and Reality* . Thus the *Beethoven Frieze* was promoted to the rank of a monumental work of art and indeed a major work of Austrian – if not European – art at the turn of the century. The frieze had always been regarded as a key to Klimt's art, and the fact that it had not been accessible for several decades almost gave it a mythical status. Since then it has been restored to the Secession building, though not to its original place. It now hangs in a basement specially converted for the purpose.

The 1902 exhibition catalogue very clearly shows the connection between the work of the Secession and its underlying philosophy. With a direct reference to the final chorus of Beethoven's Ninth Symphony, a setting of Schiller's *Ode to Joy*, the central theme of the frieze is the salvation of "weak mankind" through the mediation of art and love. The frieze starts with a depiction of man's *Craving for happiness. The sufferings of weak mankind. The supplications of the weak to the strong well-equipped outsider and the inner compassion and ambition which move him to take up the struggle for happiness.* The side wall shows the result of the struggle: *The craving for happiness finds fulfilment in poetry. The arts lead us into the ideal realm where we alone can find pure joy, pure happiness and pure love. Chorus of the Angels of Paradise, "Joy, Thou Purest Spark Divine". "A Kiss for the Whole World".* Between these elements, along the side walls, there were the *Hostile Forces: Typhoeus the Giant, against whom even the gods fought in vain,* and his daughters, *the three Gorgons, Sickness, Madness and Death. Lust, Lasciviousness, Excess, Gnawing Grief – the cravings and desires of mankind fly high above them.* Suspended

Drawing relating to the middle of the three *Gorgons*, 1902
Black chalk, partly washed, 44 x 31 cm
Historical Museum, Vienna

Beethoven Frieze, 1902
Beethoven-Fries
Central narrow wall (detail):
Unchastity, Lust and Gluttony
Unkeuschheit, Wollust und
Unmässigkeit
Casein paint on plaster, 220 cm high
Austrian Gallery, Vienna

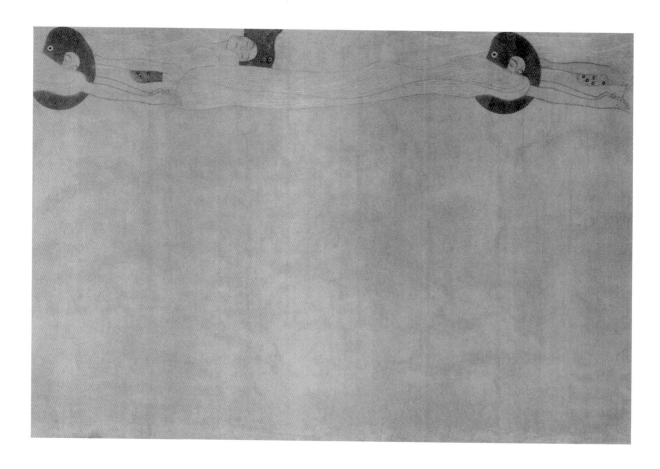

of female identity, which is split up and disintegrated. There were four linguistic conventions in German at the turn of the century: *Weib* (a term of contempt), *Dame* ("lady"), *Hure*, ("whore") and *Mutter* ("mother"), words which reflected the social roles of women as well as the wishful thinking and anxieties of men.

The final picture – *Salvation* – refers to the fourth movement in Beethoven's Ninth Symphony. However, Klimt was not so much paying homage to the original literary and musical source (only the chorus of the Paradise Angels refers to it directly). Nor was he giving an account – as promised by the catalogue – of the liberation of mankind. Together with the rest of the frieze, the finale illustrates not so much the solemn Secessionist goal of man's salvation through art and the artist, but rather a private, male obsession.

At the centre of the painting there is a couple: the "well-equipped strong outsider" has shed his armour and is embracing a woman. He is not facing us, so we cannot see his face or guess any of his feelings. This kiss is a sign that the man has been saved by the woman – in a picture that also conjures up the symbiosis between erotic humanity and nature. However, the picture also contains an oddly static or frozen quality. The couple seems to be locked together, immobile, forming part of their spatial surroundings, as if they had stiffened into a single ornament. This ornamental immobility also characterizes the

Above and right:
Beethoven Frieze, 1902
Left side wall (detail): *Yearning for Happiness*
Die Sehnsucht nach Glück
Casein paint on plaster
2.2 metres high, 13.78 metres long
Austrian Gallery, Vienna

The Beethoven Frieze

Originally it was planned that Klimt's frieze should be removed after the exhibition. For this reason, only the cheapest material was used (which was to lead to great problems in restoring the frieze): Klimt had painted it on a plastered wooden lattice, held in place with reeds. To achieve certain effects, he used – among other things – tin tacks, fragments of mirrors, buttons and costume jewellery made of coloured cut glass. Nevertheless, the frieze outlived all the other works of art in the exhibition. [53] Indeed, it has become the principal memento of the most famous of all Secession exhibitions. In 1970 the frieze was bought by the Austrian state, whereupon it was restored in a long and costly process [54]. At the same time an exact copy was made for exhibition purposes, which was shown to the public for the first time in Venice in 1984, at an exhibition called *Vienna 1870-1930 – Dream and Reality* . Thus the *Beethoven Frieze* was promoted to the rank of a monumental work of art and indeed a major work of Austrian – if not European – art at the turn of the century. The frieze had always been regarded as a key to Klimt's art, and the fact that it had not been accessible for several decades almost gave it a mythical status. Since then it has been restored to the Secession building, though not to its original place. It now hangs in a basement specially converted for the purpose.

The 1902 exhibition catalogue very clearly shows the connection between the work of the Secession and its underlying philosophy. With a direct reference to the final chorus of Beethoven's Ninth Symphony, a setting of Schiller's *Ode to Joy*, the central theme of the frieze is the salvation of "weak mankind" through the mediation of art and love. The frieze starts with a depiction of man's *Craving for happiness. The sufferings of weak mankind. The supplications of the weak to the strong well-equipped outsider and the inner compassion and ambition which move him to take up the struggle for happiness.* The side wall shows the result of the struggle: *The craving for happiness finds fulfilment in poetry. The arts lead us into the ideal realm where we alone can find pure joy, pure happiness and pure love. Chorus of the Angels of Paradise, "Joy, Thou Purest Spark Divine". "A Kiss for the Whole World".* Between these elements, along the side walls, there were the *Hostile Forces: Typhoeus the Giant, against whom even the gods fought in vain, and his daughters, the three Gorgons, Sickness, Madness and Death. Lust, Lasciviousness, Excess, Gnawing Grief – the cravings and desires of mankind fly high above them.* Suspended

Drawing relating to the middle of the three *Gorgons*, 1902
Black chalk, partly washed, 44 x 31 cm
Historical Museum, Vienna

Beethoven Frieze, 1902
Beethoven-Fries
Central narrow wall (detail):
Unchastity, Lust and Gluttony
Unkeuschheit, Wollust und Unmässigkeit
Casein paint on plaster, 220 cm high
Austrian Gallery, Vienna

freely on the plaster background which was left almost entirely in its original state, these figures form the transition to the final group.

One glance at the frieze, however, shows that there is no complete correspondence between art and text. The "strong well-equipped outsider", who can also be understood as a Narcissus-like embodiment of the Secession's elitist concept of the artist, is not actually shown as someone struggling for collective happiness. There is no conflict or fight with hostile powers.

It is not makind that is saved in the final picture, but the hero himself. Rather than being an active hero and liberator, he is a passive sufferer. The real theme of the pictorial narrative is not struggling and fighting, but the testing of the individual's capacity to suffer and endure reality. Indeed, it can be seen as a metaphor of a man's ability to hold his own in real life.

However, the frieze does not show the actual pressures to which the male ego is subjected in society. The male in Klimt's series of pictures undergoes a moral pilgrimage in which he has to prove the value of his own identity, not his social status. Rather than bringing about salvation, he seeks it! And the threat to his identity comes from the anxiety fantasies spawned by the crisis of the male liberal ego. The "hostile forces" which he has to withstand are all female – except for the less threatening monster, Typhoeus. The women are shown as ugly, repulsive and aggressive. Their sexuality is meant to have a threatening quality. They are allegories of the untamed, unrestrained instincts of the female as the real "hostile power". Having received his mission from chaste and virtuous women, the well-equipped hero with all his armour is concerned not so much with the salvation of mankind as with his own. He comes closer to it by distancing himself from the aggressiveness of female instincts and by controlling his own instincts, whose aggressive and threatening qualities are projected onto the

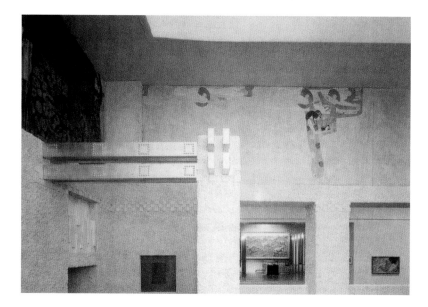

Left and opposite:
Reconstruction of the Klimt Room according to Prof. Hans Hollein's plans, Right side wall

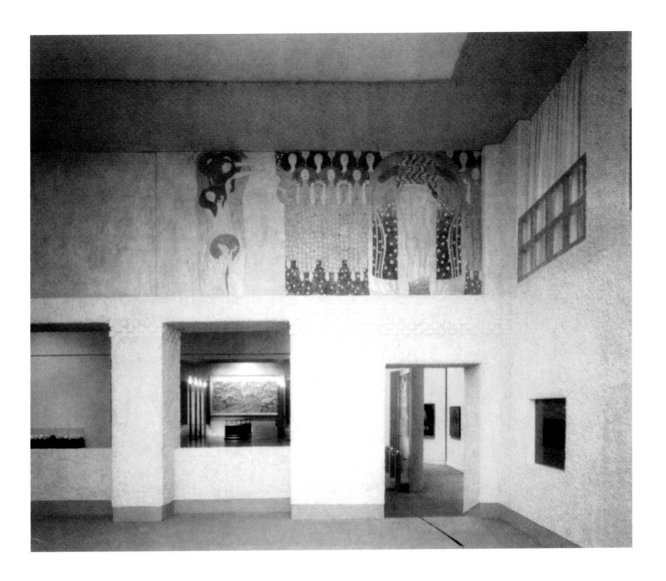

woman and associated with her. After all, each variant of this aggressive side of female nature is derived from anxiety fantasies.

The allegories of cravings and desires which – according to the exhibition catalogue – fly high above the hostile powers are literally suspended freely in space, untouched by the strong outsider's redemptive work, which is shown as a war-like conflict: "This psychological attitude [of the allegories] is, as it were, a classical expression of a weak ego that finds a substitute for its lack of power over reality: desire is everything, and argument is avoided." [55]

Splitting the image of womanhood into one of chastity and virtue, on the one hand, and a threatening image on the other reflects a real split in society, which can be found in many different variations throughout Klimt's work. Woman's image is shown in a whole range of manifestations – mythical beings, witches, mermaids and fairy-tale animals, as well as portraits of upper middle-class ladies. The male ego is formed and strengthened – so the frieze tells us – at the expense

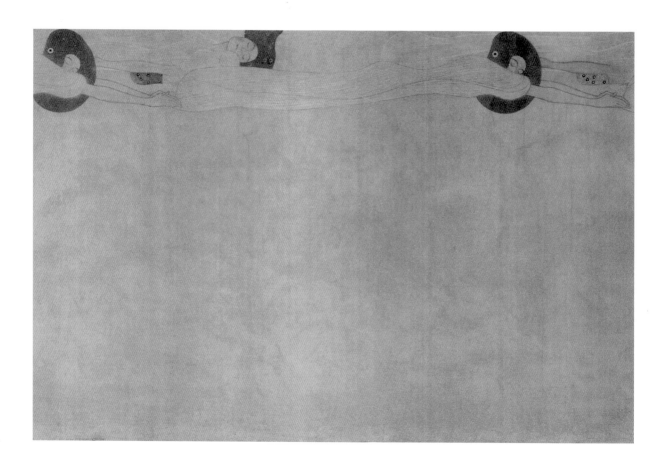

of female identity, which is split up and disintegrated. There were four linguistic conventions in German at the turn of the century: *Weib* (a term of contempt), *Dame* ("lady"), *Hure*, ("whore") and *Mutter* ("mother"), words which reflected the social roles of women as well as the wishful thinking and anxieties of men.

The final picture – *Salvation* – refers to the fourth movement in Beethoven's Ninth Symphony. However, Klimt was not so much paying homage to the original literary and musical source (only the chorus of the Paradise Angels refers to it directly). Nor was he giving an account – as promised by the catalogue – of the liberation of mankind. Together with the rest of the frieze, the finale illustrates not so much the solemn Secessionist goal of man's salvation through art and the artist, but rather a private, male obsession.

At the centre of the painting there is a couple: the "well-equipped strong outsider" has shed his armour and is embracing a woman. He is not facing us, so we cannot see his face or guess any of his feelings. This kiss is a sign that the man has been saved by the woman – in a picture that also conjures up the symbiosis between erotic humanity and nature. However, the picture also contains an oddly static or frozen quality. The couple seems to be locked together, immobile, forming part of their spatial surroundings, as if they had stiffened into a single ornament. This ornamental immobility also characterizes the

Above and right:
Beethoven Frieze, 1902
Left side wall (detail): *Yearning for Happiness*
Die Sehnsucht nach Glück
Casein paint on plaster
2.2 metres high, 13.78 metres long
Austrian Gallery, Vienna

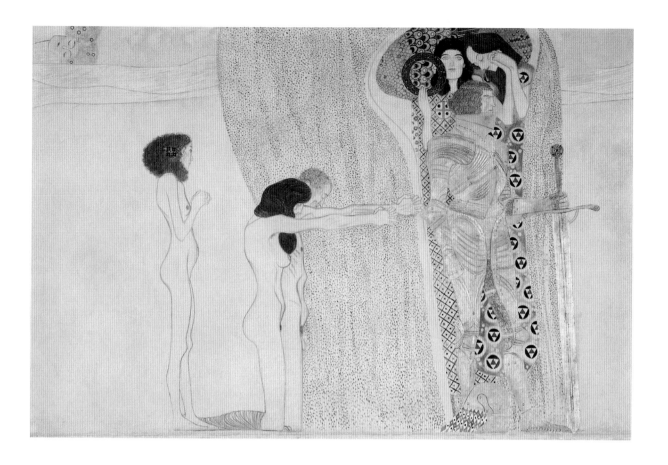

chorus of the rather uniform and therefore dull-looking Paradise Angels. The virility of the nude man's back covers the woman's body almost completely. As her face is invisible, too, the individuality of both characters remains concealed from us and seems to have merged into the compulsive and indissoluble union of the couple. Their legs are entwined by a web of blue, chain-like threads. This "salvation" is an escape, a withdrawal from life, made possible by art. Werner Hofmann has described the dubiousness of this "image of salvation" in these terms: "Klimt obviously had difficulties reconciling Schiller's jubilant compassion for the whole of mankind with his own basic motif – an eroticism that does not open up but screens itself off. Man and woman penetrate each other, protected by a precious enclosure. Is this kiss really meant for 'the whole world'? Or is it just aimed at the chosen few under the spell of the religion of aestheticism? There is no escape from this protective encasement, and fulfilment can only be achieved at the price of renouncing the world. In its motionless finality it seems tantamount to 'passionate death'." [56]

This oddly static quality of the two lovers, as Hofmann describes it, is a stylistic feature of the entire work. Klimt tends towards a narrative technique in which the individual elements are self-contained, kept apart from one another by large empty areas, so that they are lined up paratactically, as it were, without any links between them. In separat-

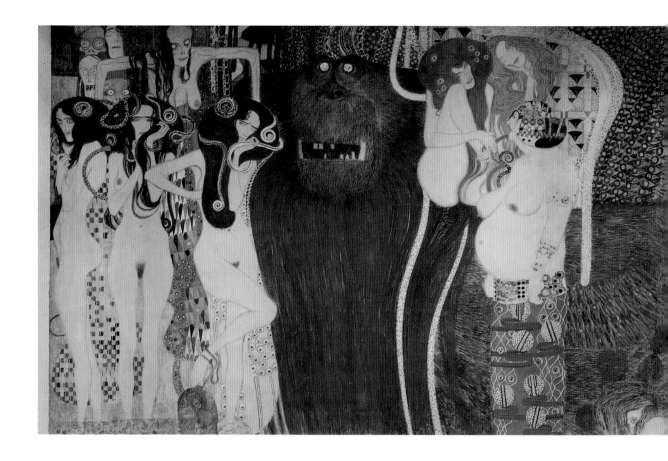

Beethoven Frieze, 1902
Central end wall (detail): *Hostile Forces*
Die feindlichen Gewalten
Casein paint on plaster, 2.2 metres high,
6.36 metres long
Austrian Gallery, Vienna

ing figures and groups of figures by empty spaces, Klimt achieved a complex network of relationships and tensions. These spaces are not even ornamented; in places, they are merely bare areas of concrete-coloured plaster. Incorporating the bare plastered ground is an unusually radical abstraction which turns the ground into the real carrier of the artist's message. In our discussion of the *Stoclet Frieze* (pp. 144f.) we shall be concentrating on similar tendencies towards abstraction where the material ground of the painting was incorporated, and we shall see that this went even further.

Old photographs of the exhibition rooms show that the three parts of the frieze were originally separated by narrow strips of wall. Rather than telling a continuous story, it was intended to form various scenes with allegorical references to the idea of salvation through art, as illustrated by Klinger's Beethoven sculpture (at the centre of the exhibition).

Obviously, in the context of the exhibition and against the background of the fin de siècle Beethoven cult, it would be wrong to read the frieze merely in terms of private obsessions. Klimt saw his work more as an allegory of cultural forces and conditions and also of the role of art and of the artist as saviour. Not many of the numerous analogies from art history and mythology that can be read into the frieze are really convincing. However, if we consider the endeavours

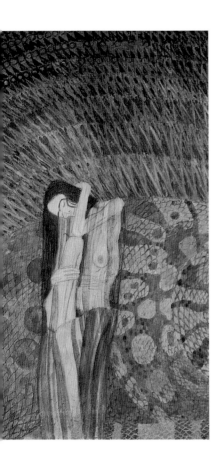

of the Secession in art policy and culture, it seems extremely plausible that the conspicuous division into three parts, with its contrast between the "work of salvation" and the "hostile forces", also contains a critique of contemporary civilization.

"The utopian vision of universal brotherhood which Beethoven had proclaimed [in his Ninth Symphony] – a vision where the whole of mankind would be set free from its pains – was contrasted with the chaos and corruption of modern civilization and the constraints imposed from above (by the state and the church) ... The 'hostile forces' in the painting apparently also included those forces which obstructed his own development as an artist ... The shock effect of this mural was a consciously calculated part of the general layout. The ape-like monster, with its pearl-shaped eyes and the name of the worst possible brute from ancient mythology, and the female figures shining brightly against the dark ornamental background ... stared at the visitor as he entered the room." [57]

The *Beethoven Frieze* is generally considered to be the turning point in Klimt's artistic career, though his stylistic idiosyncrasies have never been regarded entirely uncritically. His stylization, which sometimes led to a considerable simplification of contours, the solemnity of his two-dimensional, statue-like figures, his contrasts between colours, contours and untreated plaster ground, his predilection for

reducing certain figures to stereotype yet at the same time overloading them with meaning (figures sometimes referred to as "dummy" knights) – all these elements of form and content contradict one another and therefore do not meet with unanimous admiration.

In his treatment of the individual figures, Klimt largely avoided a Naturalist depiction, using a more planar, graphic style, which resulted in a poster-like lack of mystery, so that a number of figures – for example, those in his "suffering mankind" – were hardly able to support the resounding solemnity of his claim in the accompanying text. The art historian Fritz Novotny has very aptly defined the problem of content as an aesthetic one: "The new or 'modernist' element was more or less consciously programmatic and basically meant that thought content was more closely connected to pure form. This connection was intended to … express thought and emotional content in a new and immediate way. What is more, it was to do so more ostensibly than is necessarily the case with all works of art. The nature of the line drawing – Klimt's real forte and the most important tool of his art – was designed to express either sadness or comfort, depression or relief, or any other less easily definable emotional content. In art that takes this form – or at least art conceived in this form – it can be expected that any change of form means a change in emotional content, if not thought content. This can be seen very clearly in the difference bet-

Beethoven Frieze, 1902
Right side wall (detail): *The Yearning for Happiness Finds Fulfilment in Poetry*
Die Sehnsucht nach Glück findet Stillung in der Poesie
Casein paint on plaster, 2.2 metres high, 13.81 metres long
Austrian Gallery, Vienna

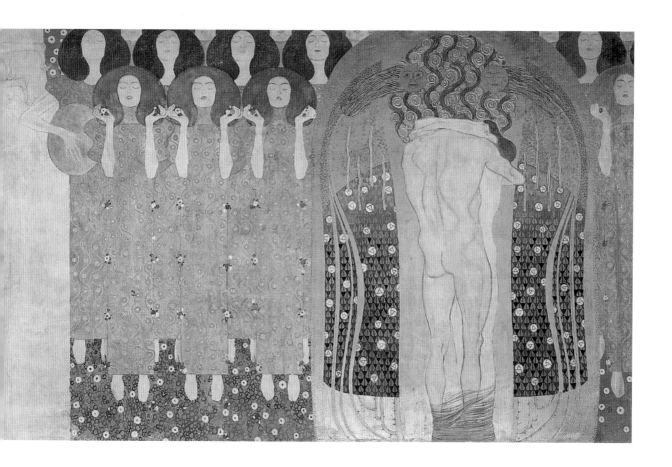

ween the two university allegories on the one hand and the *Beethoven Frieze* on the other: while the former expressed resignation and sadness at the world's woes, manifesting itself in painterly uncertainty, the latter displays the heroic solemnity of an inner struggle, made visible in an austere form that is totally remote from nature.

In opting for this later, non-Modernist style, giving greater freedom to elements of form, Klimt had ventured to a critical point as regards the visual rendering of metaphysical content. Was the emphasis he placed on 'open' linear form – lending weight to formal structure – on obvious and effective means of illustrating metaphysical ideas and symbols? Was it as obvious as logic suggested? Was not the dreamt-of harmony between form and thought content precariously threatened by the predominance of form – line, colour and particularly ornamentation? There could be no doubt that ground had been gained with regard to the aesthetic effect of form – but what about the clarity, unambiguousness and intensity of the thought content?" [58]

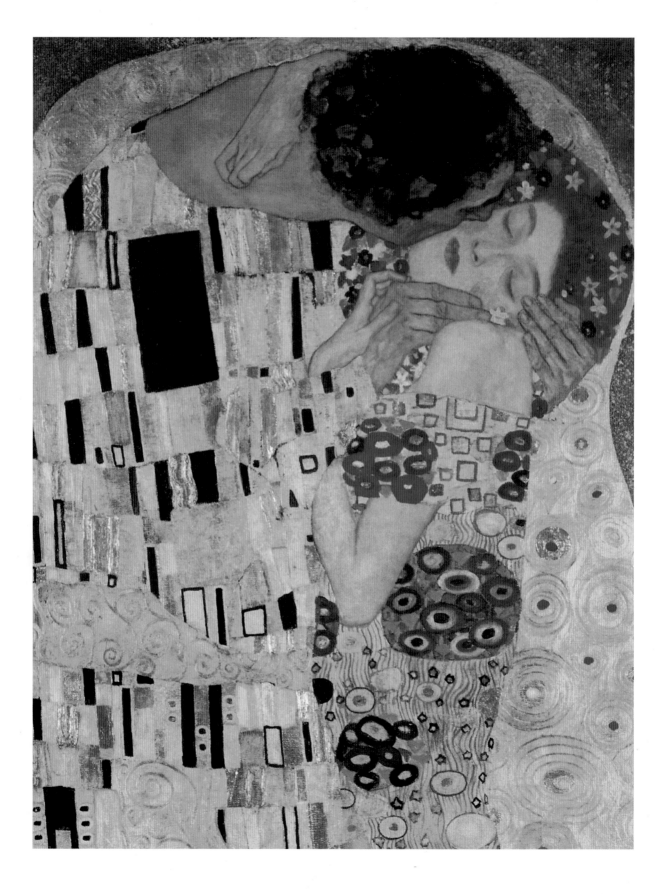

The Kiss

Klimt's painting *The Kiss* (p. 117) of 1907/08, which can now be seen at the Austrian Gallery in Vienna, is Klimt's most famous work and indeed the one that has been most widely reproduced. Klimt painted it during what is generally referred to as his "golden period" because of the considerable use he made of gold paint and real (leaf) gold. The popularity of these paintings – including *The Kiss* – may well be due to his use of gold, which, apart from being foreign to the painter's palette, has magical and religious connotations and is held as a symbol of sheer costliness and material value. Some of this costliness as well as the bright gleam of the gold is intricately connected with the content of the painting. Its "value" also affects its "meaning". The artist's stylistic idiosyncrasies during this period, the two-dimensional ornamental character of his paintings and his avoidance of any effects of depth serve to enhance the significance of each picture and its canvas. As a result of the precious ornamental structure of the surface, the "meaning" of the painting can be seen in its form and material rather than its content. The aura of the painting and its seductive beauty are due both to its ambiguous preciousness and the depiction of the lovers as the embodiment of unsullied erotic delight.

Standing on a kind of cliff, a small flowery meadow, which is not intended as a spatial reference point, the two lovers are shown completely absorbed in one another, enrapt, as it were, in an aura of gold which surrounds them like a halo, unites them and isolates them from their environment. The indeterminate location of the scene removes the lovers into a homogeneous cosmos that is close to nature but without space or time, far from all definite historical or social reality. Entirely in line with Art Nouveau philosophy, the lovers are shown as "universal, cosmogonal and in tune with nature" and expressing a complete single experience. [59]

The encapsulation of the two lovers as well as the averted face of the man reinforce the impression of isolation and distance from us. The two sexes are reduced to their biological difference, their "pure" nature. Because of the isolation of the embracing couple as well as the "pure" but unreal cosmic space around them, the promise of happiness in this picture also refers to nature itself. Happiness is only conceivable outside social reality. Non-violent relationships between the sexes and towards nature is only imaginable in the world of dreams. As in the *Beethoven Frieze*, the "promise of salvation" offers no indication of how salvation can actually be achieved.

Side View of Lovers, Standing, 1907/08
Blue crayon, 56 x 37 cm
Albertina, Vienna

The Kiss (detail), 1907/08
Der Kuss
Oil on canvas, 180 x 180 cm
Austrian Gallery, Vienna

Life is a Struggle (The Golden Knight),
1903
Das Leben ein Kampf (Der goldene
Ritter)
Oil on canvas, 100 x 100 cm
Private collection, by permission of the
St. Etienne Gallery, New York

Because of the ornamental symbolism in the lovers' garments, the
picture has often been described as symbolizing their union. How-
ever, it is precisely those ornamental elements which here distinguish
male and female. Following the clichés of biologically and psychologi-
cally distinctive features, the man has been given "harsh" forms –
rectangular areas of black, white and grey – while the woman is
endowed with the "soft" features of colourful, flowery and curved
elements. So although the lovers' embraces, their self-contained
shared outline, their background and their golden garments suggest a
single configuration, the two figures can nevertheless be distin-
guished by their own specific ornaments. However, the ornamenta-
tion also blurs their sexual differences. Indeed, it is *only* their orna-
ments which indicate, in an abstract and symbolical way, the "little
difference" between them.

"In *The Kiss* he [Klimt] has taken away the male-female tension
from the two bodies and delegated it to the opposition of rectangular
and round patterns. Thus, instinct and desire have been encoded in a
scheme of ornamental contrasts."[60] This shift of the instinctive ele-
ment from persons and bodies to ornaments also brings the sexes
closer together. Although a distinction is preserved in the form of
ornamentation, this is indeed the only area where it continues to exist.
The body language of the two figures, on the other hand, the possible
different gestures, postures and physiognomy hardly contain any dis-
tinctive features at all. Klimt's fascination with the games (not merely

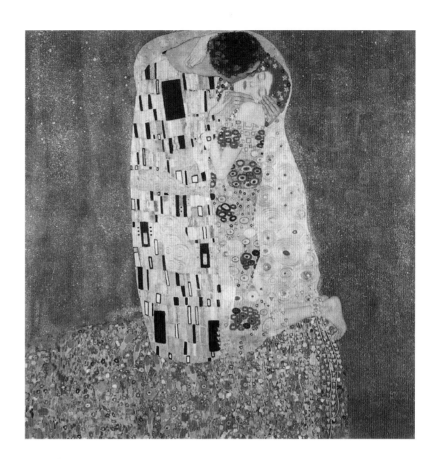

The Kiss, 1907/08
Der Kuss
Oil on canvas, 180 x 180 cm
Austrian Gallery, Vienna

of a formal nature) that could be played with the limits of sexual differentiation can be seen in all his works. In his mosaic for the side wall in the dining hall of Stoclet Palace (p. 151), which will be discussed later, he abandoned this distinction altogether, and both sexes are symbolized within one figure. The price he paid was the abandonment of the Naturalist human image, leaving man in danger of becoming an "object of artistic craftsmanship and interior design". In his *Faculty Paintings* (pp. 76f.) Klimt had shown the self-contained circular movement of a blind nature in direct opposition to the supposedly rational faith of the middle classes. In his *Stoclet Frieze* he radicalized this counter-concept by isolating the figures even further while at the same time stripping them of any meaning that might point beyond them. In return, he had to accept the power of the reality principle: man's supposed dominion over nature has changed into the dominion of the objects over man. The image of man which dreams of a rapprochement between the sexes and even the total abolition of their differences has become an abstract ornamental mosaic from which virtually all representational features have disappeared.

The halo which surrounds the two lovers in *The Kiss* is defined by the man, whose back determines the line of its contour. This shape, which seems to have a phallic quality about it, has been described as "tower-like", "bell-shaped" and "semantically almost incomprehensible". This is hardly unusual for Klimt. Similar but less ambiguous

shapes were used by Klimt in his *Beethoven Frieze* for the figure of Lust, and once, in a kind of caricature, he even portrayed himself in the form of a penis. This major symbol of masculinity has its correspondence in the man's bull-necked virility, which almost seems brutal. All the energy of motion in the picture comes from him. He is the one who grasps hold of the woman's head and turns it towards himself so that he can kiss her cheek. The woman, on the other hand, is depicted as passive. Kneeling before the man, she clearly assumes a posture of submission. Klimt's preliminary sketches show that he was particularly fond of this theme. In these drawings he had experimented with different compositional solutions in order to render satisfactorily the difference of height between the man and the kneeling woman. Eventually, he solved the problem by leaving the man's standing posture ambiguous while at the same time having the woman's feet jut out clearly from the bubble enclosure so that her kneeling posture was emphasized even further. The woman's decorative floral pattern has become a kind of halo, underlining her somnolent passivity.

The painting is full of ambivalence. While exalting the joy of erotic union, it also questions the identity of the two lovers and their sexuality. As in the back view of the kissing nude male in the *Beethoven Frieze* (p. 113), Klimt leaves no doubt about his hero's masculinity (with whom he may well have identified, though the figure should not be seen as a self-portrait, as has often been claimed). However, the biological difference is turned into mere abstraction by means of the ornaments.

Also, the merging of the two figures into one large shape must be understood as Klimt's endeavour to neutralize the difference between the sexes. The anatomical and biological element that determines their difference – the phallus – has been erected in the form of a monumental icon which defines the two people and their sexes. The utopian idea of reconciling the sexes and of neutralizing their difference inevitably becomes dominated by the male.

The composition of the painting suggests two related ways of identifying with it. The viewer is intended to identify with the man. He is the one who initiates the (few) activities within the painting, whose embraces aim at a neutralization of sexual distinctions and who seeks to identify with the female element. The play of abstract ornamentation has already detached this difference from their bodies and amalgamated them in one grand formal gesture. The man's identification with the woman is derived from what has been called the crisis of the male ego or – for those who prefer a socio-political formulation – the crisis of the liberal ego. This crisis also led to the discovery of the feminine traits in man. In the *Beethoven Frieze* they have been partitioned and fended off as terrifying "hostile forces". Likewise, in *The Kiss* there is no toleration of sexual division. The image of the woman has, as it were, been written into that of the man and made subject to the principle of masculinity. The symbolical shape of the phallus also points to the eternal and insoluble separation between the sexes, which seems to be far more of a theme in the painting than their union.

Gert Mattenklott has drawn attention to the same phenomenon in Klimt's drawings: "A large number of drawings show little girls or young women in long, often clinging garments that look as if they were a cross between gowns and sheaths. Except for the head ... the entire body remains concealed ... The shapes, sometimes trapezoidal but usually elongated and narrow, conceal any distinctive features of female physique, suggesting only one similarity, similarity with a phallus. Thus the bodies feign something they lack and covet. Symbolically, they become what they do not possess. In this way each woman compensates for her one physical deficit by means of her entire body, so that it denotes both a lack of something and its symbolical satisfaction. The lining has turned the desiring body into a symbol of the desired object – a fetish in the prop room of lust." [61]

Rather than a union or an embodiment of the triumph of Eros, the immobility of the couple in *The Kiss* – as in other depictions of couples – suggests that their embraces are a petrified regression in which the two figures no longer take any notice of themselves or the world. [62] And indeed Klimt's couples hardly ever show any of the communicative aspects of love. The lovers rarely relate to one another by means of gestures or signs of affection. (The aggressiveness of the struggle between the sexes, which was to become an important theme in early Austrian Expressionism, is totally absent). The couples are almost without exception completely rigid in their embraces or, in his later works, lost in a dream-like state and completely unrelated to one another. For Klimt this was one way of re-defining the relationship between the sexes. Another, found in his drawings, lay in reducing it to the loneliness of an erotically self-sufficient woman. The enormous popularity of *The Kiss*, in particular, may well be due to the idiosyncrasies which we have just described. It can be read as a cipher of erotic happiness because it allows no reference to the temporary and transitory nature of love and because cultural and social conditions have been excluded altogether. Erotic happiness is shown not as a promise but as the redemption of a promise, albeit at the price of statue-like rapture. The painting can be interpreted as a space on which a wide variety of different notions can be projected, a space in which intellectual and emotional content are linked to the fascination of its material preciousness, its golden aura and gold as a colour.

The Three Ages of Woman / Death and Life

In *The Three Ages of Woman* (p. 122) Klimt dealt with one of his most central themes – the cycle of life. Using the devices of stylistic contrast and different degrees of realism, he contrasted youth and old age. On the one hand, there is the young woman holding a sleeping child, a "secularized madonna" (Eva di Stefano), herself somnolent, passive, stylized and part of the ornamental background. On the other hand we see the Naturalist profile of the despairing old woman, turned aside and covering her face with her hand. These are not just stages or periods in a woman's life, but aspects of womanhood. "The contrast between the stylized girl and the Naturalistic old woman has a symbolical value", writes Eva di Stefano, "the first phase of life is characterized by an infinite number of possibilities and metamorphoses, while the last phase is marked by an unchangeable uniformity that does not allow one to escape confrontation with reality. The first phase is characterized by a dream ..., the last by the impossibility of dreaming." [63]

As in *The Kiss*, the figures are embedded in the symbolical shape of a phallus. However, whereas both sexes are represented in *The Kiss*, the identification of the artist in *The Three Ages of Woman* takes place entirely through different stages of womanhood, ranging from regressive harmony and its alter ego to the threat of old age, biological decay and impending death. Could the abstract presence of the male element in the ornamental shape of a phallus perhaps express the desire to identify with womanhood, as in *The Kiss*? If so, Klimt here depicted the regressive utopia of a life cycle – perceived as both feminine and natural – subject to male domination in content and form. The same desire for identification may possibly be corroborated by yet another of Klimt's obsessions – the prenatal, regressive (and therefore pre-sexual) harmony, which is also present in this painting in the form of motherhood. Embryonic childlikeness can often be found in his oeuvre, including many of his drawings. Two of his most famous paintings were devoted to pregnancy, and he also depicted pregnant women in his *Faculty Paintings* (Medicine). The idea of life beyond all sexual differentiation and in childlike unconsciousness is contrasted in *The Three Ages of Woman* with its pessimistic counterpart approaching death.

If – as Eva di Stefano suggests – the painting is based on traditional depictions of vanity, then *Death and Life* (p. 123) may stem from the iconographic dance-of-death tradition in art history. However, unlike many other *dance-of-death* paintings, Klimt's work shows no attempt to allegorize social differences rendered insignificant in the face of death. Again, the dominant element in the painting is regression.

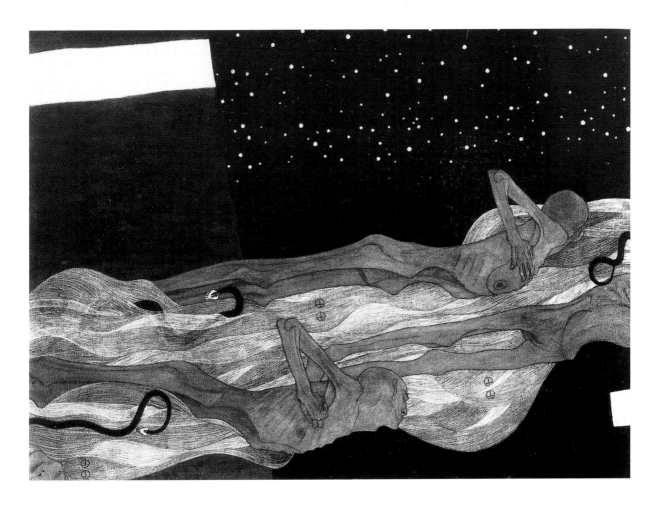

Procession of the Dead, 1903
Zug der Toten
Oil on canvas, 48 x 63 cm
Destroyed by fire at Immendorf Palace in
1945

Gathered in a mass and withdrawing into themselves, a group of people symbolizing mankind are pointedly arranged in relation to death. The group resembles the crowds in Klimt's *Faculty Paintings*. "In the lower half a man and a woman, two lovers, are embracing each other. But the painting is not about ecstatic sensuality or the triumph of Eros, but love as a refuge and comforter." [64] A comparison with Egon Schiele's works – which is drawn quite frequently in this connection – clearly shows that the message of Klimt's depictions of mankind is largely determined by their formal composition. While Schiele's expressive gestures and dissolution of form are intended to have a disturbing effect and his frequent use of bright contrasting colours suggests psychological vulnerability, Klimt's vocabulary of form is gentle and soothing. Neither gestures, movements nor glances provide a link between the two elements of the painting – death and mankind. Tension is created by the very lack of communication as well as the clear formal structure of the painting, with its large empty space between the figures. But the tension which is created by formal elements is partly neutralized again by the depiction of the people. Somnolent and dreamlike, not only are they ignoring the threat of death, they also seem to be totally unaffected by its presence.

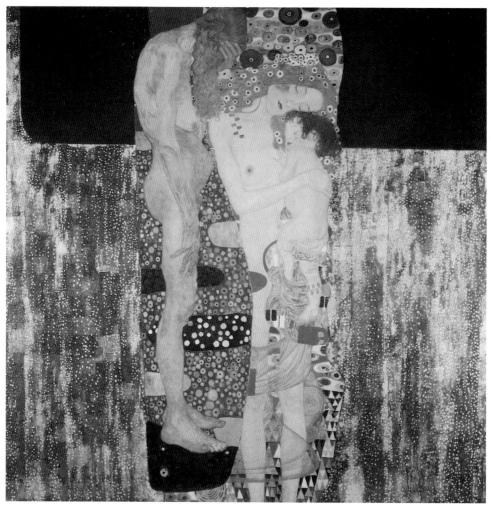

The Three Ages of Woman, 1905
Die drei Lebensalter der Frau
Oil on canvas, 178 x 198 cm
Galleria Nazionale d'Arte Moderna, Rome

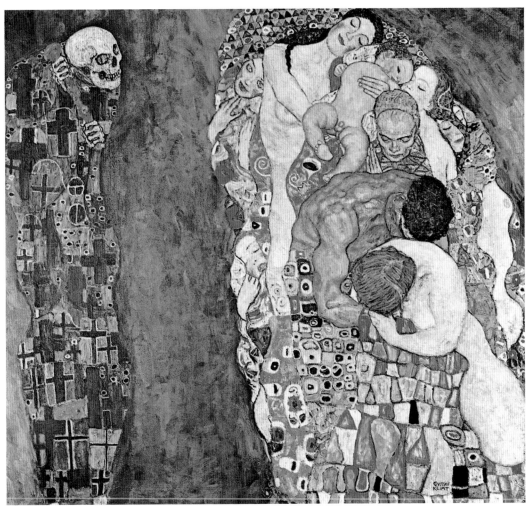

Death and Life, completed in 1916
Tod und Leben
Oil on canvas, 178 x 198 cm
Dr. Rudolf Leopold Collection, Vienna

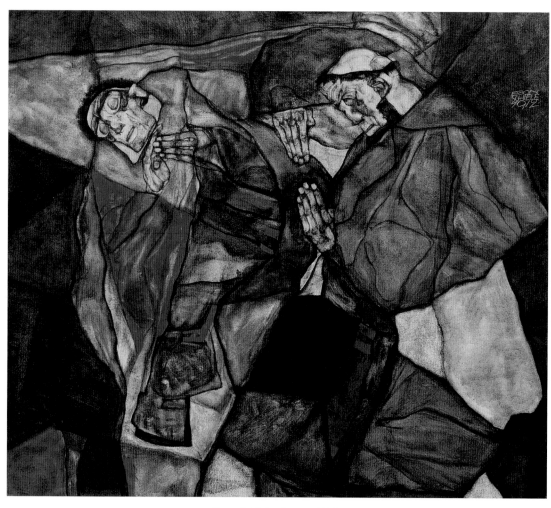

Egon Schiele, *Agony*, 1912
Agonie
Oil on canvas, 70 x 80 cm
Bavarian State Collection of Paintings, Neue Pinakothek, Munich

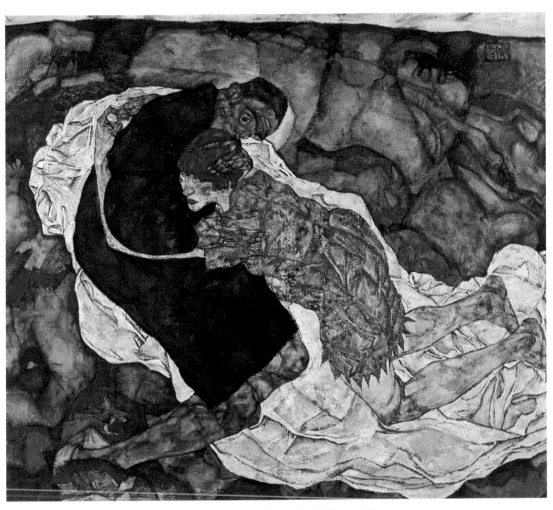

Egon Schiele, *Death and the Maiden*, 1915
Der Tod und das Mädchen
Oil on canvas, 150 x 180 cm
Austrian Gallery, Vienna

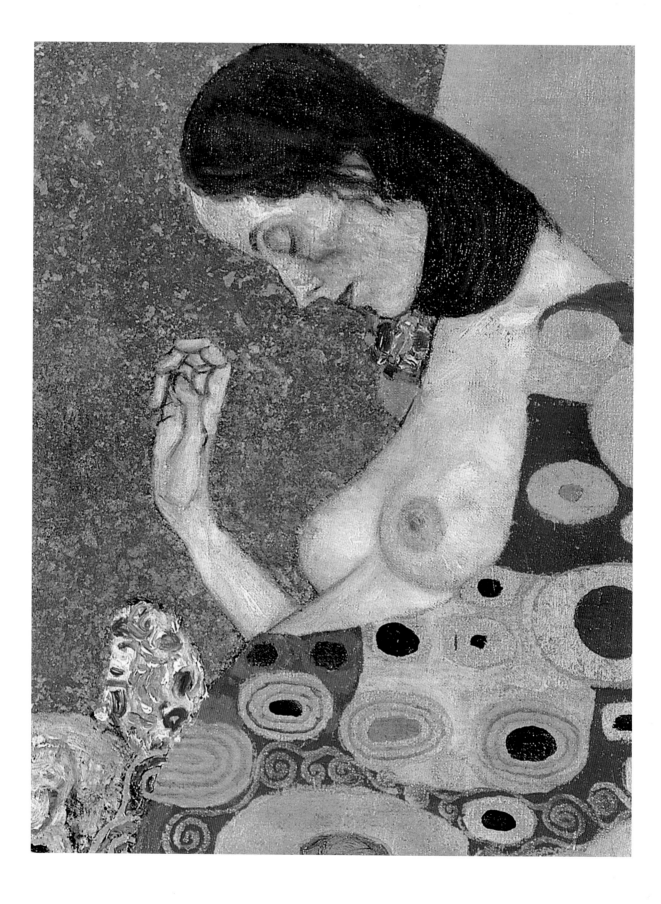

Hope

Klimt's 1903 painting of a pregnant nude, entitled *Hope* (p. 134), is one of his few works where the circumstances of its origins are relatively well-known. It therefore occupies a special place in the painter's oeuvre. Klimt, who consciously accepted that many of his pictures offended against aesthetic and moral norms, here created an artwork dealing with a topic which few in the history of art had dared or seen fit to address. Thus, he could assume from the very beginning that *Hope* would violate some taboo, and in fact it was not exhibited in public at first. It is said that the Minister of Education, von Hartel, personally persuaded Klimt not to show it publicly, to avoid adding further fuel to the controversy over his *Faculty Paintings*. [65]

The circumstance that prompted this painting was the pregnancy of one of Klimt's models, a woman known to us only by her first name, Herma. Arthur Roessler, the art critic of the newspaper *Arbeiterzeitung*, reported that Klimt continued to make her come to his studio, even though she refused at first to serve as a model during her pregnancy. But Herma was dependent on her modelling fees in order to support her family, and so she agreed to continue. The artist had no compunctions about using the difficult position of the "lass", whose "backside", according to Roessler, was "more beautiful and intelligent than many other girls' faces." [66] In the hierarchy of womanhood, male artists and critics always regarded models as the lowest of the low. The fact that not even the model's surname was considered to be worth mentioning is further evidence of this attitude. Roessler's casual account of the incident reflects the artist's view that models should always be at his disposal. Indeed, he was only interested in the physical aspect.

Klimt was extremely generous towards his models. "They all came to him, all those girls with their troubles and tribulations … Once, somebody's father had died and there wasn't enough money for the funeral. Klimt paid for it. On another occasion a family was being evicted from their flat. Klimt paid the rent." [67]. On the other hand, Klimt exploited their economic plight to the full. Their hourly fee was 5 crowns. A painting such as *The Kiss* brought in 20,000 florins. In a letter to the Wittgenstein family he estimated that "the current price of a life-size portrait by myself" was about 5,000 florins. [68] And for the portrait of Baroness Elisabeth Bachofen-Echt he received 35,000 crowns. When his drafts for the *Faculty Paintings* were rejected, he

Profile of a Pregnant Nude, Standing, Study for *Hope II*, 1907/08
Black chalk on wrapping paper, 49 x 31 cm
Historical Museum, Vienna

Hope II (detail), 1907/08
Hoffnung II
Oil and gold on canvas, 110 x 110 cm
Collection, The Museum of Modern Art, New York.
Mr. and Mrs. Ronald S. Lauder and Helen Acheson Funds, and Serge Sabarsky

was able to buy them back for 30,000 crowns. [69] The figure in *Hope* is shown in profile, so the curved, pregnant body becomes an ornamental element. Preliminary sketches for the painting show how much Klimt was interested in an ornamental treatment of the body. Experimenting with form in a variety of ways, he was fascinated by the different methods of rendering the human body more and more abstractly. In one drawing the curved contours of the woman's pregant body are duplicated, producing a textile- or carpet-like pattern. In the painting itself the woman is seen against a two-dimensional, ornamental background in front of a creature comparable to Typhoeus in the *Beethoven Frieze*. Like the octopus in *Jurisprudence*, it is threatening to engulf the woman. At the upper edge of the painting there are a skull and some ugly female faces, probably intended to symbolize "hostile powers", though the woman has turned away from them and seems to be ignoring them.

The sexual aspect is symbolically present in the form of loose, red hair – a feature of the erotic and therefore "threatening" nature of the woman in many of Klimt's paintings. In *Hope*, however, sexuality has been further defused by the allegorical figures. This made it possible to give the nude figure a symbolical meaning and to understand her as pointing to a wider significance. The exact meaning of the allegorical heads at the top edge of the painting is unclear. The title supports the interpretation that the artist probably wanted to see pregnancy as a regression into prenatal harmony, while showing the threat to the budding new life in the form of sickness, vice, death and misery.

A variety of different interpretations soon developed around the painting, giving an idea of how the subject was perceived. "Motherhood", for example, was a concept that emphasized the socially beneficial and productive aspect of sexual pleasure. Another one, "prolific fruitfulness", stressed the element of naturalness which was very much in keeping with Art Nouveau philosophy. The latter interpretation has been adopted by critics of our own time, such as Alessandra Comini, who has commented on this painting: "Life and death are equally present in the great continuum of biological renewal." [70]

Lovers – Studies, 1903/04
Black chalk, dimensions unknown, reproduced in *Ver Sacrum*, 1903, issue 22

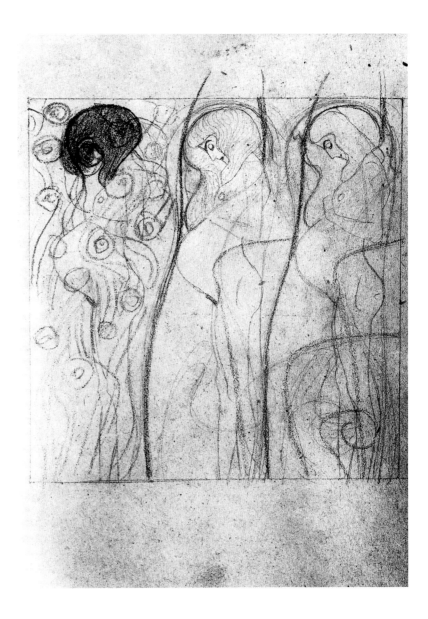

Three Pregnant Nudes in Profile, from the Left, Study for *Hope I*, 1903/04
Pencil with red, black and blue chalk,
46 x 32 cm
Historical Museum, Vienna

Interpretations of *Hope* have been extremely diverse. It was suggested, for example, that the painting depicted "satanic motherhood", or that it was a protest against 19th-century Victorian morality. Eva di Stefano interpreted the "monster" (which, as in the *Beethoven Frieze*, hardly had anything threatening about it) as a symbol of the "negative character of femininity" – a threatening, devouring motherhood which is ambivalently opposed to its prolific fruitfulness. But by painting the woman with red, open and wavy hair as well as red pubic hair, Klimt added yet another aspect of femininity that makes her interchangeable. These attributes, which are usually reserved for the world of courtesans in his paintings, also make the pregnant woman appear seductive, her calm unwavering gaze directed at the viewer.

The peculiarly iridescent quality of the painting is created by the simultaneous projection of two of the artist's favourite types of women:

Mother and Child, 1904-1908
Blue crayon, 53 x 37 cm
Albertina, Vienna

the figure is both a mother and a seductively erotic woman. These
seemingly contradictory metamorphoses of womanhood could thus
turn out to be two aspects of the same male projection of femininity.
Otto Weininger's book *Geschlecht und Charakter* (Sex and Character)
points towards a possible interpretation of the painting in this sense as
well as an assessment of Klimt's polarized typology of womanhood.
"Meanwhile," says Weininger, "we must regard women in terms of
two types, bearing within themselves sometimes more of the one and
sometimes more of the other: these are the mother and the whore ...
the one will take any man who can help her produce a child, and as
soon as she has her child, she does not need another man. This is her
only claim to the label 'monogamous'. The other woman gives herself
to any man who helps her get erotic pleasure: for her, this is an end in
itself. This is where the two extremes meet, and we hope that this will

enable us to gain some insight into the essence of womanhood as such." [71]

For several years it was impossible to show *Hope* in public, though a buyer was found immediately. Fritz Wärndorfer, one of the co-founders of the Viennese Workshop, bought the painting and, probably at Klimt's suggestion, had a lockable frame built for it, similar to a winged altarpiece. He probably did this not to "protect" the painting from "unworthy glances" (Alice Strobl) – which would have been no problem in Wärndorfer's private home – but to savour the full impact of the painting when it was revealed to his guests. "One evening," says Ludwig Hevesi, "we were sitting together and looking at the rather dry works of art Herr Wärndorfer had been collecting. One painting was hermetically sealed by two folding doors to shield it from vulgar glances. This was Klimt's famous – or rather, infamous - *Hope*, that young woman, obviously in the family way, whom Klimt had dared to paint au naturel ... a deeply moving act of creation. There she was, strutting along in her sacred state, surrounded on all sides by the vile and ugly faces of life's lustful and profane demons ... However, she can withstand all trials, and so she steadfastly walks along the path of horror. Undefiled and undefilable, she is sustained by the hope entrusted to her womb." [72]

Klimt took up the theme of the pregnant woman again in *Hope II* (p. 135), in which he changed both the style and the symbolic forms considerably. Instead of creating a densely ornamental network of relationships between the figures within a tall, narrow rectangular field, Klimt now chose his favourite format – a square. The pregnant woman, this time a statue-like figure, has drawn her "allegorical satellites" entirely towards herself: the skull seems to be sitting directly on her pregnant body while the female heads are poised, like the heads of soothing assistants, in a sleepily prayerful posture. This time the woman's glance is averted, there is no special eye contact with the figures or the viewer, and she is completely absorbed in herself. Above all, however, this *Hope* is no longer a nude. Almost the entire body has become a complex ornament with its own internal structure, a patterned area from which only the woman's head, breasts and raised hand protrude, representing – as in many of Klimt's other paintings – female corporeality. An allegorical reference to motherhood as a fertile, engulfing and at the same time threatening state may well have already been present in *Hope I*. Here, however, it has been compressed [73] and rendered less ambiguous, because the individual allegorical elements have now also become formal aspects of the woman. This lack of ambiguity is also a loss: *Hope I* laid itself open to a variety of different interpretations, all connected with motherhood, one of the major themes in Art Nouveau. The painting oscillated between psychological and erotic or sexual aspects which, in turn, contained an element of ambivalence and therefore also the threatening side of womanhood. In *Hope II* , on the other hand, the allegory is considerably more simple and superficial. It merely conveys Klimt's central idea of the eternal cycle of life and death as a natural process.

The story behind *Hope I* as well as the reactions of art critics and art

historians to the painting clearly show the extent to which male artists lorded it over their female models. This lordship was both economic and aesthetic in nature, with no dividing line, and critics and historians retrospectively provided the philosophy to justify it. Klimt's models are surrounded by myths which still abound today. A glance through the literature on Klimt quickly reveals the tenacity of a number of anecdotes for whole decades. Based on scant established facts, these episodes were embellished, amended and extended until it was almost impossible to discern the historical core among the numerous deposits of rumour and half-truth. Much of what can be read on the topic of "Klimt and his models" in the literature on the artist is but the expression of people's vivid imaginations or indeed sheer speculation on the part of modern authors.

Whenever there is any sensitivity towards the problematic relationship between the artist and his models, the role of the model is often falsely idealized. Alternatively, irrespective of our knowledge of existing social conditions, they are even ascribed emancipational abilities and intentions, which are then said to have found their expression in Klimt's art. Hans Hofstätter, one of the few authors who talk about the role of the models at any great length, even maintains that their depiction in Klimt's drawings must be regarded as revolutionary. Klimt, he says, was concerned with the "critical unmasking" of society in his erotic drawings and with achieving a "re-assessment of the role of women in society". What is more, Klimt did not attain this "work of liberation" by his own efforts; his lack of artistic restraint supposedly shows an attitude of protest on the part of his models and indeed a certain freedom which they claimed for themselves. Hofstätter turned the artist's lordship over his models into its exact opposite – the freedom of the models "to strike the most intimate poses and display the most flagrant exhibitionism". Against the background of the dominant, restrictive sexual morality of the bourgeoisie, this freedom was meant as a "challenge", a demand for a future-oriented sensuality unfettered by morality. [74]

Hofstätter failed to notice that the artist himself could constrain the freedom of his models in almost every respect – socially, materially and also aesthetically (his painting *Hope I* is a typical example) – and that it was the artist who decided how a woman should be seen. As for social prestige, models in particular were at the bottom of the scale. They had no freedom to run their own affairs and no recourse to any form of protest whatsoever. The definition of a woman's role by the male artist apparently implied not only the "discovery" of eroticism and sexuality but also the reduction of womanhood to eroticism and sexuality and nothing else. It is therefore impossible to speak of liberation in connection with Klimt and his models. Furthermore the cultural and social conditions at the time did not allow the development of unrestrained female sexuality. Otherwise, one would impute that the painter was politically committed and that he saw his art as a political medium. However, Klimt and the Secession were committed to the aesthetic refinement of society and certainly not to an art that pointed out social injustice.

Egon Schiele, *The Family*, 1918
Die Familie
Oil on canvas, 150 x 160 cm
Austrian Gallery, Vienna

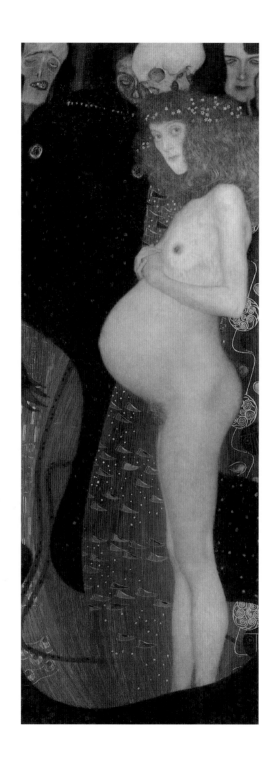

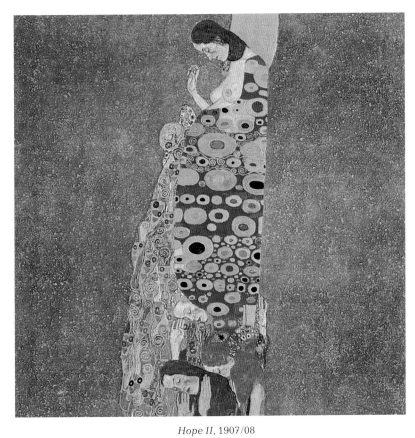

Hope II, 1907/08
Die Hoffnung II
Oil and gold on canvas, 110 x 110 cm
Collection, The Museum of Modern Art, New York. Mr. and Mrs. Ronald S. Lauder
and Helen Acheson Funds, and Serge Sabarsky

Oppposite:
Hope I, 1903
Die Hoffnung I
Oil on canvas, 189 x 67 cm
National Gallery of Canada, Ottawa

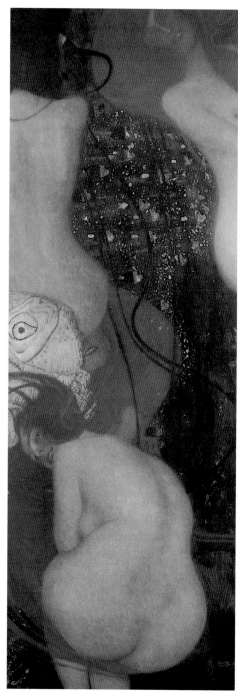

Gold Fish, 1901/02
Goldfische
Oil on canvas, 150 x 46 cm
Dübi-Müller Foundation, Kunstmuseum, Solothurn

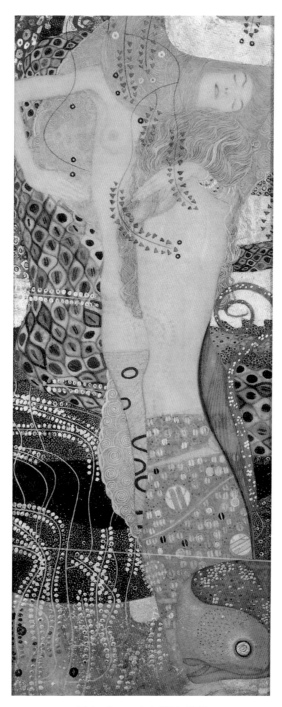

Water Serpents I, 1904-1907
Wasserschlangen I
Watercolours and gold paint on parchment, 50 x 20 cm,
Austrian Gallery, Vienna

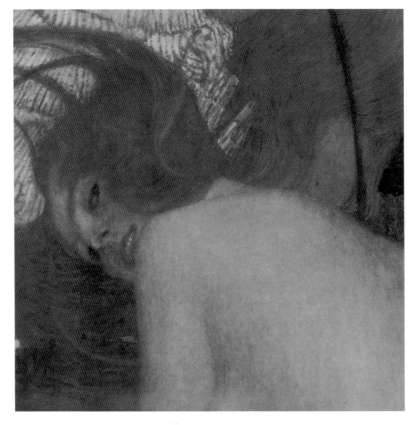

Gold Fish (detail), 1901/02
Goldfische
Oil on canvas, 150 x 46 cm
Dübi-Müller Foundation, Kunstmuseum, Solothurn

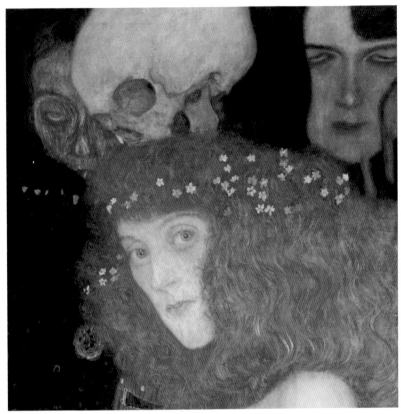

Hope I (detail), 1903
Die Hoffnung I
Oil on canvas, 189 x 67 cm
National Gallery of Canada, Ottawa

Judith

Judith I (p. 142), painted in 1901, was widely known and inter-preted as Salome, even though its frame clearly bears the inscription Judith and Holofernes. In her attempt to analyse the peculiar cir-cumstance, Alessandra Comini suggests that the renaming of the painting may have involved an involuntary act of suppression, leading some even to maintain that the painter made a mistake. Comini bases her supposition on the fact that Judith, unlike Salome, killed the man herself – a fact which those who insisted on changing the title conven-iently ignored.[75]

Klimt's painting contains no direct reference to the act of homicide. The most important feature of conventional depictions of Judith, the severed head of Holofernes, has been excluded almost completely from the painting. Instead of telling the myth, Klimt portrayed Judith. The threatening element in the picture, which – according to Comini – seems to have puzzled quite a few art historians and critics, is occasioned not by the gory decapitation of the man but by the depic-tion of Judith as a femme fatale and her exhibitionist display of sensu-ality as the only standard she is prepared to recognize. Her mythologi-cal disguise allowed the artist to conceal her transformation into a sexual object, though he did this in such a way that the transformation turned against the woman herself: rather than showing her as an active heroine killing a man who has been overcome by his erotic impulses, she herself is overwhelmed by erotic feelings, and this makes her appear dangerously unpredictable.

"This Judith ... is a beautiful Jewish courtesan ... who attracts the eyes of men at all premieres. A slender, lithe and supple woman with burning fire in her dark glances and a cruel mouth ... Mysterious powers seem to lurk in this alluring woman, violent energies that might not be quenched once those feelings catch fire – powers which are forced to die a slow bourgeois death. Along comes an artist, strips away the fashionable clothes from one of these women, puts her before us, adorned with her timeless nakedness ... The heroic women of prehistoric times rise before our eyes, come alive and walk amongst us ... The body of this Judith has been painted wonderfully, this boyishly tender, almost haggard body which seems to be stretching and extending. And this flickering fleshy hue, with thousands of lights playfully and tenderly flitting across it, this skin which looks as if it is lit from inside, as if we could see the blood circulating in its vessels. This whole pulsating body – in which there is no tranquility, where every-thing is alive and vibrant – seems electrified by the jewellery that sparkles all around it." [76]

The femme fatale was a popular subject at the turn of the century, and the fact that she was seen as threatening reflects contemporary changes in the role of women within society – changes that can be seen in Klimt, too. The much-discussed "crisis of the male liberal ego" in politics and society was by no means merely the result of economic

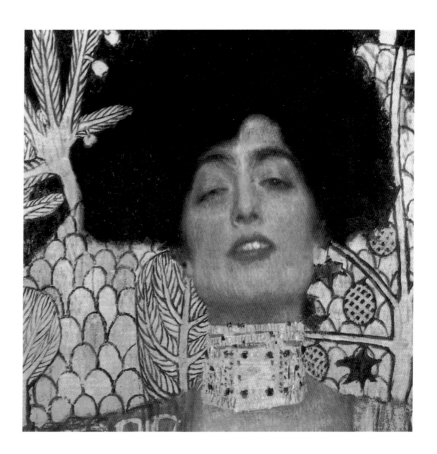

Judith I (detail), 1901
Oil on canvas, 84 x 42 cm
Austrian Gallery, Vienna

and political change and the questioning of a man's role. Another threat was the incipient emancipation of women in jobs and politics as well as its inevitable corollary, the changing role of the two sexes. Klimt – together with many others – did not have the slightest intention of analysing or describing the existing cultural changes that were taking place at the time. Contrary to popular belief, he did not want to achieve emancipation through his art. He aestheticized the problems by shifting them from reality into allegory and encoding them, as it were, out of recognition. The allegorical power of revenge which dwells in some of his female characters (such as *Judith I*, the "hostile forces" in the *Beethoven Frieze*, the Gorgons of *Justice*) also derives from the changes in women's social role, changes perceived as a threat. The "unveiling" of the sexual element went hand in hand with the process of controlling it aesthetically. Social change and the emancipation of women influenced moral standards as well as the appraisal and artistic depiction of eroticism and sexuality. In *Judith I* Klimt still took refuge in a mythological depiction, whereas later he sometimes omitted the masking effect altogether. After all, as Felix Salten's description of the picture clearly shows, we are certainly not confronted with some kind of history painting, but with one of those metamorphoses of womanhood that were characteristic of Klimt and would have offended social taboos without their mythological guise.

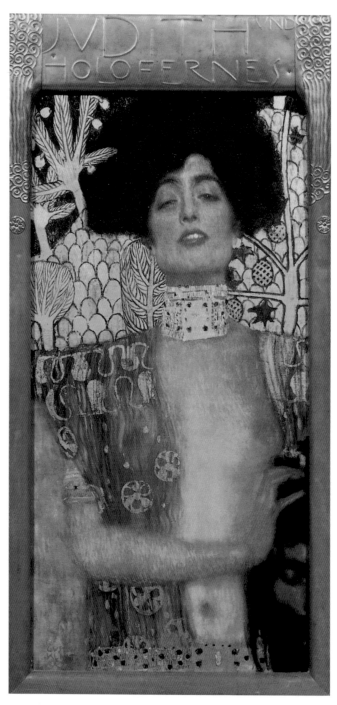

Judith I, 1901
Oil on canvas, 84 x 42 cm
Austrian Gallery, Vienna

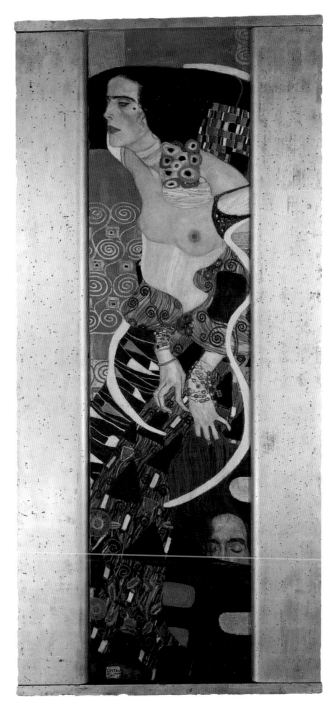

Judith II, 1909
Oil on canvas, 178 x 46 cm
Galleria d'Arte Moderne, Venice

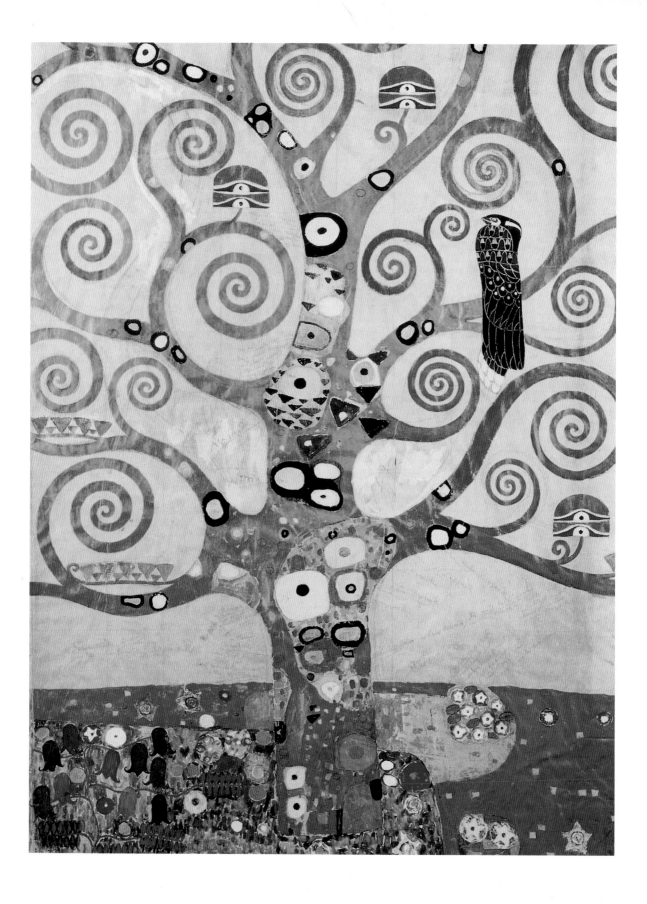

The Stoclet Frieze

Like the lovers in *The Kiss* (p. 117), the couple in the *Stoclet Frieze* (p. 153) are completely wrapped up in themselves. As in the *Beethoven Frieze* (p. 113), they form part of a larger context, though it does not tell a story. Not only are the "hostile forces" missing in this mosaic frieze, so that the promise of happiness has been purged of all dangers; there is also a certain aimlessness and timelessness. The interpretation of the picture is made even more difficult by the absence of any clear communicative relation between the figures. In many works – including Klimt's earliest ones – he created tension and significance as well as particular relationships between the figures by means of empty spaces. In the *Beethoven Frieze*, for example, this was achieved with unpainted areas of plaster. In the *Stoclet Frieze* it is done by means of ornamented areas, though they still have some representational significance (the tree of life). But unlike the other frieze, it lacks all action and mythological or historical allusions. The decorative significance of the mosaic, executed with most luxurious materials, clearly has priority over the actual message.

The wall frieze, which forms part of dining-room decorations (p. 150), is of indeterminate content and therefore open to a variety of interpretations. Indeed, it also lacks any contemporary references that might form the basis of an interpretation, and Klimt himself hardly commented on the frieze at all. He simply described the single woman in the picture as a "dancer", which provides grounds for one particular interpretation in which the woman herself is seen as an allegory of art and the couple together as an allegory of love. Others align *Expectation* (p. 152) and *Fulfilment* (p. 153) as complementary parts in a narrative, and a third view interprets the frieze as a Garden of Eden. The spiral-shaped ornaments in which the figures are embedded conjure up the idea of the tree of life or, following Christian imagery, the "tree of knowledge", and this – according to yet another interpretation – makes it plausible to speak of a "garden of art and love" which, "unlike the garden outside the palace windows (i.e. Stoclet Palace) would never fade." [77] The major motif of the picture is indeed the "spiral tree", which forms an axis of the frieze. The colourful, ornamental figures have, as it were, been "woven" into the ornaments of the tree.

With the interior and artistic design of Stoclet Palace in Brussels, the Secessionist artists of Vienna were given the great task of putting their dreams of a *Gesamtkunstwerk* into practice. And indeed they

Joseph Hoffmann, *Interior of Stoclet Palace, Brussels,*
Indian ink and pencil on graph paper,
33 x 21 cm
Museum of Modern Art, Vienna

Tree of Life, central section
Lebensbaum
Pattern for the *Stoclet Frieze,* around 1905/06
Tempera, watercolour, gold paint, silver bronze, chalk, pencil and ogagne white on paper, 195 x 102 cm
Austrian Museum of Applied Art, Vienna

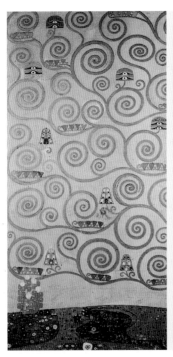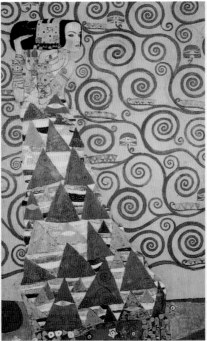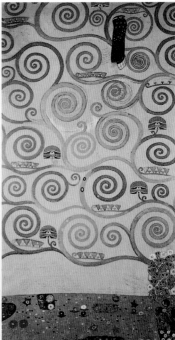

were able to do so without financial constraints or instructions as to cultural and political content.

Paradoxically, the philosophical keynote which they endeavoured to follow in their public work and their exhibitions only ever found fulfilment with the help of a private sponsor, far away from Vienna. We do not know very much about the conditions under which the palace was built or indeed the conditions under which Klimt's work on the frieze was done. Even the most important dates of the planning and completion are uncertain. In 1905 Josef Hoffmann probably made the first drafts of the building, and it is likely that Klimt's first visit to Brussels was in 1906. His drafts may have been completed in 1906/07, and the frieze itself in 1911. [78]

The lovers in the *Stoclet Frieze* are very close – both temporally and stylistically – to the couple in *The Kiss*. However, the frieze is considerably more ornamental than the painting. If it were not for their colourful garments, the two people – who are totally two-dimensional – would merge completely with the ornamental background. The distinction between the figures and the background is blurred even further by the actual material. Unlike the *Beethoven Frieze*, Klimt only used the most precious materials that were available, such as marble, copper, gold, semi-precious stones, fayences and corals. [79] The background and the figures are almost indistinguishable, as they consist of the same material. This impression is further enhanced by the two-dimensional nature of the mosaic: it is impossible to make any spatial distinction between foreground and background. The figures *are* the background, and vice versa. The only way of distinguishing between a figure and the ornamental tree of life is by the actual patterns – the

Patterns for the *Stoclet Frieze*, around 1905/06
Tempera, watercolour, gold paint, silver bronze, chalk, pencil and ogagne white on paper
a. *Left-hand edge of the Tree of Life*, 197 x 115 cm
b. *Expectation*, 193 x 115 cm
c. *Tree of Life, left-hand portion*, 197 x 105 cm

d. *Tree of Life, centre portion,*
 195 x 102 cm
e. *Tree of Life, right-hand portion,*
 198 x 103 cm
f. *Tree of Life, right-hand portion with*
 shrub, 194 x 118 cm
g. *Tree of Life, right-hand edge,*
 194 x 120 cm
Austrian Museum of Applied Art,
Vienna

yellowish white of the marble as well as the golden spiral pattern on the one hand, and the strongly colourful garments on the other. Only their hands and faces still bear some semblance of Naturalism; the rest of their bodies has been replaced by an abstract two-dimensional geometrical pattern.

These formal design features can also be found in other works of the same time, e.g. *The Kiss* and – to an even greater extent – Klimt's portrait of *Adele Bloch Bauer I* (p. 218) of 1907. They add an almost fetish-like significance to the more or less Naturalist, non-ornamental hands and faces – generally the most expressive features in portraits. This significance is increased by the fact that the two-dimensional ornamentation often fragments or severs the hands and feet, with the result that they seem divorced from the rest of the body. It is noticeable that, for no apparent reason which could be related to the overall theme, the hands are often gesticulating wildly. Klimt's description of the single figure in the *Stoclet Frieze* as a "dancer" may therefore have been a retrospective attempt to explain her gestures.

The three figures in the frieze do not communicate with the viewer. The woman in *Expectation* (p. 152) is looking in a direction almost parallel to the surface of the picture. The woman in the couple has her eyes closed, and the man not only has his head turned away from us but it has sunk almost completely behind that of the woman whom he is embracing. This means that communication with the viewer is carried mainly by the purely material nature of the mosaic: the exquisiteness of the material, its obvious preciousness and the luxuriously sensuous charm of the surface are far more fascinating than the depiction of the people and the message it expresses. Having entered the

precious scene of this picture in order to decorate its luxurious life-style, the actors have turned into objects themselves. They have become choice products of the artist's craftsmanship. The freezing of life into inorganic nature has gone further here than in any of Klimt's works. And once this has happened, inorganic nature is compensated by having life breathed into it again. Thus it can establish contact with the viewer. It does indeed seem as if the mosaic were looking at the viewer – almost, one might say, as if it had a thousand eyes. The patterns that grow in the branches in the form of blossom or leaves have pairs of eyes which are placed above one another in a singular arrangement, and these eyes are similar to those on the people's garments.

On the end wall of the frieze (p. 151) Klimt took abstraction even further. Interestingly, it remains unclear whether it is only an abstract pattern or another human figure. This part of the frieze has frequently been described as a purely abstract two-dimensional composition with no more than decorative significance – in terms of art history, a remarkable counterpiece to Josef Hoffmann's abstract relief above one of the passage-ways at the Beethoven exhibition. However, its position in a recess in one of the end walls of the room gives it special emphasis and makes it the centrepiece of the frieze. For this reason it is difficult to see why the narrow mosaic should have only a decorative function and play no role in the overall content of the frieze. I agree with the view, which has often been put forward, that the mosaic shows a human figure. With its black horizontal line and a double verticle line, the rectangle at the top centre of the ornament may well represent the facial features of a human being, and the parallel verti-cal strips with their diversity of patterns can be seen as a garment or a clothed body.

This animation of inanimate objects was quite common in architec-ture, interior decorating and applied art. In the 19th century, the individualization of inanimate matter, endowing objects with facial features, was still regarded as a form of spiritually enlivening them, a way of literally giving "human traits" to inanimate things, objects and designs. This also meant dominating and penetrating the material world with human imagination, creativity and formative spirit. Thus it was possible to put the stamp of humanity on a product culture whose automatic and industrial manufacturing process had alienated it from human and artistic work as well as from true craftsmanship. This helps us understand why everyday objects were decorated with human figures – frequently to absurd effect – and why they were often designed to represent parts of the human anatomy. Around the year 1900 this form of Naturalist imitation was vehemently criticized and rejected, for example by Adolf Loos, though the struggle against passive acceptance of anonymous, mass-produced, factory-made objects persisted. It seems that, with the *Stoclet Frieze*, Klimt gave up this resistance and surrendered to the material. Rather than trying to humanize the inanimate world, he turned the image of a human being into something inanimate. The physiognomy of the mosaic on the end wall can perhaps be understood either as a last remnant of this dis-

appearing human image or as a reaction to its impending disappearance.

If we are right in interpreting the end wall mosaic as a human figure, then – in terms of cultural history and art history – it is a remarkably early symptom of the crisis surrounding human depiction in the fine arts in modern times. The rejection of a Naturalist depiction of reality had been prepared by the late 19th-century theory of art history and applied art. The rejection of the styles and isms that prevailed in historicism gave rise to a completely new concept of art and works of art. The idea that art was autonomous had by then been promoted so much that every single one of its functions was being questioned and a work of art could only be defined as "an appearance of objects in form and colour in either two or three dimensions".[80] This meant that the role of the artist and his work also appeared in a different light. Indeed, if all content, imitation and functional application of art was denied, then the production of a work of art had to be a radically new creation without precedent – a *naissance*, as opposed to the *renaissance* of 19th century stylistic repetition and imitation. But where art's mimetic function is questioned, artistic creativity assumes the rights of nature itself: "To form its works from inanimate matter, the human hand follows the same laws of form that are used by nature for its own works. In the final analysis, all creative artistic endeavours of man are therefore nothing but a matter of competing with nature."[81] And it was said that the rejection of mimetic art went furthest where the crystalline structure in organic nature recurred in a work of art, where all similarity with external patterns had been shed, which explains why *applied art* (and interior design) as well as *abstract* ornaments played a central role in Viennese Modernism around 1900.

Having pointed out the radical experiment with form in this mosaic as well as its value in showing the practical application of the theory which prevailed in the applied art movement of Viennese Modernism, we have probably not exhausted all the possible interpretations of the picture on the end wall. The central, elongated colourful shape, which is inserted into the golden ground and on which the "head" has been placed, also consists of three elongated strips. The interlocking pattern of narrow, elongated and round ornaments repeats the same ornamental differentiation which Klimt used for the symbolical distinction between the two sexes in paintings like *The Kiss*. His painting *The Kiss* showed that this difference and the promise of erotic delight were, in a sense, presented by the ornamental structures. In the mosaic "painting" of Palais Stoclet, Klimt's treatment of the differences between male and female and their convergence became an expression of total assimilation. This would mean, however, that the utopian idea of a reconciliation between the sexes, with a retrogressive development to their original inorganic state, has been bought at a considerable price. The image of man has in fact solidified into inorganic minerals or crystals, so that the only elements which are still reminiscent of the erotic tension between the sexes are the abstract ornaments.

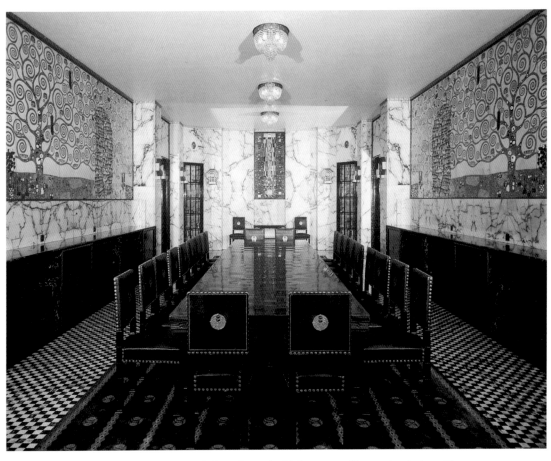

Josef Hoffmann, Stoclet Palace, Brussels. Dining room with mosaics designed by
G. Klimt, 1905-1911

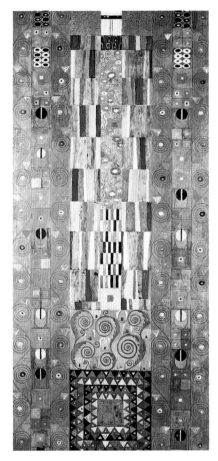

Pattern for the *Stoclet Frieze*, around 1905/06
End wall
Austrian Museum of Applied Art, Vienna

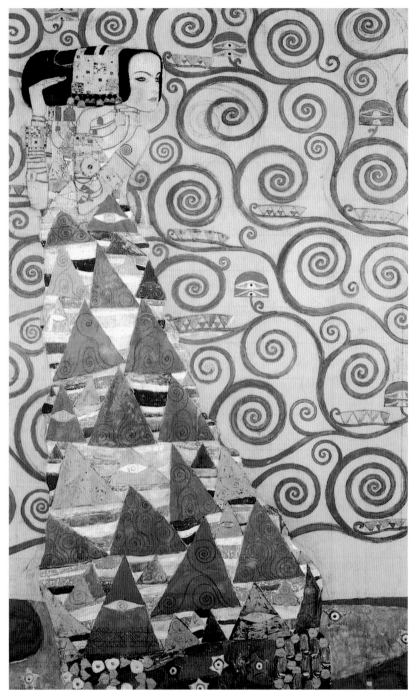

Expectation, pattern for the *Stoclet Frieze*, around 1905/09
Die Erwartung
Austrian Museum of Applied Art, Vienna

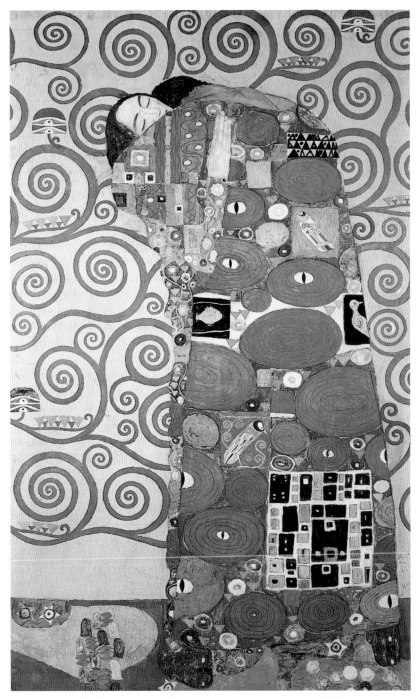

Fulfilment, pattern for the *Stoclet Frieze*, around 1905/09
Die Erfüllung
Austrian Museum of Applied Art, Vienna

The Break-Up of the Secession and the 1908 *Kunstschau* Exhibition

When, in 1904, the Secession split into two camps, this was probably caused by two circumstances: disunity among the group itself on the one hand, and the decision on the part of the Austrian government to stop its largely unconditional financial support on the other. The controversy over Klimt's *Faculty Paintings* had roused so many strong feelings among the general public that when the Secession suggested participating in the 1904 World Fair in St. Louis, the plans were rejected by the Ministry of Education. The Secessionists were in fact planning to exhibit two of the controversial university fresco drafts. The idea that these should be shown abroad and also that their contribution might consist entirely of works by Klimt [82] simply went beyond the political scope of the relevant state authorities. The idea of art playing a conciliatory role in a political and economic situation fraught with conflict had to be discarded in the light of the controversies now surrounding art policy itself.

At the same time there was an aggravation of the antagonism between two Secession camps – the "Stylists", such as Klimt, and the "Realists". Contemporary comments, however, show that this breach was not really about stylistic differences at all and that the controversy went beyond aesthetic problems. In fact, at the time, commentators found it rather difficult to identify any differences between these opposing ideas in terms of stylistic concepts and views. The Secession included such a broad spectrum of artistic options that it was impossible to draw a sharp dividing line entirely on the basis of different aesthetic modes of expression. Any attempt to divide the warring factions neatly into Stylists, Realists, Impressionists, etc. ignored the existence of more deep-rooted conflicts. Detailed comments show that the split was not primarily due to aesthetic or artistic differences. The roots of the conflict lay deeper, in the old and fundamental ideological stance of the Secession, in its perception of itself as a group of public artists with a special mission.

Joseph August Lux may perhaps come closest to the truth when he not only discusses artistic conflicts within the group but also criticizes their socio-political role, which was being questioned from outside as well. "The original idea in founding this group was not just to form an artists' association that would continually organize the kind of exhibition that existed already but to do a certain amount of cultural work, to help the right of the artist to participate in the tasks of our times and to run a kind of educational programme for this purpose." This pro-

Front View of an Athlete, 1917/18
Pencil, 56 x 37 cm
Historical Museum, Vienna

Emil Hoppe, Project for the Design Pavilion at the Kunstschau exhibition in Vienna, 1908
Pencil, crayon, Indian ink, pen, pastel and gouache, 31 x 25 cm,
Private collection

gramme, said Lux, had by no means been exhausted: "The position of applied art and its pragmatic basis in our times have still not been established in artistic terms. The same applies to all architectural questions, matters of town planning, the preservation of historic town monuments, the great tasks of preserving monuments, fountains, festive decorations, the nature and application of large and small sculptures, the art of landscape gardening and the aims of graphic art in contemporary life. These and many other problems still remain to be solved before the multifaceted right of art to express life and the evaluative power of talent can be shown." [83]

The aims of the Secession were summarized accurately as the "right of art to express life" – but they were aims for the future. Lux questioned not the Secession programme itself but the success with which it was put into practice. However, a faction must have formed within the group which questioned the programme itself and wanted to replace it with the concept of an autonomous art that was independent from all these "questions of life".

The pending crisis had been noticeable for some time. In 1903 *Ver Sacrum* ceased publication, officially because it had completed its task of propagating the art and artistic philosophy of the Secession. Four members had already left the association during the business year 1903/4. In 1903 the Viennese Workshop was founded by Josef Hoffmann, Koloman Moser and the banker and collector Fritz Wärndorfer, with the result that tendencies towards independence, splits and further splits were inevitable – this time towards more functional and economically lucrative forms of art (i.e. applied art). The foundation of the Viennese Workshop [84] was regarded as a step towards commercializing the Secession and therefore not accepted without protest. This was a tendency against which the Secession had vehemently protested when it split away from the Co-Operative Society of Austrian Artists.

Indeed this very point – convergence towards the art trade and the commercialization of art – now caused the smouldering conflicts to culminate in a breach. In 1905 the first *secessio* took place within the Secession itself, and in 1906 the *Österreichischer Künstlerbund* (Austrian Artists' Union) was founded. Members included Otto Wagner, Alfred Roller (the Imperial Opera stage designer and director of the School of Applied Art), Franz Metzner, Josef Hoffmann, Max Kurzweil and Carl Moll. The breach was in fact triggered off by Carl Moll's close co-operation – both in the planning stages and when it actually took place – with the art trade (the Miethke Gallery). The final split came when a number of artists became concerned about an "uncontrolled alliance between art and commerce, which had originally been opposed when leaving the *Künstlerhaus* association". [85]

The group explained their decision and their reasons in a letter to the Minister of Education: "We, the undersigned, herewith announce that we will leave the Association of Austrian Artists (Secession). Because of the active support which you have been giving to the association ... we feel obliged to give reasons for this step. We feel that, in view of the massive changes in general attitudes, artists should

not limit their activities exclusively to the organization of temporary exhibitions. Instead, they should endeavour to extend their influence to more and more areas of modern life. Indeed they are obliged to make use of any opportunity which offers itself in order to promote the life of art in the broadest possible sense. Through their art they must convince increasingly wide sections of the population that no life is ever too rich to be enriched by art and that none is too poor for art to find room in it.

"As our endeavours met with resistance and a lack of understanding among the majority of the association and as many of these endeavours could not even be attempted within such a narrow framework, we felt compelled to leave the association. This step was further corroborated by our realization that most of our colleagues had no confidence in the sincerity of our intentions, nor were they able to show any goodwill towards them." [86]

The 1908 Kunstschau exhibition was the climax of the new Artists' Association, now often referred to as the "Klimt Group". Also, it was the ambitious attempt to put their demands into practice – demands that could quite easily be identified as a renewed affirmation of the old Secessionist claims. The dimensions of the exhibition went beyond those of the Secession itself. Rather than a single, self-contained exhibition and an intimate setting within a single room, reserved specially for the worship of art, it aimed at expanding the whole project to include a small townscape. Designed by Josef Hoffmann, the entire complex included a variety of different sections with numerous peripheral buildings which were only intended for the duration of the exhibition and would soon be demolished again. More comprehensively than any of the Secession exhibitions, a group of artists was demonstrating the artistic articulation of "the whole" of life. Indeed the exhibition itself could be read as a metaphor of the "whole city" and its society. The exhibition quite closely reflected the ideas of the Viennese Workshop, which also participated in it. Indeed, both groups were modelled on the organizational concept of corporate work as evolved by the Artists' Association.

It is worth noting that the Kunstschau adorned itself with the same motto with which the Secession had announced its début (in an inscription on its exhibition building): 'Give our time its art and art its freedom'. However, it had opened up not only to the Viennese Workshop and the School of Applied Art but also to new artistic currents. Not only "Stylists" were represented, but also artists like Egon Schiele and Oskar Kokoschka. Even Ludwig Hevesi, a critic who gave a good deal of favourable publicity to the Secession, simply described Kokoschka as a "top savage". The public appearance of these artists soon involved the newly formed group of ex-Secessionists in more scandals. However, they also heralded a new generation of Viennese Modernism whose expressionist leanings were diametrically opposed to the aesthetic harmony of the Stylists.

"The Kunstschau", wrote Joseph August Lux, "is meant to be a house of life, or rather a pure mirror image of life as the artist would like to see it fashioned. A universal building or indeed a parable of the

Viennese Workshop, postcard, 1909, lithograph

world which encompasses the entire calendar – the humdrum routine of daily life and domestic art, the festive days of devotion and celebration, the choice moments of art in all its greatness, moments which mean more than religion, the working days when noble gifts are borne by joyful hands, the early hours of art in the dawn of childhood and the subconscious mind, safely guided by one's instincts. We can only win if we really grasp this mirror image of life, an image which has been transfigured by art, and if we use it to enrich our souls anew. [87]

The complex interior decorations of the 1908 exhibition still reflected the "aristocratic elitism" of the Secessionist generation of artists. Art was to encompass, shape and ennoble all facets of life. The Kunstschau included not only posters, the most modern form of advertising, but one room had been dedicated to the efforts of Franz Cizek, a teacher at the School of Applied Art, and his endeavours to promote children's art. With his *Small Country Villa* Josef Hoffmann was able to show an entire home, and there was even a cemetry and a garden with a theatre. "Private and public building projects merge on the exhibition premises of the Kunstschau, the public sphere is reduced to the idyllic intimacy of a private refuge. The large *House of Life* includes an inexpensive residential building with a garden designed by Josef Hoffmann, a day nursery, a restaurant, a poster room (i.e. a road not open to the general public), a garden theatre, a pseudo church and a pseudo cemetery. Children, old people, those who need comfort and those who are seeking enjoyment – everyone is looked after aesthetically. Visitors are spoilt for choice by this tremendously wide array of art exhibits based on the necessities of life and culture. Blurring the distinctions between work and leisure, real professionalism and dilletantism, this idyllic cultural environment also allows a measure of amateur art – from Adolf Böhm's ladies' painting classes – on its fringe." [88]

Contemporary critics correctly noted that the exhibition became a "festive garment" for Klimt. Sixteen of his paintings were shown, in a room situated between those set aside for church and cemetery art. Klimt also made the opening speech of the Kunstschau. Not only is it one of his few remaining programmatic statements that were made in public, but it also gives us an idea of how the artists around Klimt saw themselves, and we shall therefore quote its exact wording.

"Ladies and gentlemen, for four years now we have not had the opportunity to show you the results of our work in the form of an exhibition.

"It is a well-known fact that we do not regard exhibitions as the ideal way of establishing contact between the artist and the public; for this purpose we would much rather take on large-scale public art projects, for example.

"But as long as public life is mainly concerned with economic and political matters, exhibitions are the only option open to us, and we must therefore be extremely grateful to all public and private factors that enabled us to follow this path and to show you that we have not been idle during these exhibitionless years. Rather – probably because we were completely free from any worries about exhibitions –

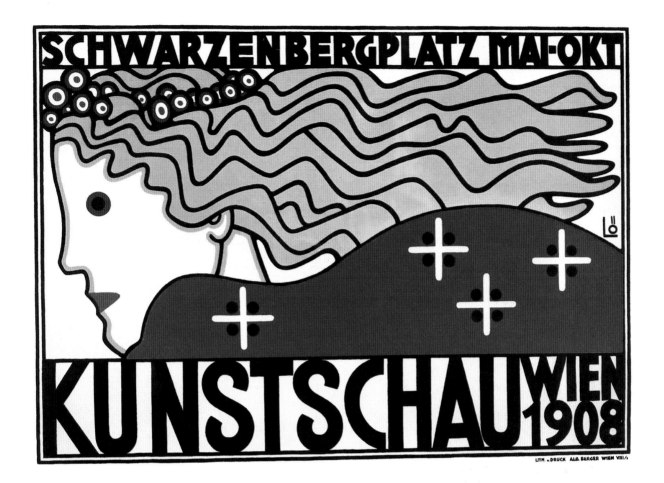

LITH.=DRUCK ALB BERGER WIEN VII/₁

Bertold Löffler, poster for the Kunstschau exhibition in Vienna, 1908
Lithograph, 68 x 96 cm
Private collection, by permission of Barry Friedman Ltd., New York

we have been working on the development of our ideas with even more diligence and devotion. We are not a co-operative society, an association or a union; we have joined forces quite informally with the express purpose of holding this exhibition, united only by the conviction that no area of human life is too insignificant or unimportant to give scope to artistic endeavours. As Morris puts it, even the most inconspicuous thing can help to increase the beauty of this earth if it has been made perfectly. Indeed, only by harnessing the artistic spirit in a drive to pervade the whole of life can culture make progress at all.

"So this exhibition does not show you the final results of artistic careers. Instead, it is a powerful review of Austrian artistic endeavours, a faithful report on the current state of culture in our Empire.

"And just as we define a 'work of art' very broadly, we do the same with the word 'artist'. We are called artists not only by those who create but also by those who enjoy, by you who are able to comprehend and appreciate what we have created. For us the 'artistic world' is the ideal community of all those who create and those who enjoy. The very fact that this building could be built and that this exhibition can now be opened shows that such a community really exists, that it is strong and powerful because of its youth, vigour and

Egon Schiele, 1890-1918 Oskar Kokoschka, 1886-1980

the purity of its convictions. And the attempts of our adversaries to declare this modern art movement dead and to fight against us are therefore completely in vain, for such a fight goes against the whole principle of growth – and indeed against life itself. Having worked on this exhibition for weeks, we will part again and go our separate ways as soon as it has been opened. But maybe, in the near future, we shall get together in completely different groups and for different purposes. Whatever the case may be, we depend on one another and I would like to thank all those who have been working on this exhibition for their diligence, their cheerful willingness to make sacrifices, and their loyalty. But I would also like to thank all our patrons and sponsors who enabled us to hold this exhibition, and in inviting you, dear visitors, to take a good look at the exhibition, I now declare the 1908 Viennese Kunstschau open." [89]

The programme that was set forth in this speech did not differ substantially from that of the Secession or the Viennese Workshop. There was nothing original in the idea that beauty was comprehensive and transcended all boundaries of genres within art (i.e. that art and craft were on the same level, as were fine art and architecture or interior design). Nor was there anything new in their ethical and political views on the aesthetic refinement of life, views which also implied a certain aesthetic elitism. After all, in the final analysis, both Klimt's works and those of, say, the Viennese Workshop were only affordable for the well-to-do, and their "aesthetic code" could only be deciphered by a small group of educated people within the upper-middle classes who took an active interest in developments in modern art.

What Klimt did not express directly in his speech was the identification of this life-reforming programme with the political reality of the

late Habsburg monarchy. The "Austrian beauty" which was mentioned so frequently in connection with Secessionist art and art policy – especially by Hermann Bahr – was not only reflected in the support which the Secession received from the state (even though this was only for a few years). Conversely, members of the Secession also identified with the patriotic idea that life in the Habsburg monarchy should be clothed in this "Austrian beauty". They accepted public jobs which encompassed virtually all areas of artistic design, ranging from stamps to railway lines (e.g. Otto Wagner's *Stadtbahn*), from exhibition buildings to monumental paintings, from posters to precious craft objects, from royal gifts to book illustrations. The Kunstschau took place in the same year as Franz Joseph II's jubilee, which was celebrated with a festive procession along the Ringstrasse. It is unlikely that when Klimt described the Kunstschau as "a powerful review of Austrian artistic endeavour" and a "report on the current state of culture in our Empire" he merely did so by chance, at a time when the Habsburg monarchy had reached a critical point and when large-scale festivities were to lend cultural credibility to the loyalty of the masses towards their ruler and their Empire. This attempt to invoke, once again, the unity of the Empire through people's cultural identification with the patriarchal personality of the Emperor was probably not very far removed from the philosophy of the Secession. With the distance of irony and time, Robert Musil made such a parallel action – the search for an appropriate form of homage to the ruler and thus to the monarchy – the centre of his novel *The Man without Properties*. With the foundation of the *Österreichischer Werkbund* and the increasing dominance of the *Heimat* style, this patriotism soon hardened into a doctrine of art that persisted until the First World War and legitimized the participation of a number of artists in the artistic glorification of the war.

However, when Klimt claimed in his speech to represent no more and no less than the "progress of life", this did not accord entirely with the demands of patriotic art. His solemn formula still implied the claims of European Modernism, that is, self-reflection within a continually progressive development, in which the new could only ever be defined in terms of its departure from the old, so that the old became "pre-modern". The "Klimt Group" did not claim any more than the Secession that it had found a static, universally applicable concept of art. The inclusion of Expressionist art at the great exhibition showed their flexibility and broad-mindedness in matters of art. In identifying the artists' circle with the "progress of life", which was certainly quite a solemn formula, Klimt undoubtedly also divulged an important part of his own, very personal artistic theory – a fraction of that "philosophy of history" in which growth and decline were seen as an organic cycle and which, deeply rooted in the philosophy of the *fin de siècle*, he expressed in many of his works.

Josef Hoffmann, tea set, samovar over tea pot warmer, tea pot, sugar bowl and
milk jug, 1903
Hammered silver, coral, wood, leather; samovar 27 cm high
Austrian Museum of Applied Art, Vienna

Josef Hoffmann, sketch for a tea set, 1903
Pencil and charcoal, 21 x 34 cm
Austrian Museum of Applied Art, Vienna

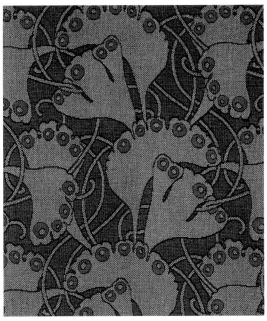

Koloman Moser, design for material, "Palm Leaf",
(detail), 1899
Cloth, 40 x 31 cm altogether
Austrian Museum of Applied Art, Vienne

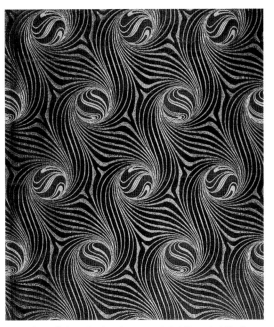

Robert Örley, design for material, "Cosmic Mist"
(detail), 1900
Cloth, 127 x 97 cm altogether
Austrian Museum of Applied Art, Vienna

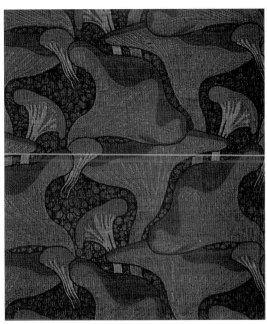

Koloman Moser, design for material, "Mushrooms"
(detail), 1900
Cloth, 112 x 91 cm altogether
Austrian Museum of Applied Art, Vienna

Koloman Moser, design for material, "Poppies"
(detail), 1900
Cloth, 130 x 124 cm altogether
Austrian Museum of Applied Art, Vienna

Oskar Kokoschka, *Lovers with Cat*, 1917
Liebespaar mit Katze
Oil on canvas, 94 x 131 cm
Kunsthaus, Zurich

Opposite:
Egon Schiele, *Seated Couple*, 1915
Sitzendes Paar
Pencil, gouache, 53 x 41 cm
Albertina, Vienna

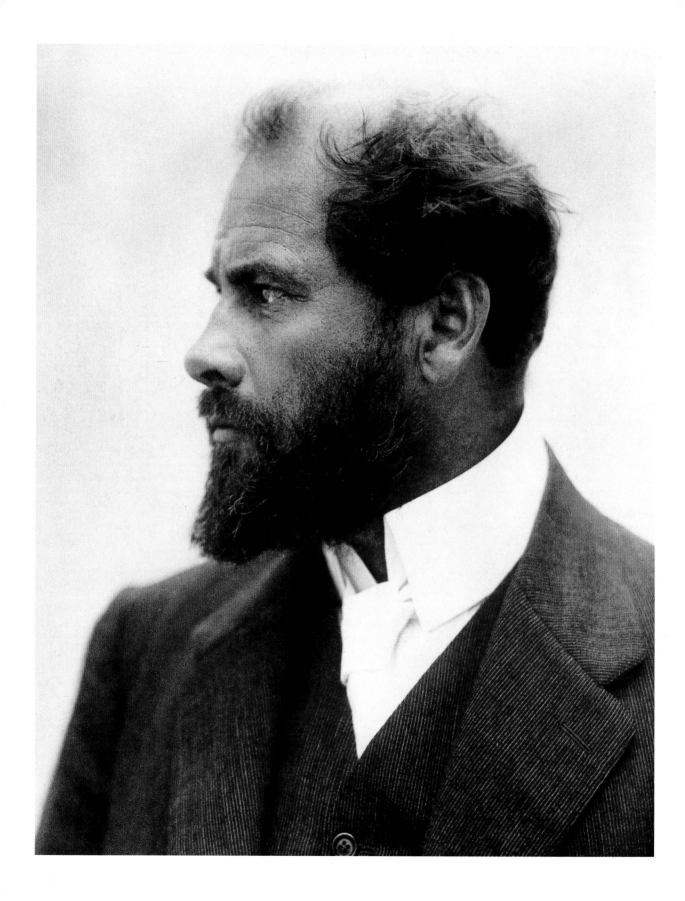

"I'm not particularly interesting"

It is of course understandable that one should take an interest in the personality of a famous artist. However, in Klimt's case such an interest can only lead to disappointment. Although there are a large number of highly elaborate legends, these are matched by very few and indeed rather shaky facts. Klimt never made any lengthy statements about himself or his work. In his official speech at the Kunstschau, he expressed neither a general political conviction nor any ideas about specific cultural policies. Not a single word indicates that he might have had a carefully considered attitude on art policy-unless, that is, one counts his vague and generally liberal idea of the artist's autonomy and his unlimited freedom.

What is known about Klimt as a person is almost entirely – at best – second-hand, and it is often difficult to discern any core of truth beneath all the obscure, cryptic innuendo, the admiring words of idolization and the obvious flattery . Even the few details that are known about his outer appearance and his everyday habits hardly add up to any clear-cut picture. "He is thickset, almost fat, an athlete, he would have liked to wrestle Hodler, his manners are cheerful, down-to-earth and unceremonious. His skin is tanned, like a sailor's, he has protruding cheekbones and small, agile eyes. Perhaps in order to make his face appear longer, he wears his hair a little too high above his temples. This is the only thing which remotely indicates that he is an individual with an interest in art. When he talks, he booms out in a loud voice and with a heavy accent. He enjoys teasing people quite a bit." [90]

In a number of biographical accounts he is described as "taciturn". "His busy existence was concealed under the shell of a philistine life. Klimt's daily routines were very bourgeois. He was so engrossed in them that any divergence from his normal course was a horror to him; going anywhere was a major event, and a big trip was only conceivable if his friends did all the shopping for him beforehand, down to the smallest detail. He even preferred to leave his business matters to other people ... The same clumsiness, which often bordered on helplessness, was reflected in his mannerisms. In a small circle he would often thaw and be childishly cheerful, though normally he remained completely silent and hardly seemed to be following the conversation around him. Occasionally he would throw in a coarse word that cut right through all the blandishments and rhetoric and hit the nail squarely on the head. This crude exterior which he presented to others was part of his disguise." [91]

Klimt's passport
Albertina, Vienna

Gustav Klimt
Albertina, Vienna

167

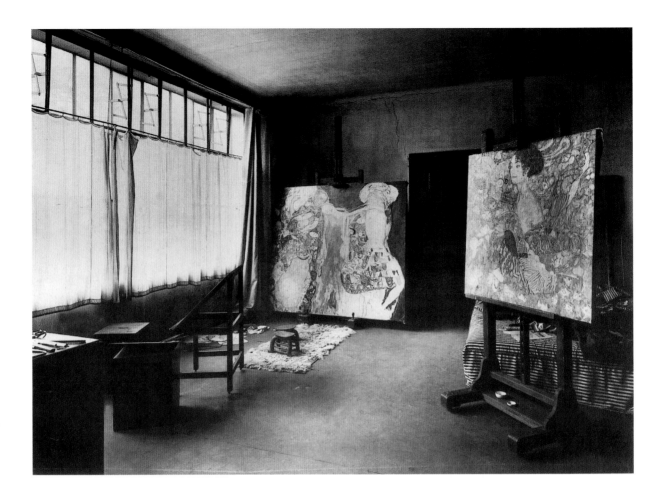

It is worth noting that Klimt showed no interest in his own person. We do not have a single self-portrait of Klimt, apart from a small caricature and some individual drawings and paintings, such as *The Kiss* (p. 117), which have occasionally been identified – and indeed very convincingly – as self-portraits. Klimt stated quite explicitly that he was not interested in himself: "There is no self-portrait of me. I'm not interested in my own person as the object of a picture. I prefer other people, especially women, and, even more, other forms of existence ... I'm sure I'm not particularly interesting as a person." [92]

The social obligations which were connected with the exhibitions as well as his business commitments, which he obviously found rather a nuisance, were kept totally separate from his family life. The same applied to his cultural activities and his travels, on which he was plagued by homesickness and almost hypochondriac worries about his health. But above all he drew a strict dividing line between his work at the studio and his private life. "... Gustav's real home was not his famous last studio in the little village-like side street in Hietzing," his sister was to write later. "Like all artists, he also needed a lot of love and above all consideration. After all, he was not naturally gregarious but a loner, and it therefore had to be the duty of his brothers and sisters to eliminate all the little things in his daily life that were

The artist's studio with the paintings he was working on at the time of his death
Photographic Archives of the Austrian National Library

Klimt in the garden of his studio
Albertina, Vienna

inconvenient. Every night he used to join us, eat his meal with hardly a word and then go to bed early. We understood his silent coming and going, we knew how much he needed some peace and quiet after his fights with the world around him. Once he had gathered strength, he would plunge into his work with such vehemence that we often thought the flames of his genius might consume him alive ..." [93]

After Klimt's death there was at first a certain respectful restraint before his personality was ruthlessly dissected and analysed. "Thoroughly human in the fullest sense of the word," wrote Hans Tietze, "he has passed away - a simple and very ordinary person to outsiders, full of riddles to those who knew him, like a well that became deeper, darker and more mysterious the more one looked at it. Superficially, Klimt's life and character appeared to be rather philistine; jealously guarding his inner soul whose blood had nourished the alluring and horrifying magic of his art, he took his deepest secret with him to the grave. Circumstances placed Klimt in the noisy marketplace of Vienna's art scene, but deep down he was a shy person who hated public appearances more than anything else. He carefully avoided making any statements about himself or his spiritual world, and the hand which hovered over the paper like a feather became like lead when he had to write a letter. Even friends were hardly ever

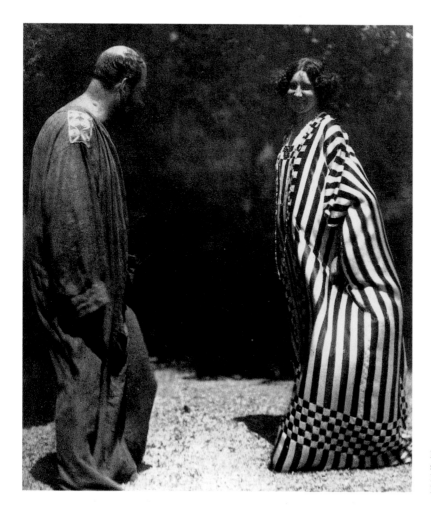

Klimt and Emilie Flöge, both in painter's smocks
Photographic Archives of the Austrian National Library, Vienna

allowed a glimpse behind the wall that Klimt had erected around himself, and so their accounts and tales provide only an incomplete picture of the man." Tietze also points out that his mother and one of his sisters had been mentally ill, which was a considerable burden for him: "Thus, his soul had been injured from early childhood onwards and his vital energy had been paralysed ..." [94]

However, the most frequently discussed chapter in Klimt's biography is his relationship with Emilie Flöge, who has only recently been the subject of an exhibition and a book. Considering that Klimt's taste in women has been described as "Turkish" in various anecdotes, the world's interest in examining Klimt's relationship with his chosen partner comes as no surprise.

In 1891 Gustav Klimt's brother, Ernst Klimt, had married Helene Flöge. The marriage only lasted fifteen months, but must have had a considerable effect on Klimt's life and career. Through Helene he met her sister Emilie, who had been running a fashion salon together with Helene since 1904. Later, just as his large-scale commissions for the Ringstrasse buildings were about to dry up, this gave him access to Viennese society. His friend, the painter Carl Moll, introduced him to

Gustav Mahler's circle. However, this indirect patronage by Emilie, her involvement in his art and her emancipated professional position could not prevent the relationship developing along stereotyped lines. Emilie became the artist's "muse", subordinate and totally subservient to the artist's genius. Commenting on the fact that Gustav and Emilie never married, Christian Nebehay, for example, wrote: "This woman, who had put her life at the service of a great man and who never impeded his artistic career, deserves all the more respect when we consider the amount of prejudice towards any loose liaison that was present in society. In extreme cases it could lead to complete ostracism, and so her social position was not easy." [95]

Details of Klimt's relationship with Emilie Flöge are almost exclusively known to us through his correspondence, which has been preserved only partially. His reticence in writing letters may well give us the most interesting clue to Klimt's character. The extent of his correspondence, and indeed in this case his mania to write several – up to eight – postcards or notes a day, shows the importance of this lifelong relationship, which ended with Klimt's words on his deathbed: "I want Emilie to come." Most of what he wrote was absurdly short and took the form of telegram-style memos, without a single hint of emotions or allusions to their relationship, showing his fear of emotional closeness. Quite often, in fact, there was not even a 'Dear Emilie', and the closing sentences were no more than stereotype formulas. It may well have suited Klimt that Emilie was economically independent and that he had no financial obligations or commitments towards her, though his reserve certainly fostered speculations about him as a "womanizer". However, when we examine the credibility of such stories, the only fact which remains is that Klimt had three illegitimate children, one by Maria Ucicky and two by Marie Zimmermann. This increased his renown and diminished Emilie Flöge's role in the eyes of his biographers.

While showing great understanding for the artist, authors have been apt to saddle Emilie with the social consequences of this open relationship. According to Klimt's biographers, his licentiousness had become part of his fame, while Emilie was admired for her – supposed – generosity. After all, " ... a real artist only lives for his work ... Klimt was someone who took a long time ... Therefore he needed these sudden flashes of enthusiasm as distractions. We know that he would often interrupt the painting of a portrait to go next door and draw one of the models who were always waiting there, simply in order to loosen up his hand, which had become tired from painting. So in order to be creative, he had to guard his personal freedom." [96]

This confidence in Emilie's "unshakable friendship and infinite warmth" had to be extended to Marie Zimmermann when it was discovered that Klimt had had two children by her: "We can see Klimt as a caring, faithfully supportive lover ... If, until now, we have admired Emilie Flöge's attitude towards Klimt's fleeting fancies, we now have every reason to extend the same admiration to Marie Zimmermann. For her love was great enough to accept that, although she had born him children, she had to bow to another woman." [97]

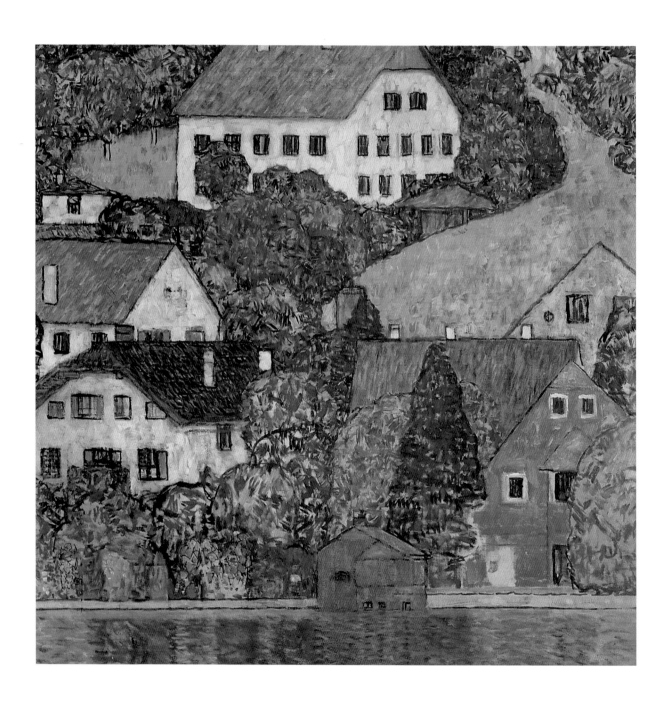

Landscapes

A large proportion of Klimt's works are landscapes. Nearly a quarter of his paintings – though virtually none of his drawings – are devoted to this subject. This lack of landscape drawings was partly due to his method of working. He worked outside and used sketch books which, except for a few, have been lost. Sometimes he did not complete his landscapes until he was back in his studio in Vienna, and occasionally he may have used photographs as an aid. It is worth noting that in the rest of his work – his allegorical pictures – landscapes are almost totally missing, while conversely his landscapes contain virtually no narrative elements and only very few people. They are mood landscapes and paintings of "views" (Fritz Novotny). Most of them are square, which makes them appear motionless and tranquil. In nearly all of Klimt's landscapes, this tranquility is totally undisturbed by any activity or kinetic energy. Even the diffuse, "Impressionist" direction of the light (for instance in his lake views) serves to emphasize the general sense of calm. The lack of kinetic energy and motion adds an element of timelessness to nearly all his landscapes.

It has often been stressed that Klimt's landscapes have an allegorical content which is similar to that of his other allegorical themes. "Refinement is a ... distinctive feature in his landscapes. Klimt was not a painter of unbroken originality. He painted neither man's sensuality nor the openness of nature. His early works were sombre mood landscapes. Tall, slender trees stood as metaphors of a man's noble solitude, dark marshes and ponds a parable of all things transient, but also of the seductive charm that emanates from the unfathomable. Such scenery of melancholy and withdrawal from the world vouchsafed a state of festive solitude. After the turn of the century this solemn detachment gradually diminished ... The blossoming beauty of gardens, flowers and fruit came to be draped in a "festive mosaic garment", which – contrary to nature's laws – lent it an air of immortality and permanence. The dense web of brush-strokes merges the spatial zones into a suspended curtain of colour, impenetrable ... and holding our glances captive like the veiled picture of Sais. Distance becomes akin to closeness, yet this closeness allows no access and remains aloof." [98]

However, there were other, entirely trivial and circumstantial reasons for Klimt's interest in landscapes, such as the long summer sojourns he spent on Lake Atter with the Flöge family from 1900

Forester's Lodge in Weissenbach at Lake Atter, 1912
Oil on canvas, 110 x 110 cm
Private collection

Houses in Unterach on Lake Atter, around 1916
Oil on canvas, 110 x 110 cm
Austrian Gallery, Vienna

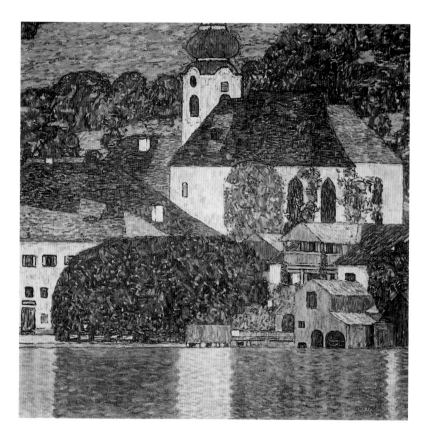

Church at Unterach on Lake Atter, 1916
Oil on canvas, 110 x 110 cm
Private collection, Graz

onwards. Describing his daily routine in a letter to Marie Zimmermann in 1903, he also communicated something of the "philistinism" often ascribed to his person: "You want to know what sort of schedule I follow – my daily routine. Well, it's very simple and indeed quite regular. I get up very early in the morning, usually at 6, though sometimes a little earlier or later. If the weather's nice and the sun's shining I go to some nearby woods where I paint a little beech grove with a few fir trees in it. I carry on until 8 o'clock, have breakfast and then go for a swim in the lake where I'm always very careful. Then I do some more painting. If the sun's shining, I paint the lake, and when it's cloudy a view from my window. Sometimes, instead of these painting sessions in the morning, I study my Japanese books – in the open air. Then it's lunch time. After the meal I have a nap or do some reading until supper. Before or after supper I go for another swim, not every day but usually. After supper I start painting again - a large poplar tree at dusk, with an approaching thunderstorm. Occasionally, instead of painting, I go bowling with a few friends in the neighbouring village, though this is rare. Then it gets dark, I have a little snack and go to bed early so that I can get up in good time the following morning. Sometimes this schedule is interrupted by a bit of rowing to loosen the muscles ... The weather here is very changeable – not at all hot, with frequent showers of rain. As for my work, I'm equipped for all eventualities, which is very good to know." [99]

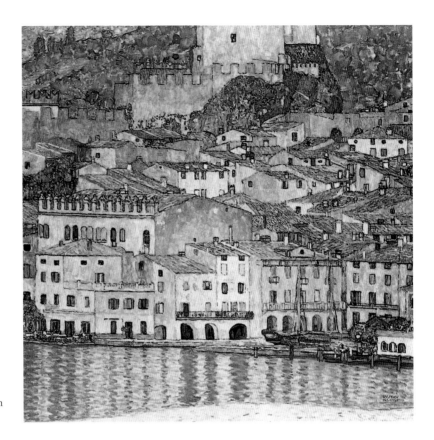

Malcesine on Lake Garda, 1913
Oil on canvas, 110 x 110 cm
Destroyed by fire at Immendorf Palace in
1945

Aside from Klimt's interest in symbolism and his personal worka-
day motivations, Johannes Dobai quotes yet another reason for the
artist's discovery of landscapes - particularly "mood landscapes" –
around the year 1900: the controversy surrounding art policy at the
birth of the Secession and the row over Klimt's *Faculty Paintings*.
Landscapes reflected, as it were, a measure of non-political privacy
and introspection. [100] "They have in common the expression of medita-
tive contemplation ... of the phenomenon of life outside the realm of
human existence, unfolding, as time goes on, with cool, quiet pa-
tience." [101] Such pictures enable us to lose ourselves completely in
contemplating a depiction of nature full of atmosphere. There are
almost no dramatic or dynamic elements. The partiality of the view,
the direction of the light, the spatial arrangement and even the square
format typical of Klimt's landscapes captivate the viewer by conjuring
up a delicate atmosphere. Klimt's favourite compositional techniques
for creating a specific atmosphere include the sporadic use of frag-
ments, such as parts of a tree, as well as extremely high horizons. In
some paintings of Lake Atter, these turn the surface of the water with
its reflections and refractions of light and colours into the sole subject
of the painting. Naturalism was nearly always undesirable, as was
topographical accuracy – even though such accuracy did indeed occur
in some paintings (e.g. of Lake Atter).

Two concepts link Klimt's landscapes with his "humanity paint-

ings" – that of organic life outside and independent of man-made history and the idea of natural history as a cyclical process of never-ending growth. A symbolist interpretation of his landscapes suggests itself particularly when we consider his water paintings: his "still ponds", Lake Atter and his marsh paintings follow a common Art Nouveau attitude – the idea of water as the mother of all (organic) life, an interpretation which is supported formally by the depiction of boundless expanses of water, i.e. water surfaces that encompass almost the entire painting. [102] Some of Klimt's drawings, such as *Fish Blood, Water Serpents, Water in Motion, Gold Fish* and *Mermaids* (pp. 63, 137, 67, 136, 58) are about water in this symbolist sense, establishing a direct link between woman and water. They speak of the same regressive fantasies that were expressed in "humanity paintings" such as *Death and Life, The Three Ages of Woman* (pp. 123 and 122) and *Hope* (p. 134).

However, the fact that Klimt's landscapes formed their own independent biological cosmos (almost entirely lacking sky, clouds or stars) without reference to man, also has a socio-historical significance. Confronted with the increasing exploitation of nature and the feeling that it is under mounting threat, we tend to feel a growing yearning for a "pure", unadulterated nature, forever renewing itself, as it were, from its own resources. Not only do Klimt's landscapes lack any depiction of human labour or activity, but man's work has not

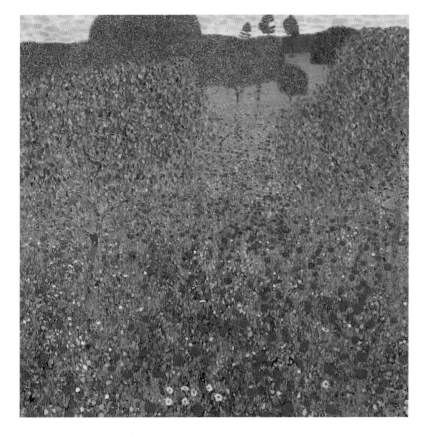

Poppy Field, 1907
Mohnwiese
Oil on canvas, 110 x 110
Austrian Gallery, Vienna

even left any traces *within* nature. His peasant gardens, his avenues and even his views of buildings appear as compacted multi-coloured ornaments of an untouched, organic nature. The growth which Klimt depicts in an increasing number of new variations is the growth of *plants*. Animals are extremely rare, and people only occur in a small number of paintings such as *The Grounds of Schönbrunn Palace and Malcesine on Lake Garda* (p. 175), where they are purely incidental.

The slow and invisible growth of plants emphasizes a time dimension that is both independent of human history and points beyond it. It is a static nature – matched by the static square format of the landscapes – and it is only very rarely disrupted by the rapid and dramatic changes brought about by changing light or by the weather. Even then, however, Klimt only depicted the state before (*The Big Poplar Tree*, *Approaching Thunderstorm*) or after the event (*After the Rain*, p. 93), but never the dynamic change itself.

This self-sufficient biological passivity of a nature independent of man called for an approach in which the artist remained strictly detached, uninvolved. In 1899 the art historian Alois Riegl published an essay entitled "Die Stimmung als Inhalt der modernen Kunst" (Atmosphere as the Contents of Modern Art), and in his introduction [103] – surprisingly personal and confessional for an academic paper – he characterized the understanding of nature at the turn of the century.

For the quiet contemplation of nature, he says, it is necessary to

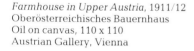

Farmhouse in Upper Austria, 1911/12
Oberösterreichisches Bauernhaus
Oil on canvas, 110 x 110
Austrian Gallery, Vienna

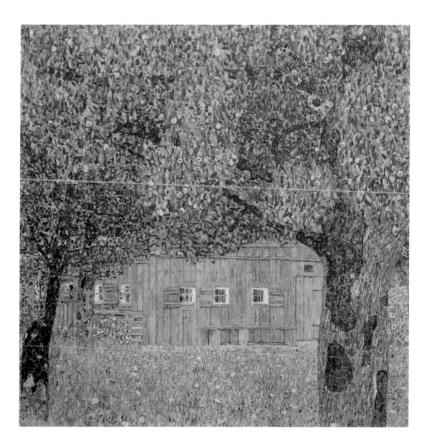

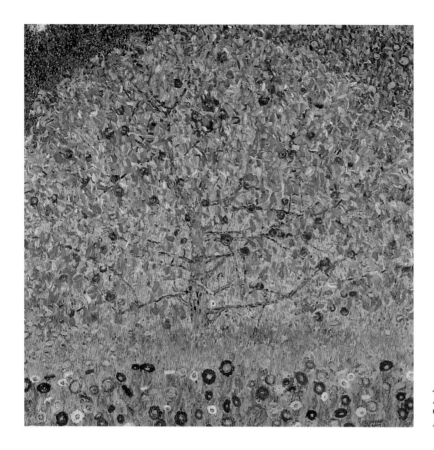

have inner peace and a "broad perspective", so that the viewer (who derives aesthetic enjoyment from nature in the same way as from a painting) is relieved of "the anxious pressure which never leaves him in his normal life". Instead, he is given "atmosphere", a feeling of "harmony above the dissonant noise and of calm above the movement." [104]

These observations sound like direct descriptions of Klimt's landscapes – though with one exception: Klimt almost never took a "broad perspective", presenting an overall view which might allow us to look at nature or a certain scene from a distance. Rather, they are characterized by a "close perspective", which – according to Riegl – destroys distance. Klimt's landscapes are close-ups and, as Dobai puts it, often turn nature into an "interior". [105] Rather than casting a section of nature as a landscape in the usual sense of the word, the artist's view points to the potential infinity of the whole of nature – both with regard to space (sectional character of the paintings) and time (restful passivity, slowness of biological growth).

Indeed, apart from some of his earlier works, Klimt even goes as far as omitting any hint of a horizon, that is, any spatial depth stretching far into the background. In this sense, it may therefore be a little misleading to compare his landscapes with interiors. Often they become two-dimensional decorative patterns, which explains why the

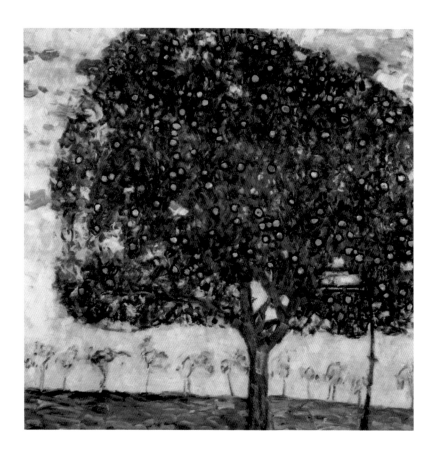

Apple Tree II, around 1916
Apfelbaum II
Oil on canvas, 80 x 80 cm
Austrian Gallery, Vienna

viewer remains "outside", faced with an impenetrable, ornamental "mosaic". This mosaic sometimes even has a material density as in the ornaments in the ladies' portraits of the Golden Phase or even the abstract ornaments on the side wall of the *Stoclet Frieze* (cf. p. 151), (*Garden Landscape with Mountain Peak* , *Apple Tree I*, around 1912, p. 178; *Poppy Field*, 1907, p. 176; *Roses under the Trees* , 1905). This "close perspective" is even effective where Klimt – without using a central perspective – layered his paintings for depth. The layers appear as thick two-dimensional areas.

Klimt's seeming paradox of a close perspective and a lack of accessibility presupposed a very special technique of perceiving landscapes on the part of the artist. Not only did Klimt use a square template to find suitable sections, he apparently also used optical gadgets such as a telescope and opera glasses in order to produce a close perspective from the distance. On a postcard from a summer holiday sent to his sister Hermine in 1915, he complained about his forgetfulness: "Have arrived safe and well. Forgot opera glasses – need them urgently." [106]

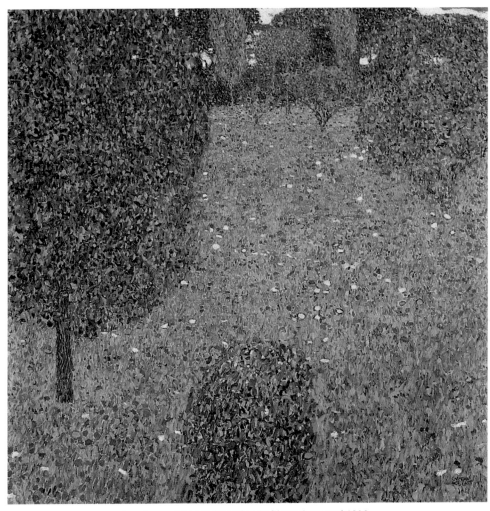

Landscape Garden (Meadow in Flower), around 1906
Gartenlandschaft (Blühende Wiese)
Oil on canvas, 110 x 110 cm
Private collection, New York

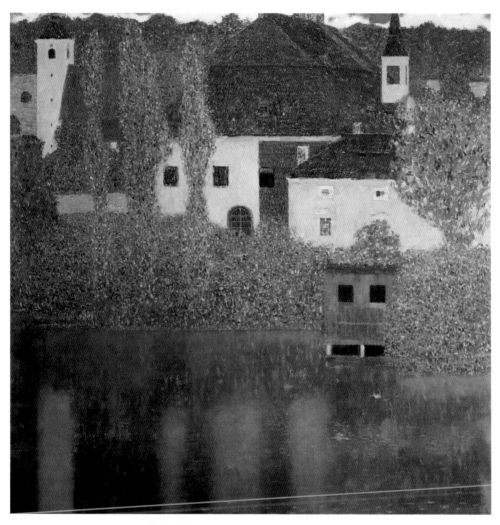

Schloß Kammer at Lake Atter I, around 1908
Schloss Kammer am Attersee I
Oil on canvas, 110 x 110 cm
Národní Gallery, Prague

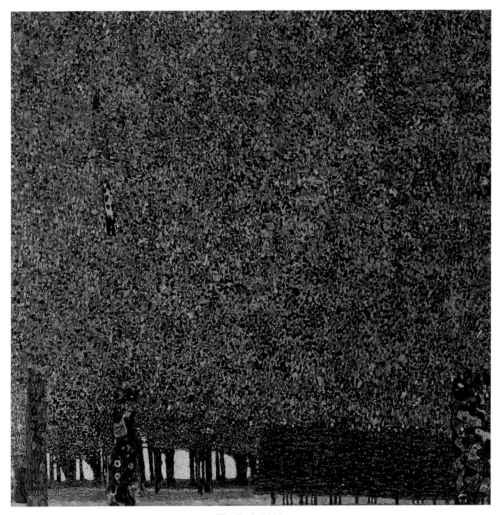

The Park, 1910
Der Park
Oil on canvas, 110 x 110 cm
Gertrude A. Mellon Fund, Collection, The Museum of Modern Art,
New York

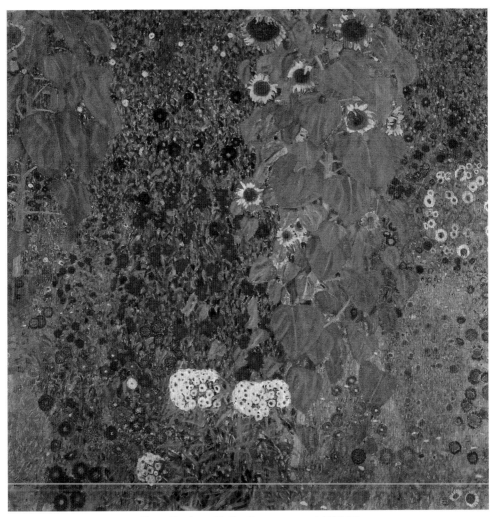

Farm Garden with Sunflowers, around 1905/06
Bauerngarten mit Sonnenblumen
Oil on canvas, 110 x 110 cm
Austrian Gallery, Vienna

Avenue in Schloss Kammer Park, 1912
Allee im Park von Schloß Kammer
Oil on canvas, 110 x 110 cm
Austrian Gallery, Vienna

Unterach on Lake Atter, 1915
Unterach am Attersee
Oil on canvas, 110 x 110 cm
Rupertinum, Salzburg State Collections, Salzburg

Farm Garden with Crucifix, 1911/12
Bauerngarten mit Kruzifix, 1911/12
Oil on canvas, 110 x 110 cm
Destroyed by fire at Immendorf Palace in 1945

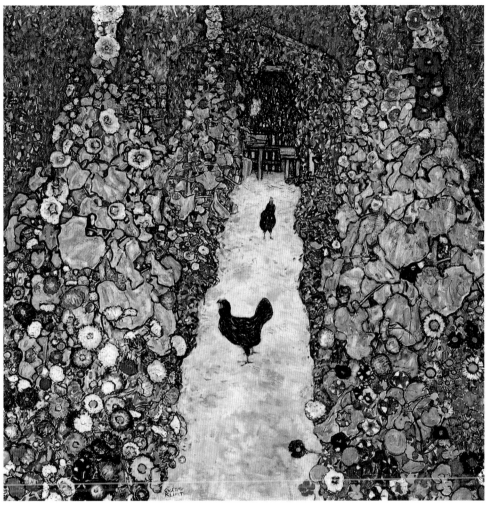

Garden Path with Chickens, 1916
Gartenweg mit Hühnern
Oil on canvas, 110 x 110 cm
Destroyed by fire at Immendorf Palace in 1945

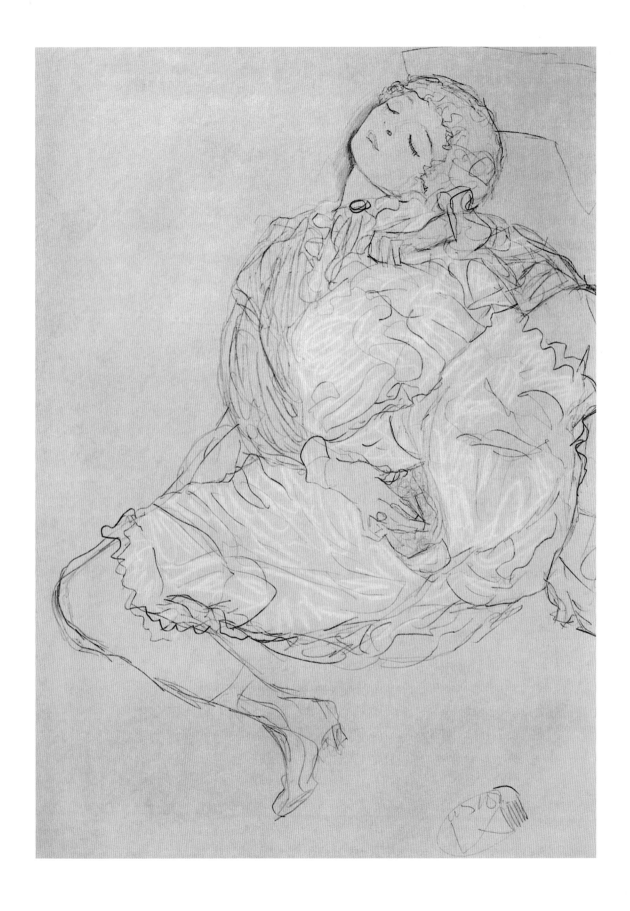

"Solitary Dialogues":
Klimt's Erotic Drawings

Even during his lifetime Klimt's drawings were regarded by many critics as the best things in his entire oeuvre – a view which is still shared by several art historians today. We must bear in mind, however, that these works were the least likely to be widely known to Klimt's contemporaries. Although a few drawings were occasionally shown at exhibitions and some were published in *Ver Sacrum* or in very limited private editions of erotic prints, many drawings only ever served as sketches for other works and were therefore never presented to the public. Not until Klimt's death did it become possible to gain an initial overview of his drawings. As early as 1918, the year Klimt died, the art dealer Gustav Nebehay organized an exhibition of the artist's legacy. Since then – and particularly since the 1960s – there have been many publications and exhibitions of Klimt's drawings, though it was not until 1984 that a comprehensive oeuvre catalogue in three volumes was published by Alice Strobl, containing just over 3,000 drawings which are still accessible today. It is estimated that originally the drawings ran to about 5,000 – 6,000 sheets. Not only did the artistic quality of these drawings serve to increase Klimt's fame, but their erotic aspect, in particular, has always held a certain fascination. Klimt's reputation as an "erotic master" was based particularly on his drawings. They are regarded as an important indication of his protest against the moral ideas of his time and the emancipatory function of his art.

However, considering that only very few drawings were published during Klimt's lifetime, it seems rather devious to claim that they had a subversive function and to ascribe some kind of *practical* significance to them. There are at least two reasons why we cannot regard this as social art, i.e. an art which deliberately and purposefully aims to bring about social change: firstly, Klimt never pursued any socio-political objectives with his art, and secondly, most of his drawings were only meant as studies in preparation for other works or as private sketches without any public significance whatever.

Those who see this part of Klimt's sketch work as a manifesto against certain aspects of the suppression of women (a point which will be discussed later) are taking a very general and dubious view of the scope of art. Not only are they grossly overestimating the effectiveness of aesthetic objections to unfavourable social conditions, but they are ignoring the socio-political conditions under which Klimt's art was created and discussed. Then as now, his work has always been far

Girl-Friends from the Front and Back,
around 1905
Black chalk, 45 x 31 cm
Historical Museum, Vienna

Seated Woman, with Open Legs, 1916/17
Pencil, red crayon, highlighted in white,
57 x 38 cm
Oil on canvas, Austria

more admired than critically analysed. And although it is true that Klimt was continually at loggerheads with a number of groups, this is by no means an indication of any social or cultural commitment on Klimt's part. He did indeed create the occasional scandal because of his "obscenity" – for example with his exhibition of sketches for the *Faculty Paintings* – but the greatest resistance to his works (especially the *Faculty Paintings*) was due to his world view rather than his liberal attitude towards the erotic.

Contemporary attitudes towards the erotic element in Klimt's work can be gleaned from the only known legal action that was taken against his drawings. When Klimt published a number of studies for *Medicine* (p. 83) in *Ver Sacrum*, he was nearly prosecuted for offending against "public decency". However, the regional court disagreed and protected the artist, pointing out that these were sketches "for a publicly exhibited work of art in a journal which is ... mainly aimed at artists." Putting forward legal arguments, the court underpinned the cultural and political principles of promoting modern and Secessionist art. The freedom of the arts, it said, must not be subject to any limitation, and the only permissible form of state intervention should be that of protecting this freedom: "It should hardly need mentioning that no narrow boundaries must be drawn with regard to the objects of an artist's imagination or the execution of an artistic idea. Nor must there be a prohibition on the natural depiction of nudity, which has always been part of any art. And whenever we are dealing with a serious work of art, purely governed by aesthetic considerations, it would be inappropriate to speak of an offence against people's sense of morality or modesty." [107]

What did Klimt draw? Roughly speaking, Klimt used drawings in two contexts: either as preliminary studies for paintings and monumental paintings or as autonomous media of his private obsession to create for himself images of erotic women. Landscape, architecture, interior, genre, etc. – none of these categories were relevant to his drawings. There are some pictures of couples, e.g. in preparation of *The Kiss* (p. 117), as well as some drawings that can be called "family pictures", but drawings of children and indeed of single men occur so seldom that they are interesting simply because they are rare. Male nudes only ever played a (minor) part while he was a student at the School of Applied Art and in his early works. In his studies, preliminary sketches and autonomous drawings he concentrated almost entirely on women, producing portraits, nude drawings and – one of the largest areas within his oeuvre – erotic depictions of his models.

These erotic drawings did not begin to receive publicity until the advent of modern reproductive techniques, the popularization of exhibitions and the publication of books primarily devoted to erotic drawings. It is an established fact that Klimt had never intended or regarded these drawings as anything other than private notes, and only when they were published, studied, catalogued and exhibited did they become objects of art history. Indeed, it was only when they received wide mass media coverage that they ceased to be objects of private obsession and came under the scrutiny of art lover rather than

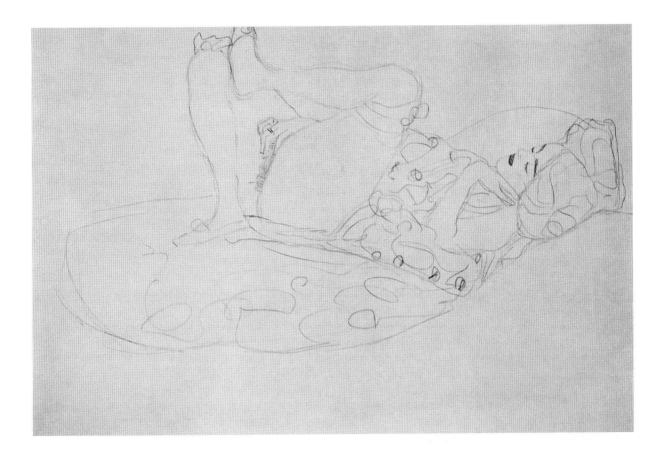

Recumbent Semi-Nude from the Right,
1914/15
Blue crayon, 37 x 56 cm
Historical Museum, Vienna

artist. Indeed, this is the only point at which we can begin to ask all those questions which concern the complex relationship between the viewer, the work and the depicted person, questions which also include the issue of voyeurism.

Many of these erotic drawings are quite bluntly aimed at a male viewer. Klimt often arranged models in postures where they were exposing or offering themselves. For some nudes he chose an extremely close-up view together with an equally extreme perspective so that certain parts of the body were particularly stressed or the women appeared fragmented – an artistic device to emphasize and enhance the erotic and sexual element of the moment captured in the drawing. The psycho-physical states that interested Klimt included sleep, feelings of passivity, dreaminess and the entire gamut of sexual sensations in endless variations. It is therefore hardly justified to describe him as a great "psychologist of womanhood": the range of emotions which Klimt allowed his models was rather limited. "Womanhood", for Klimt, consisted in an unlimited capacity for erotic and sexual enjoyment – no more. Although he had elevated sexuality to the level of art in a way nobody had ever attempted before, he also tried to reduce the female to this element.

"It is certainly true," writes Mattenklott, "that to express his lechery and lust, Klimt knew no medium but the sexuality of women, and indeed in such a radical sense that he would probably have

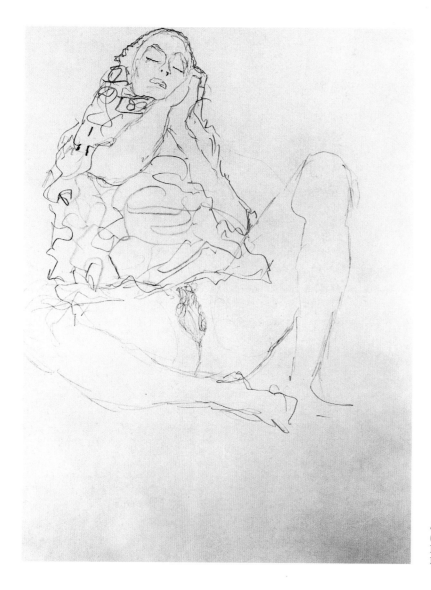

Seated Semi-Nude with Closed Eyes
(detail), 1913
Pencil, 57 x 37 cm
Historical Museum, Vienna

wanted to discard men as the object of female sexual desire
altogether. On the other hand, it was with unconcealed pleasure that
he depicted the tender caresses of lesbian girls. For Klimt, the bodies
of the embracing girls may have combined to form that world which
womanhood represented for him – an erotic world that was not
impeded by forbidden pleasures or perversions. Indeed, the girl-
friends in his drawings or the entranced female masturbator do not
seem to be interested in causing a scandal. They are images of a totally
self-centred, drowsily solipsistic world, in which the man as an outside
spectator and voyeur holds his breath in lewd suspense. However, he
is always outside, tense with fascination." [108]

The solipsistic element of this erotic world can be seen in terms of
content and form. The drawings contain virtually no indication of an
overall spatial context or higher meaning. They no longer have a
literary or mythological significance, which the depiction of the erotic

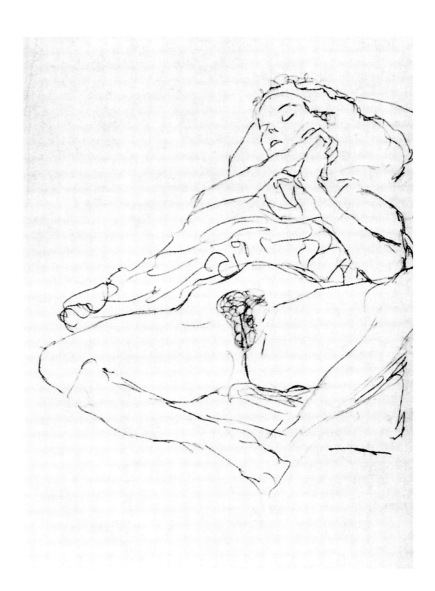

Reclining Semi-Nude Leaning Back
(detail), 1913
Pencil, 56 x 37 cm
Historical Museum, Vienna

needed in 19th-century art in order to be justified, and which is also present in Klimt's allegorical Symbolist paintings (e.g. *Danae*, p. 209). The omission of any narrative or historical elements also means that the drawings have no temporal dimension.

It has often been described how Klimt frequently isolated his models by drawing only their outlines and then enhancing this isolation by omitting any internal modelling of their bodies. The Art Nouveau "harmony" of contours – often totally unnatural – sometimes turns the depicted women into patterns or ornaments reminiscent of textiles or applied art. The passivity of the woman is a further means of creating distance, though we should perhaps put this more tentatively and speak of a means of controlling the relationship between the drawing and the viewer. The women are often shown with their eyes closed or averted. By contrast, in a painting like *Hope I* (p. 134) the effect depends partly on the woman's calm gaze directed straight at the

any fragmentation of this kind attacks a woman's integrity and is therefore an indication of the dominating "male point of view"; others, however, warn that it is wrong to cling to the "phantasm of the whole body", as it has no psychological or social equivalent and a body can never be experienced in all its original completeness.

Klimt restricts our view of the female body to certain sexual aspects. He draws attention to them by various formal techniques (perspective, foreshortening, distortion, shifts in proportion) and by sophisticated use of concealment and revelation. In his book *Geschichte der erotischen Kunst* (History of Erotic Art), Eduard Fuchs has been one of the few authors who emphasize this fact: "When Gustav Klimt paints a female nude, he always stresses her genital area. He often does so very discreetly and delicately, but so unambiguously that our glance is necessarily directed towards it. And wherever the observer's eye comes to rest, it encounters an area of the picture to which the artist has paid special attention." [110] The sexual impact of a woman's body is often caused by clothing her in such a way that she seems unclothed: "The women's clothes, pulled up, folded over and cast aside change his nudes into naked bodies; studies of unclothed bodies become erotic pictures of sexual desire or satisfaction. The nakedness of the body is underlined by textile ornament, nudity is peeled out of fabric. Instead of concealing, the material provides a frame or presentational setting for an object of desire: the breasts of two girlfriends, the arched buttocks of a girl, or the open legs of a woman; he doesn't clothe – he reveals." [111]

The extent to which the fragmentation of the body can mean the fragmentation of the person is evidenced by Klimt's treatment of his models (cf. for example the comment on *Hope I*, pp. 127ff.). With his "synthesizing" eye he was able to create new, idealized shapes based on a variety of models – selected from the academy "model market" for their physical attributes – their movements, postures and "body

Two Girl-Friends Lying on their Stomachs, 1906
Red crayon, 37 x 54 cm
Albertina, Vienna

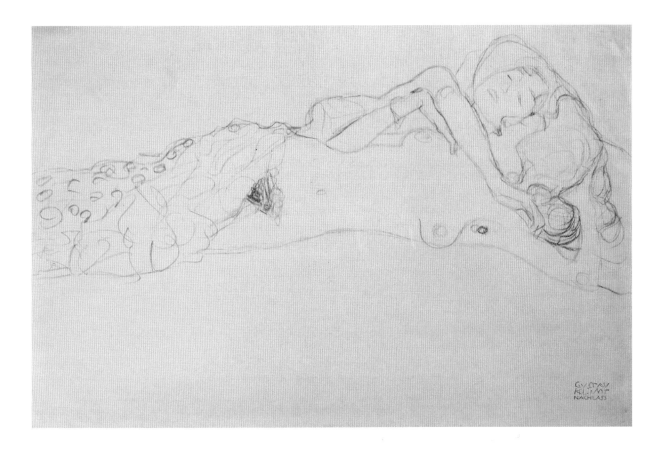

Two Nudes Lying on their Backs,
(1905/1906)
Red crayon, 37 x 56 cm
New Gallery at the Joanneum State
Museum, Graz

fragments". For Klimt, models were not real people but merely physical shapes that could be utilized artistically. His words that a model's "posterior is often more beautiful and intelligent than her face" gives some idea of the extent to which he applied the "artistic principle" to real people. [112]

Although Werner Hofmann speaks about the "selfishness" of such a creative act, he only means it in a "purely artistic" sense. Nevertheless, he is the only art historian who has analysed in depth the relationship between the work, the (nude) model, the artist and the viewer. "With the female body, Klimt had control over the origin of all form, from which all his themes developed like the fruit from the seed ... In her ... passivity the woman is the graphic epitome of a mouldable substance at the mercy of the creative act." [113] The direction of this painterly act can also be turned around: the substance is not only the "material" from which the image of a human being is created, but this image can also be changed back, as it were, into the substance. This has already been discussed. In the *Stoclet Frieze*, the artist had reached an extreme point of this reversal: it is no longer possible to decide whether the picture on the side wall of the dining room (p. 151) is that of a person – and if so, what sex? – or an abstract mosaic pattern. This retrogressive change of human beings into substance, with the gradual dissolution of the depicted persons into the (ornamental) material of the picture can also be seen in Klimt's ladies' portraits.

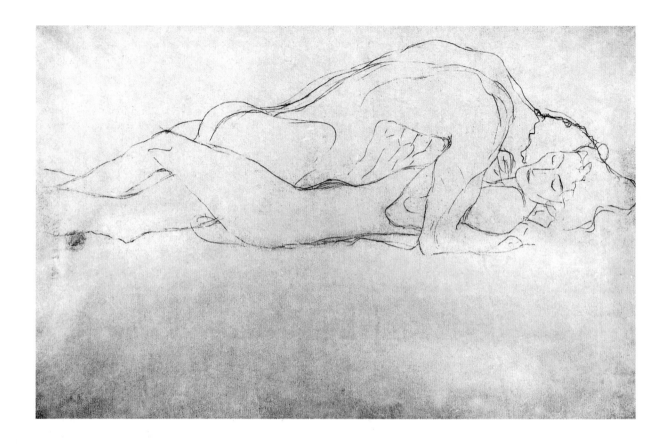

Recumbent Lovers, from the Right,
around 1908
Black chalk, 35 x 55 cm
Historical Museum, Vienna

Thus Hofmann gives a precise description of the male artist's control over the woman, though only in relation to the artist's act of creation which – as we should understand it – necessarily includes his control over the substance as the "origin of all form". Surprisingly, without even qualifying his approach, Hofmann makes no distinction between models and the material which the artist uses (canvas, paper etc.) but groups them together under the concept of "substance". By equating the artist's act of creation with that of sexual intercourse and its inherent "self-surrender", he then tries to turn the relationship between the artist and his model into its exact opposite and completely denies the element of control or dominion in it: "The ... man's dominance is of course limited and diverted into a give-and-take dialogue.

In Klimt's work, although the woman is not art she makes the artist. In the final analysis, it is Klimt who receives, and he repays his female creator by creating a world in the form of womanhood." [114] Thus the real relationship between the painter and his model has been deliberately turned upside down. Hofmann suppresses everything that can be said about the actual control of the painter over his model. It is totally obscure what the active and autonomous role of the model and indeed her "repayment" should be. Instead, he points out the significance and the identification of Klimt's "world" with his "image of Woman" which went so far in his drawings that all allegorical or

historicist extras, "disguises" and justifications were omitted to permit full concentration on the psychological and erotic.

The above-mentioned stylistic peculiarities of Klimt's drawings may now be more easily identifiable as formal expressions of Klimt's obsessive concern with "womanhood". The isolation of the girls through their outlines, the lack of spatial reference points, the idiosyncratic way in which bodies and gestures create their own space, the absorbed oblivion, drowsiness and passivity of the women – all these elements indicate the exclusiveness with which Klimt treated erotic and sexual feelings and on which he based his image of womanhood. The more he succeeded in purging it, as it were, from all qualifications, and the more he approached his ideal image of womanhood as the epitome of the erotic, the more the women he depicted became independent of any communication with the viewer. Thus, they keep their distance in a solitary dialogue. "Only as sexual beings do Klimt's women gain any territory, and it is only within this territory and with the corresponding intimacy that Klimt renders their gestures in his late works ... Like classical sculptures which look at us with blind eyes, Klimt's emotional gestures are introverted and nearly always restrained. The meaning of these gestures will remain their secret ... The eyes of these women are mostly cast down or closed. Their sexuality is meant to be looked at. Are they allowed to be aware of it at all? The sexuality of women has been discovered, but it seems as if they were only half conscious of it and as if the other half were their social bodies. The gestures of Klimt's women are reminiscent of somnambulists or dreamers, and this numbness cloaks their movements like a veil of inhibition." [115]

Even in the most trivial protestations that Klimt was interested in the emancipation of the instincts one can discern the truth that Klimt's search for a "female image of the world" enabled him to discover and sensitively depict experiences which, until then, had been taboo in art. One cannot deny, however, that this gamut of female erotic emotions had sprung from the obsessions of a male artist whose own male identity crisis made him look for a female identity.

"The World in Female Form"

One only has to browse through an oeuvre catalogue of Klimt's paintings and monumental works (about 220 are given in the catalogue by Novotny and Dobai) to realize that they fall into very neat categories and that the painter had certain focal points of interest, with a clear emphasis on women's portraits (though the individuals cannot always be identified), allegories, "humanity paintings" and landscapes. There are not many paintings outside these four subject areas, and one has to go back to his 1899 historical genre painting *Schubert at the Piano* (p. 47) to discover an exception. Obviously, one will find other subjects among his early works, when Klimt was still far more dependent on commissioned work – for example, men's portraits which later disappeared completely from his oeuvre (*Portrait of Count Traun, 1896; Hofburg Actor Josef Lewinsky as Carlos*, 1895, p. 50; and *Joseph Pembauer*, 1890, p. 51). If we add the drawings to this survey, then this definition of a small number of subjects becomes even more obvious. Klimt's pictures of women, which largely determined his reputation and his fame, are indeed in the majority.

Even Klimt's earliest works show his tendency to prefer women as identification tags in his art. In his paintings for the Court Museum of Art History (*Egyptian Art II, p. 30)* and compositions for his allegorical portfolio, which he started in 1895 (*Allegories*, New Series) he used traditional depictions of women in such a way – both stylistically and as regards content – that an erotically stimulating vividness was added to them. [116] He did so by painting them in an untraditional, Modernist manner. Step by step, Klimt abandoned the historical pattern which he had learnt during his academic training, that is, the distanced, statue-like depiction of the female body. At the same time, he was beginning to diversify or split the image of Woman into that of the erotic *femme fatale* and the *magna mater* (*Tragedy*; p. 45) on the one hand and the idealized society lady on the other.

In his allegories, "humanity paintings", portraits and drawings, the artist's message is generally conveyed by women. They are at the centre of those grand, monumental allegories, and they also dominate his later paintings, which are difficult to interpret and devoid of any action or allegory. They also prevail in his drawings, which are often regarded as the most important part of his oeuvre.

Klimt's "oedipal revolt" (as Schorske calls it) broke completely with the male-dominated paintings of the 19th century and of its historicism. However, his revolt was not just a philosophical and

Half-length Portrait of a Nude Girl, from the Front, around 1916
Pencil on slightly brown paper,
57 x 38 cm
Kunstmuseum, Berne

The Virgin (detail), 1913
Die Jungfrau
Oil on canvas, 190 x 200 cm
Národní Gallery, Prague

aesthetic protest, but partly – though not exclusively – that of a generation conflict in the midst of a particularly dramatic political and cultural crisis. Klimt's work relates to the radical changes which were affecting male and female images as well as the relationships between men and women in society.

Although Klimt almost exclusively used "womanhood" as a medium of identification, this does not mean – as is often claimed – that his works constituted an analytical and reflective penetration of a different psyche comparable to Freud's psychoanalysis – quite apart from the obvious fact that Klimt was far less interested in himself and the artistic analysis of his psyche than almost any other artist. It is at this point that the widespread comparison between Klimt's art and Freud's psychoanalysis breaks down. Freud's "revolt" consisted in the productive transformation of his own "social death", that is, he managed to re-shape a totally stagnant traditional career and indeed his failure to adapt to the conventional demands of society. Interacting with his therapeutic attempts, this transformation culminated in an unprecedented and radical self-analysis as the basis of his discoveries and his academic and analytical work. However, no matter how hard we try, it seems impossible to detect any comparable efforts of self-examination or self-reflection in Klimt's work.

Woman with Raised Lower Arms, Standing, from Right to Left, around 1908
Pencil, 56 x 37 cm
Historical Museum, Vienna

One possible explanation of this remarkable circumstance could be that Klimt never took an interest in his own masculinity (cf. his words "I'm not particularly interesting"), though he was certainly interested – and indeed exclusively – in a man's (and his own) female masculinity. His search for an identity in the midst of cultural and personal crises did not lead to any self-examination or an examination of bisexuality (which had been discovered by Freud) but to the attempt to find his identity in the image of a woman. [117] Klimt was by no means alone in this. Under headings such as "feminization" and "self-feminization", the "re-assessment of femininity" has been described as the "revaluation of male femininity". These changes and new values in the relationship between man and woman were a cultural phenomenon of the 19th century and therefore reflected in all the arts.[118] "Self-feminization" of a man "did not mean that a man turned towards women but that he claimed womanhood for himself" (Silvia Eiblmayr). The male image tended to disappear from art, which was then monopolized by the female image – though at the expense of turning women into demons, mythological figures and fetishes. Woman's image changed into that of *Judith I* (p. 142), witches, legendary figures (*Water Serpents*, pp. 9 and 137) and monsters (*Beethoven Frieze*, pp. 104f.), or – with the discovery of nudity for advertising in Art Nouveau - into the aesthetic allurement of commercial products.

These pictures do not document man's surrender to the power of Eros or indeed his attempt to come to terms with an alien feminity. Rather, they are projections of "male femininity" (Eiblmayr). Not only in Klimt's art did such projections lead at times to the mutual convergence of the two images of male femininity and the feminization of man. Art Nouveau, in particular, knew a large number of ways in which the difference between the sexes was neutralized, e.g. through

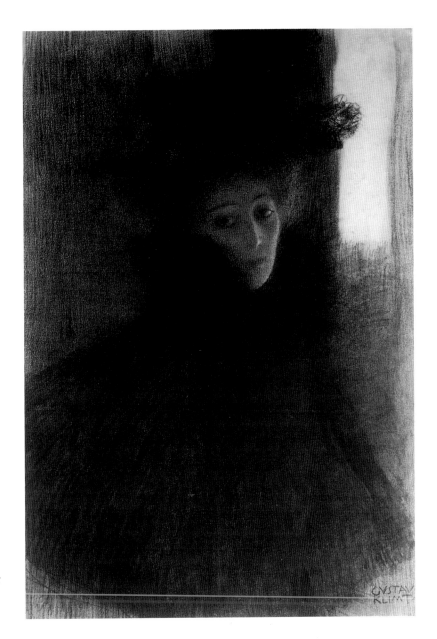

*Lady with Cape and Hat, Three-Quarter
View from the Right*, 1897/98
Black and red chalk, 45 x 32 cm
Albertina, Vienna

the androgynous image of mankind or the masculinization of Woman.
Otto Weininger, the anti-feminist theoretician of femininity at the turn
of the century, spoke of a "neutralization of the sexes" which, he said,
was typical of the times and in fact a characteristic feature of the
Secession and its image of mankind. Quoting Klimt's words that "at
certain times more masculine women are born", he commented con-
temptuously that "this probably explains the entire 'Secessionist' taste
which gives the beauty prize to tall, slender women with flat chests
and narrow hips. The immense proliferation of dandyism and
homosexuality in the last few years can only have been caused by an
increase in femininity in our times." [119] The converse of this masculini-
zation of women – the feminization of men – was a threat to the artist

because it made him aware of his own feminine aspects. These were then cut off and depicted as hostile forces.

Many of Klimt's contemporaries expressed a good deal of understanding for his (self-)feminization. They pointed out not only the extent to which Klimt dealt with the image of Woman in his art, but also the central role which this search played in his life as an artist and a person. Their comments showed that they were interested in Klimt's identity and that his image of Woman should be understood not as an artistic manifestation of an experienced reality but as a "creation" that went beyond the realm of art and aimed at stabilizing the male ego. "The direction Klimt has taken," said Hans Tietze, "can be followed much more clearly in his portraits of women. Klimt has experienced womanhood profoundly and, being a genuine eroticist, he has created each woman from within himself. He has projected himself into every contour of her body, her dress, every smile and every movement. Flattering her, he has captured every expression of her vitality, but what he paints and draws is no mere rendering of reality. His type of woman is both experience and yearning, true and untrue. It is the confession of an artist. His eroticism – his devotion to the subject and his mastery of it – makes Klimt a prophet of female beauty." [120] Another contemporary, Berta Zuckerkandl, commented that "Klimt paints the woman of his time. Down to the most secret fibres of her

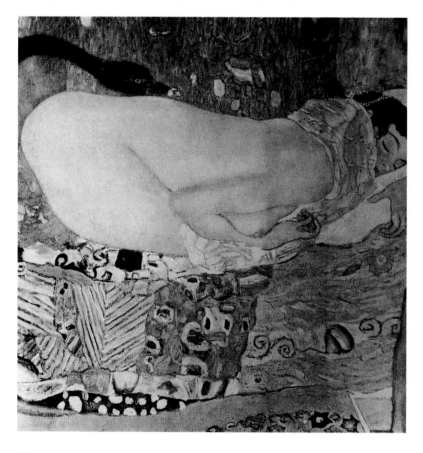

Leda, 1917
Oil on canvas, 99 x 99 cm
Destroyed by fire at Immendorf Palace in 1945

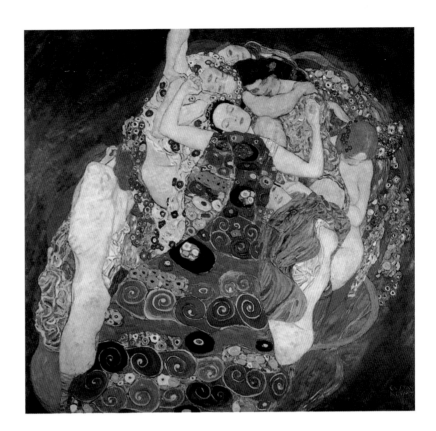

The Virgin, 1913
Die Jungfrau
Oil on canvas, 190 x 200
Národní Gallery, Prague

being, he has followed the structure of her frame, the outlines of her shape, the modelling of her flesh and the machinery of her movements and has made them a permanent part of his memory. With his feet firmly on this secure ground, he varies the theme of Woman in all its relations to creation and nature. Whether they are cruel and lustful or cheerful and sensual, his women are always full of mysterious charm. The scintillating fleshy hue of a woman's slender body, the phosphorescent sheen of her skin, the square angularity of her broad head and the sinfulness of her ginger-haired mane add up to an overall effect which is profoundly psychological and picturesque. In his portraits he creates sinewy, racy women with a thirst for life or a general drowsiness, and despite all their typical differences, they are all creatures who owe their existence to Klimt's grace. As an ideal figure, however, he dissolves a woman's body into magnificent, decorative lines. All elements of chance and everything that is individual or characteristic has been eliminated, and all that remains with the greatest stylistic purity is the artist's sublimated extract of the typical modern woman." [121]

In fact, in an inconspicuous comment in Hermann Bahr's "Speech on Klimt" of 1901, it is no longer the content of his art which is the object of desire but the painting as such: "Friends say ... jocularly that I am in love with his art, and it is indeed a feeling akin to love. Just as only a lover can reveal to a man what life means to him and develop its innermost significance, I feel the same about these paintings." [122] The

forms of the responses to Klimt's art, which we have already discussed in the context of the Secession exhibitions, were related to modes of experience that were regarded as specifically feminine at the time: observing, enjoying and empathetic feeling. Mood – a central theme of the time – united all those features in an aesthetic-psychological attitude. Not rational control and analysis of the world was at the centre of an experience of art but some kind of passive aesthetic education in which the egocentric enjoyment of one's own self was more important than developing one's attitude towards the thematic content of art.

The phenomenon of the man's femininization in the woman's image makes it tempting to seek explanations in the personality of the artist himself and to enquire about "male hysteria", a question which was being discussed at the turn of the century. However, too little is known about Klimt's biography to draw any conclusions. Klimt never made statements about his image of women except through his art, and, as we have seen, his relationships with women are obscured by many layers of legend and anecdote. But there are a small number of accounts published immediately after Klimt's death, for example in the form of obituaries. These must have been relatively fresh and can therefore claim a measure of authenticity. They certainly give the impression that there was very little truth to today's myth of Klimt's "Turkish taste for women" [123]. In 1919, Hans Tietze wrote that, "according to his friends, ... Klimt's power seemed riddled with contradictions. Although he was basically kind-hearted, he led a solitary existence and met with indifference and hostility because his greatest need was love. We are trying to understand these contradictions in human terms so that we can gain a better understanding of his profound and mysterious art. There are even greater secrets, and these must be handled very gently when dealing with an artist whose song of praise to the enticing magic of the female body takes so much room in his work. Klimt's rugged forcefulness had an enormous effect on people, particularly women, and whenever he appeared there was a strong air of earthiness about him. Again, there was that internal contradiction which paralysed his unconditional surrender to life. For many years he was bound to a woman in the most intimate friendship, though without ever daring to commit himself completely. That vibrantly erotic neurasthenia [124] which is present in some of his most delicately sensitive drawings may well be full of most painful experiences. Klimt did not dare to take the responsibility of happiness upon himself and the only privilege he gave to the woman he had loved for years was to attend to his painful death." [125] Klimt's contemporaries – such as Hermann Bahr – regarded neurasthenia as male hysteria, a crisis in the male ego which was exposed to the deprivation of its personality. Tietze's quite delicately encoded intimations conceal more than they explain. They do, however, give us an inkling of Klimt's personality, which must have been far less one-dimensional than many choose to make out nowadays. Furthermore, they show that no simple, straightforward correspondence can be established between the artist's personality and his work.

The Dancer, around 1916/18
Die Tänzerin
Oil on canvas, 180 x 90 cm
Private collection, by permission of the
St. Etienne Gallery, New York

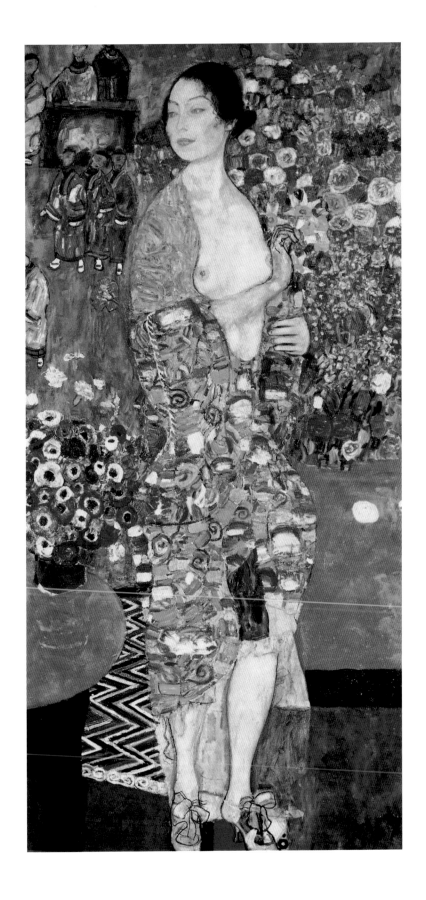

Danae

The legend of Danae, who was loved by Zeus in the form of a gold shower, has often been depicted by famous artists. When Klimt painted it, he gave it his own distinctive features, eliminating all narrative and transitory elements. Instead, he captured the timeless moment of conception – in ancient mythology, the conception of Perseus. Within a single painting Klimt combined the Art Nouveau motif of "omnifruitfulness" and his obsession with a totally self-contained female sexuality. The connection with the original myth has been severed almost completely. The attributes generally ascribed by long-standing iconographic tradition to *Danae* – as in the case of *Leda* (p. 204) – were reduced to a minimum. The compositional elements are curved outlines and ornaments, entirely serving the erotic effect of the painting, which is further enhanced by its golden colours. The focus on Danae and the distorted perspective in the painting add a sexual dimension to her whole body, though at the same time distance is created by the ornamental elements: "The gold shower entering Danae's body and the ornamental elements give a quality of holy ecstasy to this ancient motif. The experience of sexual pleasure, which is granted by the enticing ornaments, is more than mere compensation. It achieves something which a male partner would be unable to do, that is, it changes the woman's flesh into an ornamental cipher – a work of art. Eros becomes an icon." [126] In no other picture did Klimt push the reduction of Woman to her sexuality to such an extreme. To illustrate this point and without further comment, Werner Hofmann quotes from fin-de-siècle ideology (Otto Weininger and Karl Kraus), which saw "the entire female body as an appendage to the genitals". [127]

Danae is one of the most extreme examples illustrating Klimt's concept of a totally autonomous femininity. Indeed, this autonomy is served by the distance which is maintained even in this painting by means of stylization and formalization. Like numerous other nude paintings by Klimt, it displays a self-absorbed sexual craving in which nudity itself becomes décor. Klimt's "revolution" does not really offend at all, even where it breaks taboos. Occasionally, as in this nude painting, which was supposedly aimed at his critics, he broke taboos quite deliberately and with irony. But because of its calm, aesthetic harmony, his depiction of the erotic also permits calm, composed viewing. "Sensuality and the erotic are present everywhere, but these sparsely clad women, these sleeping nudes, were actually accepted by Vienna's bourgeoisie and aristocracy. Klimt overcame moral prejudices by means of a rich decor. Embraces, a naked body against a background of old gold or azure and the women's clothes mingle with the multicoloured flowers of a meadow or the impression of sumptuous beauty and unlimited wealth which characterize all paintings by Klimt. As a result, we forget the women's nudity, which is no more than a decorative element in such a magnificent ensemble." [128]

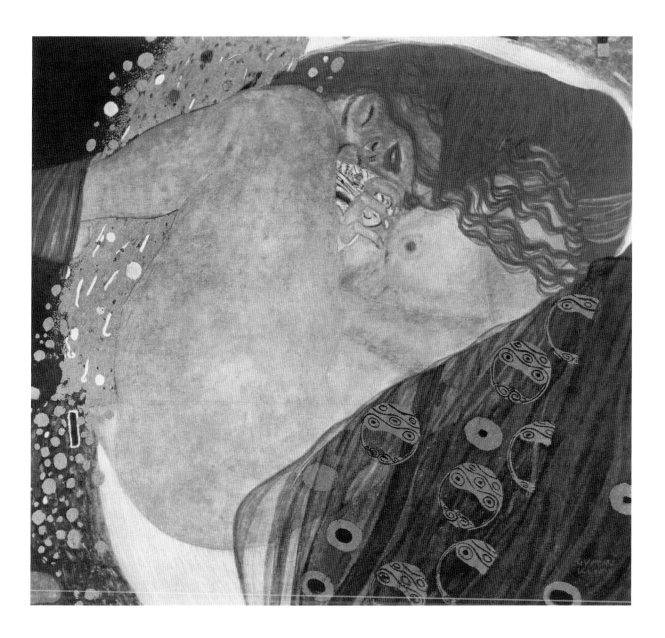

Danae, 1907/08
Oil on canvas, 77 x 83 cm
Private collection, Graz

The most significant aspect of the painting is not so much the distance which is created by the ornamentalization of the woman's body, but the narcissistic regression that stimulates these formal energies. As in many other works by Klimt, the woman is overcome by drowsiness and sleep, so that *Danae* can be depicted as completely wrapped up in herself and her instincts. This gives her autonomy from the viewer. *Danae* is an "icon of the feminine Narcissus" – created out of male fantasies and so engrossed in herself that there is no room for any object of love other than her own body. While in *Leda* the principle of maleness was still present in the symbolically encoded form of a black swan's neck and head, it is reduced here to the abstract symbol of the black rectangle in the shower of gold – one ornament among many.

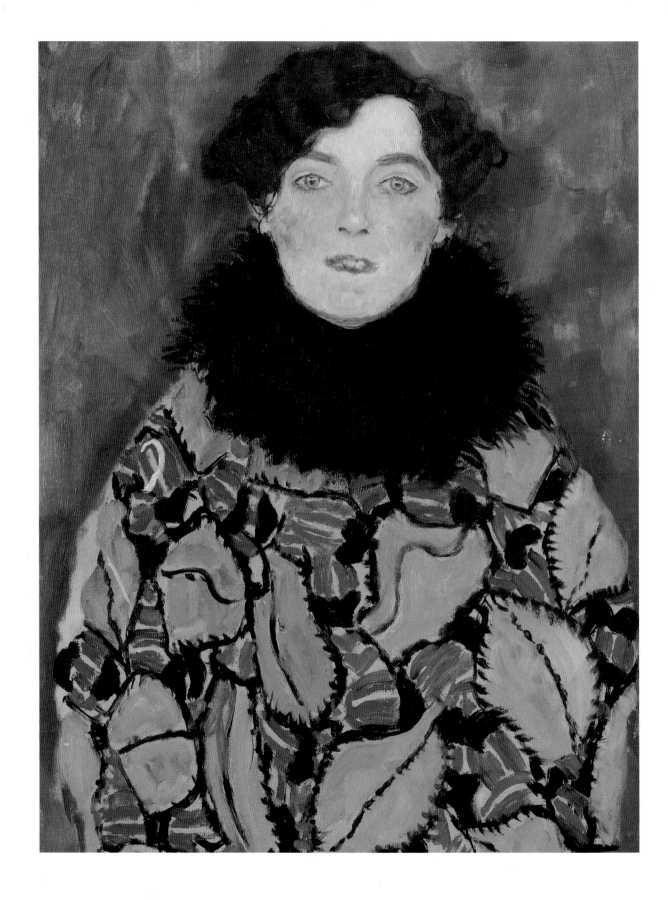

Ladies' Portraits

It is a remarkable fact that Klimt's portraits, which are among the best-known works in his oeuvre, have never attracted much attention for the accuracy with which they depicted living persons. Instead, there has been far more interest in their formal properties and their development. Indeed, his portraits of the ladies of Viennese society have been analysed sociologically and seen as metaphorical statements, as it were, on the life of the social elite and society at large at the end of the Habsburg Empire, rather than as artistic treatments of a particular character or person. Thus they have been seen in similar terms as achievements of cultural and historical analysis, and – yet again – Klimt has been falsely credited with a critical attitude. Even Max Eisler, one of Klimt's first biographers, hardly showed any interest in the depicted persons or the function of a particular portrait. Instead, he merely gave a very general description of Klimt's portraits as expressing criticism of the *Décadence*: " ... In general it is ... a spoilt, cultivated, urban social class which he portrays ... usually a sardonic or blasé lady, intellectually indifferent or even mindless, who wants to appear important or scintillating. Klimt never verges on the satirical – his taste and indeed his indifference forbids such an attitude. But on the whole, because of his uninhibitedly pragmatic depiction, he stands as the historian of this lukewarm, indolent and empty social class. Nevertheless, everything is still polished, partly because of the seriousness of his artistic approach, even towards this kind of material – an attitude which links these portraits not only to one another but also to the rest of his works." [129]

It is only logical that those who ascribe an analytical or critical function to Klimt's portraits should concentrate on formal aspects which support their belief. There are numerous descriptions of the contrast between two- and three-dimensional space, between ornament and skin colouring and the polarity of distance and (erotic) closeness or availability and withdrawal. "Klimt dematerializes the substance of a body and dissolves it into decorative movements, while at the same time giving weight and a sensual function to the decorative accessories. Thus he succeeds in eliminating all exact definition from his figures. He always surrounds them with an aura suggesting both distance and proximity ... The surface bearing the image of the woman changes; it is no longer reliable, it seems to hint at unknown depths. Because of the amazing optical illusion between background and foreground, two- and three-dimensional space, clothes and body,

Study for the *Portrait of Amalie Zuckerkandl*, 1917/18
Pencil, 57 x 38 cm
Albertina, Vienna

Portrait of Johanna Staude (unfinished), 1917/18
Bildnis Johanna Staude
Oil on canvas, 70 x 50 cm
Historical Museum, Vienna

willingness and reticence, it is no longer possible to grasp his portraits in an 'objective' way." [130]

However, this needs to be qualified, because Klimt did indeed distinguish between different degrees, ranging from the formal means of allegorical and mythical depictions to those of official portraits, where the erotic element is much more remote, more sublimated. In an analysis of the colours in Klimt's *Portrait of Margaret Stonborough-Wittgenstein* (p. 217), Thomas Zaunschirm has discovered that this complex relationship between closeness and distance is reflected in the relationship between the transparency and density of the paint and the artist's treatment of colours. The iridescent white and grey structure of the brilliantly painted dress make it appear both veiled and transparent. [131]

It is worth noting that these portraits lack any clear spatial structure in which the women depicted might find support. One exception is Klimt's *Portrait of Sonja Knips* of 1898, in which the seated woman gives the illusion that she has been placed in a garden. Within the artist's oeuvre, this is an extremely rare portrayal of a figure in a natural setting. In all other portraits, the spatial definition of a location has been replaced by the heraldic integration of the figure into the surface of the picture. Merging into complex ornamental areas, the women are virtually banished to the painting's background – from

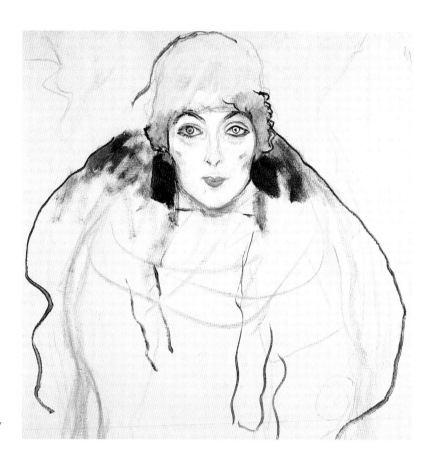

Woman's Head, 1917/18
Frauenkopf
Oil on canvas, 67 x 56 cm
Wolfgang-Gurlitt-Museum, New Gallery
of the City of Linz

which naturalistic depictions of the subject's face, features and hands protrude. As a result of this pronounced difference between naturalistic and decorative two-dimensional elements, Klimt emphasized a woman's gestures and features and therefore also her expression, character and the significance of her personality. On the other hand, however, these parts of the body also appear like fragments or iconic elements, oddly detached from the rest of the body.

"The argument which was relevant to Cubism at the time, between two- and three-dimensional space, has its Secessionist analogy in these works, sometimes at the price of losing physical clarity. However, the fragmentation of the objects depicted always had a decorative purpose and never disrupted their physiognomical integrity." [132]

The impact of the naturalistic faces is further enhanced by ornamental surrounds in the form of halos, crowns or hats. Another function of these decorative yet meaningful forms is to capture a figure in a structure of two-dimensional ornamental areas as if it were totally immobile. (*Emilie Flöge*, 1902; *Fritza Riedler*, 1906; *Adele Bloch-Bauer I*, 1907; pp. 216, 219 and 218).

The increasing use of ornaments in Klimt's portraits was a gradual development. The ladies portrayed became more and more "disembodied". Unlike his other, "anonymous" ladies' portraits, it is not the entire body which is given erotic significance, but the eroticism is

Woman with Hat and Bag (The figure is duplicated), study for the *Portrait of Adele Bloch-Bauer II*, 1912
Pencil, 57 x 37 cm
Albertina, Vienna

Portrait of Adele Bloch-Bauer II, 1912
Bildnis Adele Bloch-Bauer II
Oil on canvas, 190 x 120 cm
Austrian Gallery, Vienna

shifted onto the ornaments (in a similar way to *The Kiss*). Furthermore, the ornaments add an element of material luxury and preciousness to the characters, as if their status were much higher than is suggested by the photographs of the same persons. And unlike these photographs, despite the detailed naturalism, each lady is given an aura which goes far beyond were portraiture.

This aura is further emphasized by a formal "trick", that is, being viewed from below which makes the depicted person seem slightly raised. The extreme lengthening of some figures, who appear to be looking at us from a somewhat higher position, also serves to stress their distance as exclusive society ladies. Their ornamental garments are meant as a reflection of their social prestige. Thus, the portrait has become a way of lending dignity to the person portrayed as well as distance to the viewer, a certain majestic stateliness which may not always be due to their social positions but which has been accorded to them by the artist. That such an elevation sometimes made these ladies feel rather uneasy can be gathered from the rejection of Klimt's *Portrait of Margaret Stonborough-Wittgenstein* by her family and the re-working of a portrait of Ria Munk into a *Dancer* (p. 207). In his speech, Hermann Bahr tried to interpret these portraits as showing something of the "innermost nature of each lady" [133], but this is precisely what his portraits conceal. And indeed, they do so by means of wealth – a wealth which manifests itself in status, conventions and golden ornaments. The true personality and nature of the ladies – including their eroticism – only ever shines through very indirectly and as if it had been fragmented by the ornaments.

Despite his rather exaggerated and effusive enthusiasm, Peter Altenberg has nevertheless discovered a very important feature of Klimt's portraits: rather than portraying the ladies, they "clothe" them and put them into a context of unreal existence. Altenberg therefore sees them as part of Klimt's endless projective typology of womanhood. "These ladies' portraits are like the perfect creatures of nature's most tender romanticism. Delicate, finely proportioned, fragile creatures – the poet's dream, never-ending and never finding release! Their hands are the expression of a noble soul, with a hint of childlike vitality, refined and at the same time kind-hearted!

"Whatever their positions may be at a certain hour or on a certain day in real life, they are all outside earth's gravity. All of them are princesses in a better and more delicate world. The painter realized this, he did not allow himself to be confused and he raised them to their rightful position, to their own high and lofty ideals! ... These are the aspects that count in the artist's eyes. This is how the woman should be seen! Staring into the mysteries of existence, proud, invincible, yet tragically sad and introverted! Except for the beauty of those hands, a beauty that is supernatural and triumphs over life and its manifold snares and perversions. Those hands say, 'We will remain like this until we are seventy, and it will be seen in the dignified old lady that we were born to inspire enthusiasm in painters and poets! They are our only unfailing climaxes'." [134]

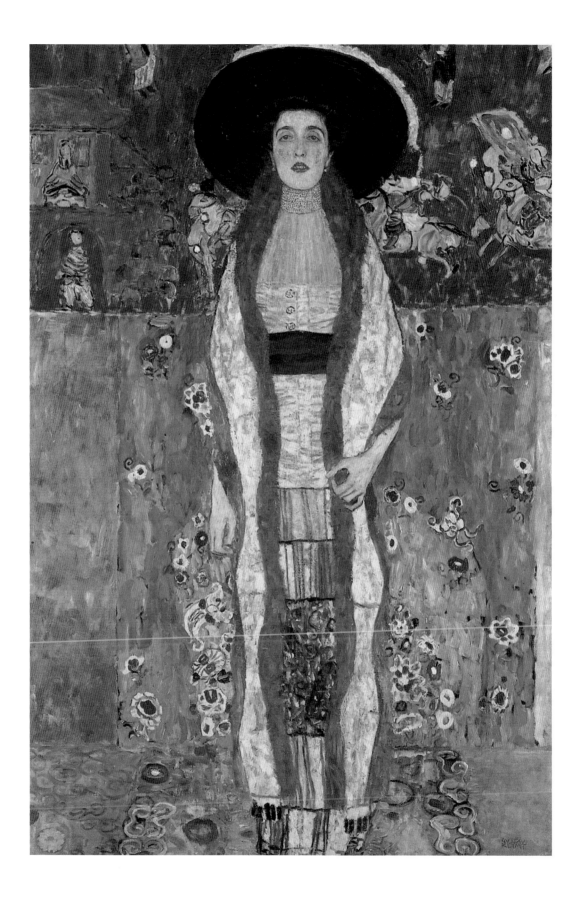

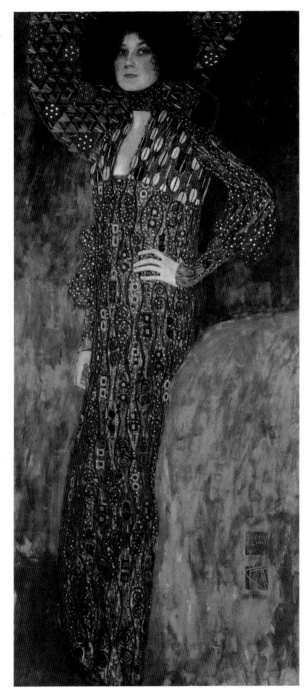

Portrait of Emilie Flöge, 1902
Bildnis Emilie Flöge
Oil on canvas, 181 x 84 cm
Austrian Gallery, Vienna

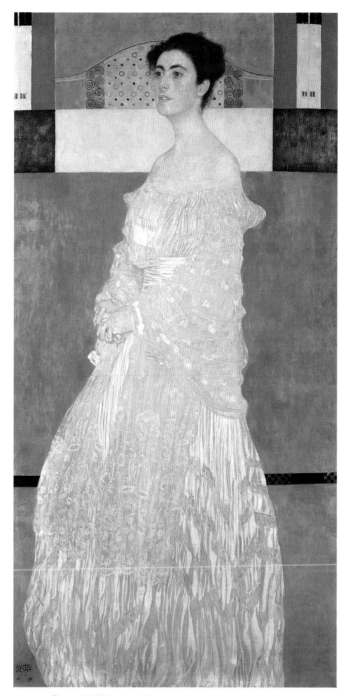

Portrait of Margaret Stonborough-Wittgenstein, 1905
Bildnis Margaret Stonborough-Wittgenstein
Oil on canvas, 180 x 90 cm
Bavarian State Collection of Paintings, Neue Pinakothek, Munich

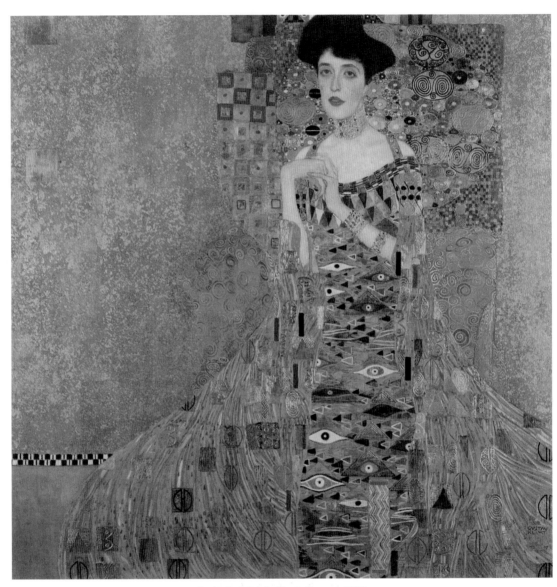

Portrait of Adele Bloch-Bauer I, 1907
Bildnis Adele Bloch-Bauer I
Oil and gold on canvas, 138 x 138 cm
Austrian Gallery, Vienna

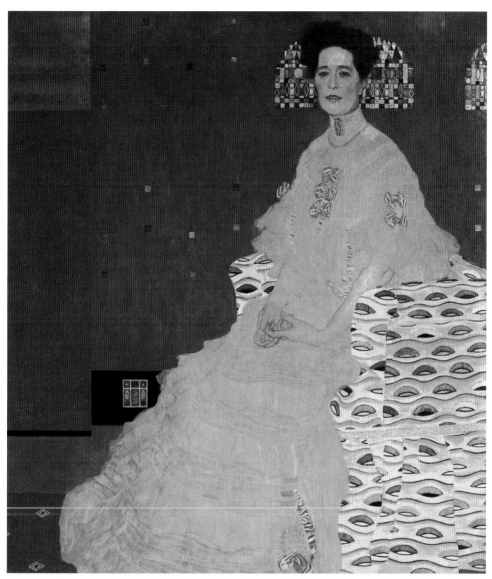

Portrait of Fritza Riedler, 1906
Bildnis Fritza Riedler
Oil on canvas, 153 x 133 cm
Austrian Gallery, Vienna

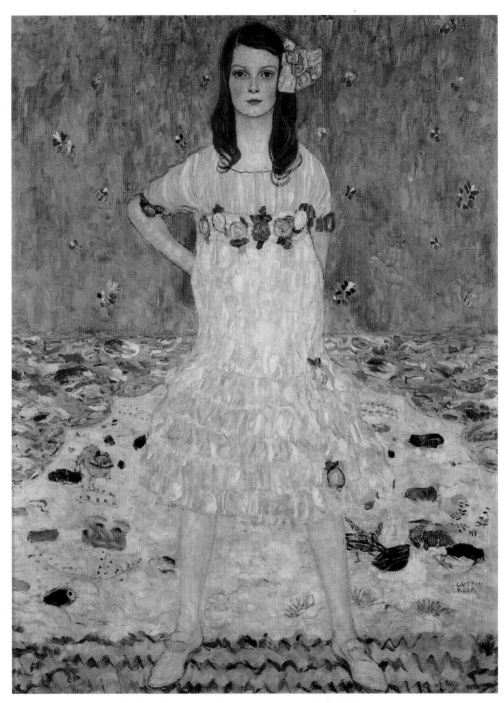

Portrait of Mäda Primavesi, around 1912
Bildnis Mäda Primavesi
Oil on canvas, 150 x 110.5 cm
Metropolitan Museum of Art, New York, gift of Andre and Clara Mertens, in mem-
ory of her mother, Jenny Pulitzer Steiner, 1964.

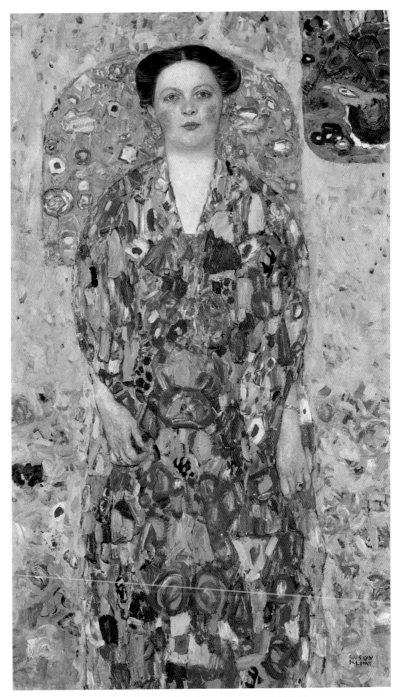

Portrait of Eugenia Primavesi, around 1913/14
Bildnis Eugenia Primavesi
Oil on canvas, 140 x 84
Private collection, U.S.A.

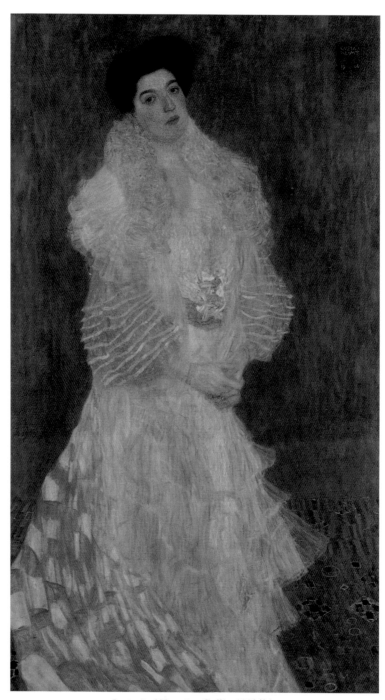

Portrait of Hermine Gallia, 1903/04
Bildnis Hermine Gallia
Oil on canvas, 170 x 96 cm
National Gallery, London

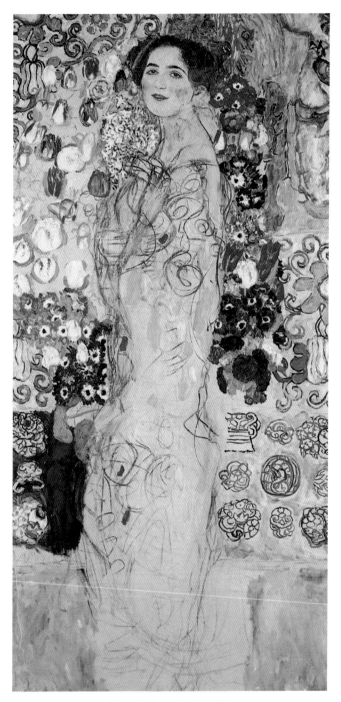

Portrait of a Lady, 1917/18
Damenbildnis
Oil on canvas, 180 x 90 cm
Wolfgang-Gurlitt-Museum, New Gallery of the City of Linz

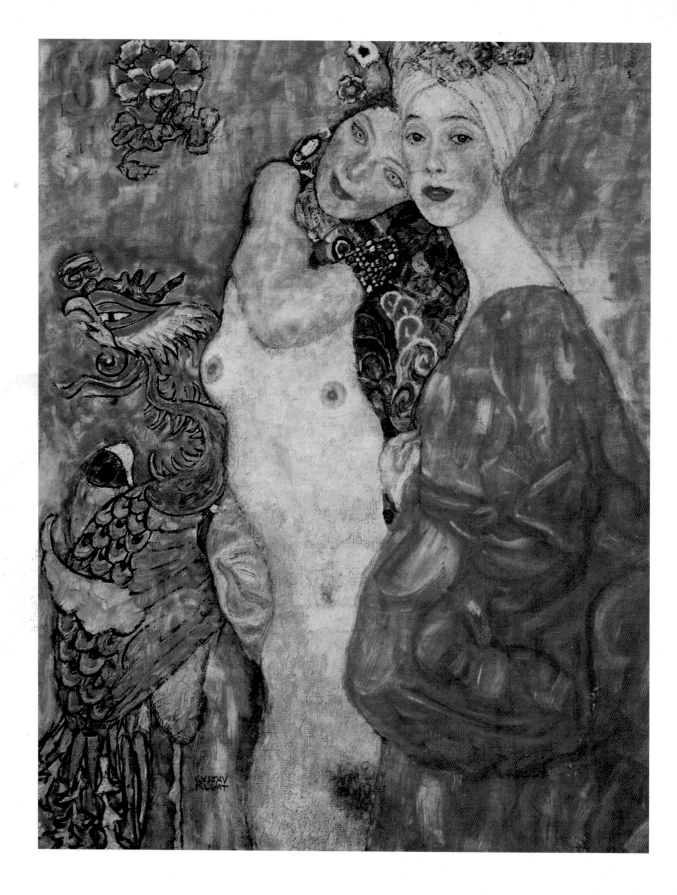

Late Works

When Klimt died on 6th February 1918, a number of unfinished works were found in his studio. These have defied all interpretation until now, not only because of their fragmentary nature but also their allegorical content. To some extent, they can be seen as further developments of Klimt's cyclical and allegorical "humanity paintings" of the "Golden Phase" – a new discussion of the "cycle of life", depicted as a natural and fateful process. Here, however, the cycle is seen more optimistically and in more regressive terms, without any allusions to social events and institutions, as was the case either openly (*Faculty Paintings, pp. 76ff.*) or in encoded form (*Hope I*, p. 134) in his "humanity paintings", where the allegory of motherhood was partly treated as a social institution.

What makes it difficult to decode these paintings is the lack of iconographic elements to facilitate such a task. What is more, there is hardly any coherent interaction between the different characters. They are completely reduced to passivity and emotions. *The Bride* (p. 227) is an exception in that it affords at least a very general framework for interpretation in which the figures form part of a natural, biological context, eroticized but without extreme passions or emotions. This is reminiscent of Klimt's metaphor of different ages, painted back in 1905 (*The Three Ages of Woman* , p. 122), and also *Death and Life* (p. 123). Those earlier works, however, displayed greater clarity of form as well as content, whereas his later works became increasingly ambiguous in content and freer in form. In his late works the allegorical element is even more obviously presented by female protagonists than before. Men are either absent altogether (*The Three Ages of Woman* ; *The Virgin*, p. 205), or – as in Klimt's cyclical "humanity paintings" – they are depicted concealing themselves. Their feelings are not shown and their scope of action has been frozen (*Death and Life* ; *Adam and Eve*, p. 229). These paintings, too, may perhaps be understood within the context of men's "self-feminization" – projections of an eroticized female nature and naturally erotic womanhood, though women are totally reduced to their sexuality, just as in Klimt's erotic drawings, both with regard to content and form. All these late paintings are dominated by drowsiness, sleep and a somnolent, regressive numbness, without hope of an awakening that might bring relief.

The lack of realism in these paintings (despite some highly naturalistic details) is a result of their stylization, form and – often

Two Female Nudes, Standing
Technique, dimensions and owner unknown

Girl-Friends (detail), 1916/17
Die Freundinnen
Oil on canvas, 99 x 99 cm
Destroyed by fire at Immendorf Palace in 1945

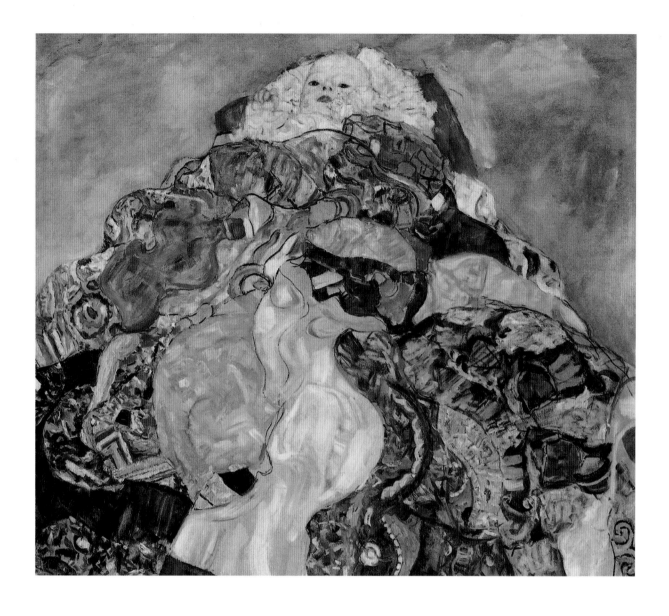

Baby (detail), 1917/18
Oil on canvas, 110 x 110 cm
National Gallery of Art, Washington D.C.

diffuse – allegorical content. Klimt's formal devices are no less resistant to critical analysis than the spiritual and material content that is depicted. "The smoothness and sharpness of the outlines had been replaced by ... more restrained, painterly lines ... The power of the ornaments, too, had been softened by a new element of restraint ... Thus, in his last paintings, the *Bride* and the Virgin, he achieved a new synthesis, a new interplay of form and thought. His clusters of people are in fact only very superficially related to the masses of people in *Philosophy* and *Medicine*, and despite the traditional allegorism, hardly any remnant of 'literature' is left. Their mysteriousness is of a completely novel kind. This was achieved by emphasizing a painterly form that abandoned illusionism altogether. Klimt's eccentric juxtapositions still dominated his paintings ... However, the end result – though incomplete and in the form of a promise – was a vision of

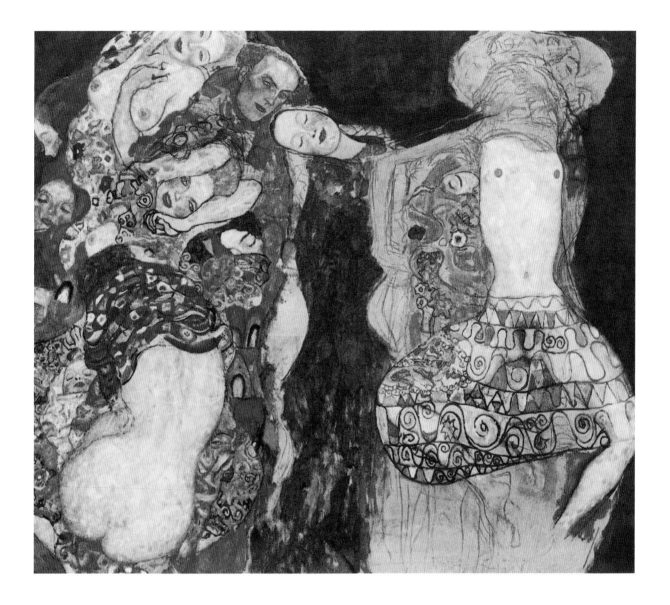

The Bride (unfinished), 1917/18
Die Braut
Oil on canvas, 166 x 190 cm
Private collection, Vienna

dreamlike uncertainty, elevated into a realm of forms that could only be imagined in his earlier compositions. Starry skies had become superfluous, and so had his abstract geometrical fields, though there were still the inhibited and dejected gestures as well as the ecstatic ones, but because of the new, less meticulous outlines, they were no longer burdened by their previous tragic seriousness. Everything had become more weightless, with a calmly breathing, radiant and organic liveliness." [135]

While Klimt had always refrained from critically examining contemporary society in his art, his late works show an even more radical refusal to comment on social reality. Indeed, they no longer contain the slightest hint of man as a social or historical being, and there is a sign of powerful, Prometheus-like saviour or "strong well-equipped outsider" with the historic task of redeeming mankind. The topic of his

paintings is no longer a work of redemption, but the state of being redeemed. This redemption is outside space and time, it is a plant-like state without memories of the past or visions of the future. Man merely exists, without communicative gestures, i.e., the persons depicted cannot be defined as forming a social group or belonging together in any way. Communication between individuals and the sexes has been replaced by the renunciation of any connection with time or society and the return to infantile levels of mankind or the human psyche.

Refining his aesthetic techniques, Klimt pushed his development to its extreme and indeed its limits: "An artist who wants to show dissonances in the social structure," says Werner Hofmann at the end of his Klimt monograph, "must reflect critically on his own language and make it accessible to dissonance. Naive trust in the unchangeable ornamental nature of *any* form, including ugly forms, does not allow any dissonance or truth in one's style without the decorum of beauty ... Stylization prevents the artist from engaging in a fundamentally creative act: its form is never open, but closed, it is consonance, not dissonance. A creative urge which is dominated by stylization remains limited to self-assertion and affirmation. It precludes both a critical analysis of its language and a critique of forces within society. Its festive garment, woven by art, brings about general reconciliation, and legitimizes both itself and the existing social conditions. The painter Gustav Klimt also displays this one-sidedness, which shows both the limits and the greatness of his art." [136]

Klimt's late works underline the dilemma or fundamental contradiction which permeates his entire oeuvre. The image of pure, erotic and totally natural happiness becomes reduced to mere regression. Klimt's oeuvre can be understood as an aesthetic alternative to the historical culture of his father's generation. As such it brought forth a "world in female form" as a resonse to the crisis in society and the individual. Klimt offers us the utopian realm of an autonomous, natural eroticism, a regressive fantasy world which necessarily had to deny its social and individual origins. This regressive utopia of a feminine culture relieved the man, in particular, of the necessity to perceive the social reality which frightened and threatened him. In many works this reality was suppressed altogether. In his *Faculty Paintings*, for example, Klimt contrasted it with projections of a blind, eroticized and supposedly natural cycle. Or he carefully excluded social reality from the sacred sphere of art and the cult of the artist, as we have seen in the way in which the Secession organized and staged its exhibitions. Klimt's popularity and also his central role in Viennese Modernism were both a result of this oddly regressive utopia. Works such as *The Kiss* and the *Beethoven Frieze* radically refuse to be perceived in terms of everyday reality, and it has therefore always been possible to enjoy and understand them as promises of unsullied erotic delight.

Adam and Eve (unfinished), 1917/18
Adam und Eva
Oil on canvas, 173 x 60 cm
Austrian Gallery, Vienna

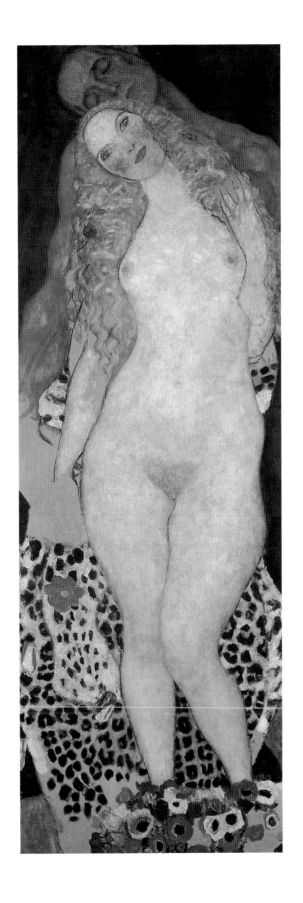

Chronology

1862　Klimt is born at Baumgarten near Vienna on 14th July. He is the second of seven children. His father, Ernst Klimt (1832-1892) is an engraver and comes from Bohemia. His mother, Anna Klimt (née Finster, 1836-1915) was born and bred in Vienna. Brothers and sisters: Klara (1860-1937), Ernst (1864-1892), Hermine (1865-1938), Georg (1867-1931), Anna (1869-1874) and Johanna (1873-1950).

1876　Joins the School of Applied Art of the Royal and Imperial Austrian Museum for Art and Industry, Vienna, where he is taught painting by Prof. Julius Viktor Berger.

1879　Starts working together with his brother Ernst and their fellow-student Franz Matsch. Takes part in Laufberger's sgraffito work for the Museum of Art History in Vienna as well as the artwork of the procession for the Imperial silver wedding.

1883　Finishes his training at the School of Applied Art in Vienna. Forms *Künstlercompagnie* (Artists' Company) and opens studio together with his brother Ernst and Franz Matsch.

1883−85　The three artists take on decoration jobs for the municipal theatre of Fiume (Yugoslavia).

1886　Klimt and his Artists' Company start decoration work on the staircases of the Burgtheater.

1887　Klimt is commissioned by Vienna's city council to paint an interior view of the old Burgtheater.

1888　Completion of the Burgtheater paintings. Klimt is awarded the Golden Cross of Merit.

1888/89　Travels to Cracow, Trieste, Venice and Munich.

1890　Starts working on the decorations (spandrels and intercolumniation) of the staircase in the Museum of Art History in Vienna. He is the first person to receive the newly created Imperial Award for

Joseph Maria Olbrich (left) with *Koloman Moser, Gustav Klimt* (both on reclining chairs) and an unidentified person in Klimt's garden
Photographic Archives of the Austrian National Library, Vienna

Opposite, left:
Klimt in the garden of his studio
Albertina, Vienna

Opposite, right:
Klimt in a painter's smock, with a cat in front of his studio
Photographic Archives of the Austrian National Library, Vienna

his painting *Auditorium at the Old Burgtheater* (p. 40).

1891 Joins the Co-Operative Society of Austrian Artists (*Künstlerhaus*). It is suggested that he should receive a professorship at the Academy, but he is not appointed. Together with his brother Ernst and Franz Matsch, he receives the "highest possible recognition" for his decorations at the Museum of Art History.

1892 His brother Ernst and his father both die.

1893 Travels to Hungary, where he is commissioned by Count Esterhazy to paint the theatre in Totis.

1894 Klimt and Matsch are commissioned by the Ministry of Education to paint the *Faculty Paintings* (p. 76f.) for the ceiling of the grand auditorium at Vienna University.

1896 Klimt and Matsch submit sketches for the arrangement of their *Faculty Paintings*.

1897 Klimt leaves the Co-Operative Society of Austrian Artists. The Viennese Secession is founded by Joseph Maria Olbrich, Josef Hoffmann and Klimt, who becomes its first president. He paints his first landscapes and works on the *Faculty Paintings*, *Philosophy* (p. 80) and *Medicine* (p. 83).

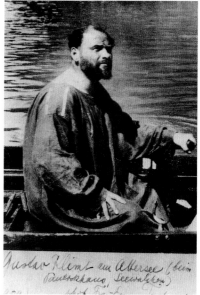

1898 First Secession exhibition. Foundation of the Secession journal *Ver Sacrum*. After lengthy arguments, Klimt is eventually commissioned to paint the *Faculty Paintings*. The Secession Building, designed by Joseph Maria Olbrich, is opened. Klimt is accepted as a member of the International Society of Painters, Sculptors and Engravers, London, and as an associate member of the Munich Secession.

1899 Concludes his sopraporte paintings *Schubert at the Piano* (p. 47) and *Music* (p. 46) for the music room of Dumba Palace.

1900 Together with landscapes, exhibits his unfinished *Philosophy* at the Secession Building, arousing vehement protest. Receives Gold Medal for this painting at the Paris World Exhibition. Becomes a member of the Berlin Secession.

1901 Klimt's painting *Medicine* meets with vehement rejection from the press but interest among

the public. The Bavarian State Collection of Paintings acquires *Music* (p. 13).

1900–02 Spends the summers at Lake Atter.

1902 Beethoven Exhibition of the Secession, with Klimt's *Beethoven Frieze* (pp. 104ff.) as a prominent work of art. A number of drawings are bought by the Albertina Graphics Collection, Vienna.

1903 Josef Hoffmann and Koloman Moser found the Viennese Workshop, which Klimt then influences considerably. Collective Secession exhibition with 80 works by Klimt. Travels to Ravenna and Florence. Continues to work on his *Faculty Paintings*, making radical changes.

1904 Klimt is asked to produce drafts for the *Stoclet Frieze* (p. 144f.), a mosaic frieze for Stoclet Palace in Brussels. Takes part in exhibitions in Dresden and Munich.

1905 Rescinds the contract for the *Faculty Paintings* and buys back the drafts. Klimt Group leaves the Secession. Travels to Berlin, where he shows 15 paintings at an exhibition of the German Artists' Union, and receives the *Villa Romana Award*.

1906 Foundation of the Austrian Artists' Union, of which Klimt becomes president in 1912. Travels to Brussels for the first time (*Stoclet Frieze*), then to London and Florence. He is made an honorary member of the Royal Bavarian Academy of Fine Arts, Munich.

1907 Completes his *Faculty Paintings* and exhibits them in Vienna and Berlin. J. Zeitler, Leipzig, publishes erotic drawings by Klimt.

1908 *Kunstschau* in Vienna, an exhibition which encompasses all areas of art, including 16 paintings by Klimt. *The Kiss* (p. 117) is bought by the Austrian State Gallery. Klimt is given the Gold Medal

for *The Three Ages of Women* (p. 122). Travels to Munich and spends the summer at Lake Atter.

1909 Takes part in the international *Kunstschau* exhibition in Vienna. Starts working on the mosaic frieze for Stoclet Palace, Brussels, at the Viennese Workshop. Also participates in the International Art Exhibition of the Berlin Secession. Travels to Prague, Paris and Spain. End of his "Golden Period".

1910 Takes part in the Venice Biennial.

1911 Contributes eight paintings to the International Art Exhibition in Rome, where he is awarded 1st prize for his *Death and Life* (p. 123). Travels to Rome and Florence.

1912 Klimt is appointed presi-

dent of the Austrian Artists' Union. Takes part in the Great Art Exhibition in Dresden. First health holiday in Bad Gastein, where he goes every year from now on.

1913 Exhibitions in Munich, Budapest, Mannheim. Spends summer at Lake Garda, painting landscapes.

1914 Exhibition of the Austrian Artists' Union in Rome. Travels to Brussels.

1917 Honorary member of the Academy of Fine Arts, Vienna, after his professorship has been rejected for the fourth time by the Ministry of Education.

1918 Suffers a stroke in his flat in Vienna on 11th January. Dies on 6th February, leaving numerous unfinished paintings.

Notes

1) Cf. Serge Sabarsky in his introduction to: *Gustav Klimt. Zeichnungen* (exhibition catalogue of drawings), Hanover 1984, pp. 9ff.

2) *Die Fackel*, 13th July 1908, pp. 24f. Quotation from: Werner Hofmann, *Gustav Klimt und die Wiener Jahrhundertwende*, Salzburg 1970, p. 11.

3) Walter Koschatzky in his introduction to: Christian M. Nebehay (ed.), *Gustav Klimt Dokumentation*, Vienna 1969 (no pagination).

4) Hermann Bahr, *Rede über Klimt*, Vienna 1901, pp. 4ff.

5) Thomas Zaunschirm, *Gustav Klimt – Margarethe Stonborough-Wittgenstein*, Frankfurt 1987, p. 10.

6) Nike Wagner, *Geist und Geschlecht. Karl Kraus und die Erotik der Wiener Moderne*, Frankfurt 1982, p. 41.

7) Cf. Carl Schorske, *Wien – Geist und Gesellschaft im fin-de-siècle*, Frankfurt 1982, pp. 210ff.

8) Cf. Alessandra Comini, *Gustav Klimt*, London 1975, p. 28.

9) Gert Mattenklott, 'Figurenwerfen. Versuch über Klimts Zeichnungen'. In: *Gustav Klimt. Zeichnungen* (exhibition catalogue of drawings), op.cit., p. 27.

10) Jacques Le Rider, 'Modernismus/Feminismus – Modernität/Virilität. Otto Weininger und die asketische Moderne.' In: Alfred Pfabigan (ed.), *Ornament und Askese im Zeitgeist des Wien der Jahrhundertwende*, Vienna 1985.

11) Hans Bisanz, 'Gustav Klimt – Zeichnungen und Vorstellungsbilder des Seelischen'. In: *Gustav Klimt. Zeichnungen* (exhibition catalogue of drawings), op.cit., p. 20.

12) Schorske, op.cit., pp. 210f. and 213.

13) Albert Ilg, 'Moderne Vornehmheit'. In: *Gegen den Strom. Flugschriften einer literarisch-künstlerischen Gesellschaft*, issue XX. Vienna 1886, pp. 10-13.

14) Cf. Alice Strobl, *Gustav Klimt. Die Zeichnungen*. Volume I: 1876-1903, Salzburg 1980, p. 15f.

15) Letter to Rudolf Eitelberger of 2nd February 1884. Quoted from: Nebehay, ibid., 1969, p. 81.

16) Schorske, ibid., p. 198.

17) This painting together with its counterpart *Music* and many other works such as his drafts for the *Faculty Paintings* were burnt at Immendorf Palace in 1945, where numerous works of art had been stored during the Second World War.

18) "This is not a view of antiquity through the eyes of a contemporary culture which is trying to assimilate it in the form of an ideal image of the past. It is an attempt to come to terms with a conceptual essence of the past via transitory objects, which are given archaeological authenticity and a permanent factor represented by music." Irit Rogoff, 'Gustav Klimt: A Bridgehead to Modernism'. In: *Intellectual and the Future in the Habsburg Empire*, London 1987, p. 36.

19) Schorske, op.cit., pp. 200ff.

20) The most recent summary of the early history of the Secession can be found in Wolfgang Hilger, "Geschichte der 'Vereinigung bildender Künstler Österreichs' Secession 1897-1918". In: *Die Wiener Secession. Die Vereinigung bildender Künstler 1897-1985*, Vienna 1986, pp. 9ff.

21) Quoted from: Nebehay, op.cit., 1969, p. 135.

22) *Ver Sacrum*, year 1, issue 1, January 1898, p. 27.

23) The original idea was that there should be a Secession building on the Ringstrasse. This scheme had already been approved by the City Council of Vienna, but failed, partly because there was doubt as to whether the Secession was really a "modern artistic movement". When Olbrich, the architect, submitted his plans, the council changed their minds and decided not to include it among their monumental buildings on the Ringstrasse. From the point of view of town planning, it would have had rather a prominent position for a building, so that its style and the artists' association itself would have received far more status than the council was prepared to give them. Cf. Otto Kapfinger/Adolf Krischanitz, *Die Wiener Secession. Das Haus: Entstehung, Geschichte, Erneuerung*, Vienna, Cologne, Graz 1986, pp. 15ff.

24) *Ver Sacrum*, year 1, issue 1, January 1898, pp. 1f.

25) Bahr, loc.cit., 1901, p. 10.

26) From the exhibition catalogue. Quoted from: Hilger, op.cit., p. 13.

27) In 1898 Austria celebrated the 50th Jubilee of the Emperor Franz Joseph. The Secession tried to organize an event parallel and in competition with the *Künstlerhaus* Co-Operative Society and indeed on the premises of the Horticultural Society, which were also used by their rival organization. This can be regarded as a last-minute attempt to participate in the cultural activities of the Jubilee Year.

28) Berta Zuckerkandl, *Ich erlebte fünfzig Jahre Weltgeschichte*. Stockholm 1939. Quoted from: Nebehay, op.cit. 1969, pp. 135ff.

29) Quoted from: Nebehay, op.cit., 1969, p. 149.

30) *Ver Sacrum*, year 1, issue 1, January 1898, p. 3.

31) Schorske, op.cit., pp. 215ff.

32) Ibid., p. 216.

33) *Die Kunst für alle*, Munich 1900. Quoted from: Hofmann, op.cit., 1970, p. 23.

34) Ibid., p. 218.

35) The petition of the Secession to the Minister of Education, von Hartel (26th March 1900), is worth noting in this context.

In the interest of the freedom of art, they asked for state protection, thus showing that the dialectic of state promotion and state intervention was beginning to take shape. Among other things, the artists expressed the following resolution: "The ... association turns to Your Excellency as a figure of authority. We herewith solemnly protest against occurrences that might seriously endanger the sincere artistic interests of our fatherland ... We consider the said work [*Philosophy*] an outstanding and highly encouraging manifestation of Austrian art ... If certain people, who are highly respectable but incompetent with regard to artistic questions, were to become influential, then the free development of art would suffer immensely. We would therefore most humbly petition Your Excellency to accord art the protection without which any profitable development, having started so promisingly, would be impossible." Quoted from: Fritz Karpfen, *Österreichische Kunst. Gegenwartskunst*, Vienna 1923, p. 26.

36) Quoted from: Nebehay, op.cit., 1969, p. 240.

37) Schorske, op.cit., p. 228.

38) Quoted from: Hofmann, op.cit., 1970, p. 23.

39) Berta Zuckerkandl, *Zeitkunst – Wien 1901 – 1907*. Quoted from: *Gustav Klimt. Zeichnungen* (exhibition catalogue of drawings), op.cit., pp. 149f.
In an interview quoted by Berta Zuckerkandl, Klimt described the complications of the personal involvement of von Hartel, the Minister of Education. The more the official state support for the Secession was criticized, the more the Minister of Education was held personally responsible, so that the destiny of the Secession and its artists became dependent on him personally.

40) Schorske, op.cit., p. 237.

41) Ibid., p. 238

42) Ibid., p. 238

43) Quoted from: Christian M. Nebehay, *Gustav Klimt. Sein Leben nach zeitgenössischen Berichten und Quellen*. Munich 1976, p. 171.

44) Hofmann, op.cit., 1970, p. 24 (my italics)

45) Quoted from: Fritz Novotny/Johannes Dobai, Gustav Klimt, Salzburg 1967, p. 388.

46) Ibid.

47) Quoted from: *Gustav Klimt. Zeichnungen* (exhibition catalogue of drawings), op.cit., p. 144.

48) Schorske, op.cit., p. 240.

49) Hermann Bahr, 'Meister Olbrich'. In: Gotthard Wunberg (ed.), *Die Wiener Moderne. Literatur, Kunst und Musik zwischen 1890 und 1910*, Stuttgart 1981, p. 510.

50) Quoted from: Nebehay, op.cit., 1969, p. 349.

51) Rudolph Lothar, *Von der Secession*. Quoted from: Gotthard Wunberg (ed.): Das Junge Wien. Literatur- und Kunstkritiker 1887-1902, volume II, Tübingen 1976, pp. 921f.

52) Ibid.

53) As early as 1902, the author Ludwig Hevesi regretted in a review of the exhibition: "If it is true that the frieze, together with the rest of the exhibition, is only meant to serve this temporary Beethoven purpose and will subsequently be destroyed, then Austrian art will have suffered a major loss, and a masterpiece will have gone up in smoke on Beethoven's altar." Quoted from: *Gustav Klimt. Zeichnungen* (exhibition catalogue of drawings), op.cit., p. 147.

54) When, in 1970, a Socialist government took office in Austria, the new federal chancellor, Bruno Kreisky suggested to Erich Lederer, the owner of the frieze, that the Austrian state should buy and restore it. The frieze, which was stored in the archives of the Austrian Gallery, was in a very poor state. The restoration was started by the Austrian *Bundesdenkmalamt*, the Federal Austrian Agency for the Protection of Monuments.

55) Schorske, op.cit., p. 248.

56) Werner Hofmann, 'Gesamtkunstwerk Wien'. In: *Der Hang zum Gesamtkunstwerk* (exhibition catalogue), Aarau/ Frankfurt 1983, p. 88.

57) Marian Bisanz-Prakken, 'Der Beethoven-Fries von Gustav Klimt in der XIV. Ausstellung der Wiener Secession (1902)'. In: *Wien 1870-1930. Traum und Wirklichkeit* (exhibition catalogue), Salzburg and Vienna 1984, p. 537.

58) Fritz Novotny, introduction to Novotny/Dobai, op.cit., p. 36. – Commenting on Klimt's allegorism, Ludwig Hevesi, who reviewed the exhibition, made a telling statement: "Klimt has painted the yearnings of mankind for happiness. That, at any rate, is the general gist, because allegories are never meant to be understood completely." Quoted from: *Gustav Klimt. Zeichnungen* (exhibition catalogue of drawings), op.cit., p. 147.

59) Jost Hermand, *Der Schein des schönen Lebens. Studien zur Jahrhundertwende*, Frankfurt 1972, p. 148.

60) Werner Hofmann, 'Das Fleisch erkennen'. In: Alfred Pfabigan (ed.), *Ornament und Askese im Zeitgeist des Wien der Jahrhundertwende*, Vienna 1985, p. 122.

61) Gert Mattenklott, 'Figurenwerfen. Versuch über Klimts Zeichnungen'. In: *Gustav Klimt. Zeichnungen* (exhibition catalogue), op.cit., p. 291.

62) Cf. Eva di Stafano. In: Wolfgang Pircher (ed.), *Debut eines Jahrhunderts. Essays zur Wiener Moderne*, Vienna 1985, p. 124f.

63) Ibid., p. 122.

64) Ibid., p. 125.

65) Schorske, op.cit., p. 238.

66) Arthur Roessler, 'Klimt und seine Modelle'. In: *Arbeiterzeitung* 15th August 1953, pp. 10ff.

67) Bertha Zuckerkandl. Quoted from: Nebehay, op.cit., 1976, p. 262f.

68) Quoted from: Thomas Zaunschirm, *Gustav Klimt – Margaret Stonborough-Wittgenstein. Ein österreichisches Schicksal*, Frankfurt 1987, p. 17.

69) Nebehay, op.cit., 1969, p. 56.

70) Alessandra Comini, *Fantastic Art in Vienna*. New York 1978, p. 15. (Life and death are equally present in the great continuum of biological renewal.)

71) Otto Weininger, *Geschlecht und Charakter. Eine prinzipielle Untersuchung*, Munich 1980, pp. 281f. and 288. Here quoted from: Jacques Le Rider, *Modernismus/Feminismus – Modernität/Virilität. Otto Weininger und die asketische Moderne*. In: Pfabigan, op.cit.

72) Quoted from: Nebehay, op.cit., 1969, p. 428.

73) For an interpretation of the two *Hope* paintings, cf. Stefano, op.cit., pp. 109ff.

74) Hans Helmut Hofstätter, *Gustav Klimt – Erotische Zeichnungen*, ed. by Louisa Seilern, Cologne 1979, pp. 18ff.

75) Alessandra Comini, 'Titles Can Be Troublesome: Misinterpretations in Male Art Criticism'. In: *Art Criticism*, vol. 1, no. 2, New York 1979.

76) Felix Salten, *Gustav Klimt. Gelegentliche Anmerkungen*. Vienna/Leipzig 1903. Quoted from: Otto Breicha (ed.), *Gustav Klimt. Die goldene Pforte. Werk – Wesen – Wirkung. Bilder und Schriften zu Leben und Werk*, Salzburg 1978, pp. 31f.

77) Eduard Sekler, *Josef Hofmann. Das architektonische Werk*, Salzburg 1982, p. 94.

78) The frieze was inlaid on 15 marble plates, using mosaic, metal, enamel, ceramics and gold, with members of the Viennese Workshop co-operating on the project. Cf. Alice Strobl, *Gustav Klimt. Zeichnungen*. Vol. II: 1904-1912, Salzburg 1982, pp. 139f.

79) The material itself is said to have cost about 100,000 crowns. The work does not simply depict the wealth of the artist's client, it "materializes" it.

80) Alois Riegl, *Historische Grammatik der bildenden Künste*. Quoted here from: Hofmann, op.cit., 1970, p. 41.

81) Alois Riegl, *Historische Grammatik der bildenden Künste*, Graz/Cologne 1966, p. 21.

82) Cf. Novotny/Dobai, op.cit., p. 388.

83) Joseph August Lux, 'Die Spaltung der Wiener Secession'. In: *Hohe Warte*, year 1, 1904/05, p. 318.

84) The Viennese Workshop was founded by two lecturers of the Academy of Applied Art, Josef Hofmann and Koloman Moser, as well as the industrialist Fritz Wärndorfer. The aim was to manufacture and market works of high-quality and artistic craftsmanship. " . . . the promotion of the economic interests of its members through training and educating the same in applied art, producing a variety of objects of art and craft, following designs by members of artistic co-operative societies, opening workshops and selling the finished products." Entry in the trade register, quoted from: Elisabeth Schmuttermeier, 'Die Wiener Werkstätte'. In: *Traum und Wirklichkeit. Wien 1870-1930* (exhibition catalogue), Vienna 1985, p. 336. Although the Viennese Workshop was able to put its artistic aim into practice, it failed economically, due to the incompatibility of their costly arts and crafts products for a small, elitarian public and the requirements of automatic mass production. The enterprise went into liquidation in 1932.

85) Hilger, op.cit., p. 49.

86) Novotny/Dobai, op.cit., p. 49.

87) Josef August Lux, [. . .]*Deutsche Kunst und Dekoration*, XXIII, 1908/09, 44. Quoted from: Hofmann, op.cit., 1970, p. 11f.

88) Hofmann, op.cit., 1970, p. 12.

89) Catalogue of the Kunstschau exhibition in Vienna, 1908; quoted from: *Gustav Klimt Zeichnungen* (exhibition catalogue), op.cit., p. 150.

90) Alfred Lichtwark, *Reisebrief*. 1924. Quoted from: Novotny/Dobai, op.cit., p. 389.

91) Hans Tietze, 'Gustav Klimts Persönlichkeit. Nach Mitteilungen seiner Freunde'. In: *Die bildenden Künste*, 2, 1919, issue 1-2, p. 9.

92) Nebehay, op.cit., 1969, p. 32. Quoted from: Alessandra Comini, *Gustav Klimt. Eros und Ethos*, Salzburg 1975, p. 9. Klimt's words about not being "particularly interesting" in Breicha, op.cit., p. 33.

93) Hermine Klimt on her brother Gustav, recorded by Rosa Poor-Lima, 'Eine alte Wiener Künstlerfamilie – Das Erbe des Maler-Apostels Gustav Klimt'. In: *Neues Wiener Tageblatt*, 29 December 1940. Quoted from: Nebehay, op.cit., 1969, p. 26.

94) Tietze, op.cit., p. 1.

95) Nebehay, op.cit., 1976, p. 184.

96) Ibid., p. 183.

97) Christian M. Nebehay, 'Gustav Klimt schreibt an eine Liebe'. In: *Klimt Studien (Mitteilungen der Österreichischen Galerie)*, Nos. 66/67, Vienna 1978/79, p. 103.

98) Hofmann, op.cit., 1970, p. 16.

99) *Inselräume. Teschner, Klimt & Flöge*, place of publication unknown, 1988, p. 12.

100) Johannes Dobai, *Gustav Klimt. Die Landschaften*, Salzburg 1981, p. 13.

101) Ibid., p. 14.

102) Ibid., p. 19.

103) Alois Riegl, 'Die Stimmung als Inhalt der modernen Kunst'. *Graphische Künste*, XXII, 1899, pp. 49ff. Reprinted in: Alois Riegl, *Gesammelte Aufsätze*, Augsburg/Vienna, 1928.

104) Ibid., p. 28. Riegl's conclusion about the social function of art is in fact quite close to the Secession's "secularized religion of art": "Art must conjure up, as if by magic, what nature only ever affords man in certain rare moments. In the final analysis and insofar as man's fine arts go beyond the purpose of usefulness and decoration – though we regard this as 'higher art', too – it has from the very beginning never had any other purpose than to give man the reassuring certainty of that order and harmony which he misses in the narrowness of the world's

tumult, a harmony for which he is forever yearning and with-out which life would seem unbearable to him." op.cit., p. 31.

105) Dobai, op.cit., p. 20.

106) Anselm Wagner, 'Aspekte der Landschaft bei Gustav Klimt'. In:*Inselräume*, op.cit., p. 45.

107) Hermann Bahr, *Gegen Klimt*, Vienna 1903. Quoted from: *Gustav Klimt. Zeichnungen* (exhibition catalogue of draw-ings), op.cit.

108) Mattenklott, op.cit., pp. 27f.

109) Ibid., p. 27.

110) Eduard Fuchs, *Geschichte der erotischen Kunst. Das individuelle Problem* II, Berlin 1977, p. 270.

111) Mattenklott, op.cit., p. 32.

112) Quoted from: Nebehay, op.cit., 1976, p. 259.

113) Werner Hofmann, 'Einsame Zwiegespräche'. In: *art, issue 5, 1980, p. 77.*

114) Ibid., p. 79.

115) Mattenklott, op.cit., p. 34.

116) Cf. Hans Bisanz, 'Gustav Klimt – Zeichnungen und Vor-stellungsbilder des Seelischen'. In:Gustav Klimt. Zeichnungen (exhibition catalogue of drawings), op.cit., pp. 14ff.

117) Against the background of these considerations even seemingly trivial circumstances become important, e.g. the fact that Klimt preferred to work in a "painter's smock" and apparently enjoyed being photographed in this outfit. As can be seen in photographs of himself and Emilie Flöge, it was very similar to the dress of the suffragettes . In fact, Klimt even designed suffragette dresses for Emilie Flöge and her salon.

118) Cf. also the essay by Jacques Le Rider, 'Modernismus/ Feminismus – Modernität/Virilität. Otto Weininger und die asketische Moderne'. In: Pfabigan, op.cit.; also: Christina von Braun, 'Männliche Hysterie Weibliche Askese. Zum Paradig-menwechsel in den Geschlechterrollen'. In: Karin Rick (ed.), *Das Sexuelle, die Frauen und die Kunst*, Tübingen, undated, pp. 10ff.

119) Otto Weininger, *Geschlecht und Charakter. Eine prin-zipielle Untersuchung*, Munich 1980, p. 90. Here quoted from Le Rider; I am indebted to Sylvia Eiblmayer for pointing out the essay by Christina Braun and also the discussion of "(self-)feminization".

120) Hans Tietze, 'Gustav Klimt'. In: *Kunstchronik.* N.F. XXIX, 1917-18, p. 219.

121) Berta Zuckerkandl in:*Zeitkunst – Wien 1901-1907.* Quoted from:*Gustav Klimt. Zeichnungen* (exhibition cata-logue of drawings), op.cit., p. 149.

122) Hermann Bahr, *Rede über Klimt*, Vienna 1901, p. 14.

123) Anton Feistauer, *Neue Malerei in Österreich*, Zurich/ Leipzig/Vienna 1923, p. 11: "Eros plays a prominent role, indeed his taste in women is almost Turkish . . ." And: "He loved the good life, and he loved peace as if he was a real oriental. He even looked like one, he was benevolent and generous and, as a real bachelor, lived the light-hearted life of Vienna, with wine, women, song and games." (op.cit., p. 13)

124) It is difficult to decide whether Tietze already had in mind the psychoanalytical meaning of the term as a sexual event, unable to relieve the libidinous tension or whether he was thinking of the older, more general sense, i.e. nervous exhaus-tion as a result of physical strain or over-excitement.

125) Hans Tietze, *Gustav Klimts Persönlichkeit*, op.cit., p. 10.

126) Werner Hofmann, 'Das Fleisch erkennen'. In: Pfabigan, op.cit., p. 122.

127) Weininger, quoted from: Hofmann, op.cit., 1970, p. 35.

128) Jean-Michel Palmier, 'Träume um Egon Schiele'. In: Wolfgang Pircher (ed.), *Début eines Jahrhunderts. Essays zur Wiener Moderne*, Vienna 1985, pp. 129ff.

129) Max Eisler, *Gustav Klimt*, Vienna 1920, pp. 22f.

130) Nike Wagner, *Geist und Geschlecht. Karl Kraus und die Erotik der Wiener Moderne*. Frankfurt 1983. Quoted from: *Gustav Klimt. Zeichnungen* (exhibition catalogue of draw-ings), op.cit., p. 23.

131) Zaunschirm, op.cit., pp. 56ff.

132) Ibid., p. 35.

133) Bahr, op.cit., 1901, p. 17.134) Peter Altenberg, *Bilderbo-gen des kleinen Lebens*, Berlin 1909 (the quotation refers to works by Klimt which were exhibited at the 1908 *Kunstschau*). Quoted from: Nebehay, op.cit., 1969, p. 423.

135) Novotny/Dobai, op.cit., p. 45.

136) Hofmann, op.cit., 1970, pp. 49ff.

Bibliography

BAHR, Hermann, *Rede über Klimt*, Vienna 1901

BAHR, Hermann, *Gegen Klimt*, Vienna 1903

BAHR, *Hermann, Gustav Klimt. 50 Handzeichnungen*, Leipzig/Vienna 1922

BISANZ, Hans, 'Gustav Klimt. Zeichnungen und Vorstellungsbilder des Seelischen'. In:*Gustav Klimt. Zeichnungen* (exhibition catalogue of drawings), Hanover 1984, pp. 13-22

BISANZ, Hans, 'Ornament und Askese'. In: Alfred Pfabigan (ed.), *Ornament und Askese im Zeitgeist des Wien der Jahrhundertwende*, Vienna 1985, pp. 130-141

BISANZ-PRAKKEN, Marian, *Gustav Klimt. Der Beethovenfries. Geschichte, Funktion und Bedeutung.* Salzburg 1977, new and enlarged edition Munich 1980. – This publication continues to be the most important source of information on Klimt's main work, even though extensive restoration has taken place since its publication, bringing new insights into the artist's work, and although the frieze is now accessible to the general public.

BISANZ-PRAKKEN, Marian, 'Der Beethovenfries von Gustav Klimt in der XIV. Ausstellung der Wiener Secession'. In: *Wien 1870-1930. Traum und Wirklichkeit* (exhibition catalogue), Salzburg/Vienna 1984

BREICHA, Otto (ed.), *Gustav Klimt. Die goldene Pforte. Werk – Wesen – Wirkung. Bilder und Schriften zu Leben und Werk*, Salzburg 1978. A collection of 70 years' worth of source material. Because of its wealth of important and authentic contemporary statements on Klimt's work, this is one of the most readable – and indeed richly illustrated – books about the artist.

COMINI, Alessandra, 'From Façade to Psyche, the Persistence and Transformation of Portraiture in Fin-de-Siècle Vienna'. In: Tibor Horvath (ed.), *Evolution générale et développements régionaux en histoire de l'art. Acts of the Twenty-Second International Conference of Art Historians 1969, Budapest 1972*

COMINI, Alessandra, 'Vampires, Virgins and Voyeurs in Imperial Vienna'. In: Thomas B. Hess/Linda Nochlin (eds.), *Women as Sex Objects. Art News Annual 38*, New York 1972. Also in:*Women as Sex Objects. Studies in Erotic Art 1730-1970*, London 1973, pp. 207-221

COMINI, Alessandra, *Gustav Klimt, London 1975*

COMINI, Alessandra, *Fantastic Art in Vienna*, New York 1978.

COMINI, Alessandra, 'Titles Can Be Troublesome: Misinterpretations In Male Art Criticism'. In:*Art Criticism*, vol. 1, no. 2, New York 1979.

DOBAI, Johannes, *Das Frühwerk Gustav Klimts*, Vienna 1958 (manuscript)

DOBAI, Johannes, 'Zu Gustav Klimts Gemälde *Der Kuss* '. In:*Mitteilungen der Österreichischen Galerie*, year 12, 1968, no. 56, pp. 83-142

DOBAI, Johannes, 'Klimt's *Hope I*'. In:*The National Gallery of Canada Bulletin*, 17/1971

DOBAI, Johannes, *Opera completa di Klimt*, Milan 1978

DOBAI, Johannes, *Gustav Klimt. Die Landschaften*, Salzburg 1983.

EISLER, Max, *Gustav Klimt*, Vienna 1920

EISLER, Max (ed.), *Gustav Klimt. Eine Nachlese,* Vienna 1931,[2]1946

FLIEDL, Gottfried, 'Das Weib macht keine Kunst, aber den Künstler. Zur Klimt-Rezeption'. In: Renate Berger/Daniela Hammer-Tugendhat, *Der Garten der Lüste. Zur Deutung des Erotischen und Sexuellen bei Künstlern und ihren Interpreten*, Cologne 1985, pp. 89-149

HATLE, Ingomar, *Gustav Klimt. Ein Wiener Maler des Jugendstils*, Graz 1955 (unpublished doctoral thesis)

HEVESI, Ludwig, *Acht Jahre Secession. Kritik – Polemik - Chronik*, Vienna 1906

HEVESI, Ludwig, 'Kunstschau in Wien 1908'. In: *Zeitschrift für Bildende Kunst*. Leipzig 1908, 19, pp. 245ff.

HEVESI, Ludwig, *Altkunst- Neukunst*, Vienna 1909

HILGER, Wolfgang, 'Geschichte der 'Vereinigung bildender Künstler Österreichs' Secession 1897-1918'. In:*Die Wiener Secession. Die Vereinigung bildender Künstler 1897-1985*, Vienna/Cologne/Graz 1985

HOFMANN, Werner, *Gustav Klimt und die Wiener Jahrhundertwende*, Salzburg 1970. – Although this book was published some 20 years ago, it is still one of the best discussions of Klimt's work. Giving a broad panoramic view of the cultural history of Austria, the author presents a critical analysis of Klimt's oeuvre as well as the antagonistic aspects of the history of art and culture towards the end of the Habsburg monarchy.

HOFMANN, Werner, 'Einsame Zwiegespräche'. In:*art*, issue 5, 1980

HOFMANN, Werner, 'Gustav Klimt'. In:*Experiment Weltuntergang: Wien um 1900* (exhibition catalogue)

HOFMANN, Werner, 'Gesamtkunstwerk Wien'. In: Harald Szeemann (ed.), *Der Hang zum Gesamtkunstwerk – Europäische Utopien seit 1800* (exhibition catalogue), Aarau/Frankfurt 1983, pp. 84ff.

HOFMANN, Werner, 'Das Fleisch erkennen'. In: Alfred Pfabigan (ed.), *Ornament und Askese im Zeitgeist des Wien der Jahrhundertwende*, Vienna 1985, pp. 120-129

HOFMANN, Werner, 'Gustav Klimt'. In:*Vienne 1880-1938: L'apocalypse joyeuse* (exhibition catalogue), Paris 1986, pp. 192-227

GUSTAV KLIMT, *50 Handzeichnungen*. With an introduction by Hermann Bahr. Vienna 1922

Klimt Gedächtnisausstellung (Memorial Exhibition). *XCIX. Ausstellung der Vereinigung Bildender Künstler Wiener Secession* (catalogue), Vienna 1928

GUSTAV KLIMT 1862-1918. Zeichnungen (drawings)

Emilie Flöge and Gustav Klimt. Doppelporträt in Ideallandschaft (exhibition catalogue), Vienna 1988/89

'Klinger. Beethoven'. XIV. Ausstellung der Vereinigung Bildender Künstler Österreichs. Secession (April – June 1902, exhibition catalogue), Vienna 1902

LUX, Joseph August, 'XIV. Kunst-Ausstellung der Vereinigung bildender Künstler Österreichs – Secession 1902. Klingers Beethoven und die moderne Raum-Kunst'. In:*Deutsche Kunst und Dekoration*, Darmstadt 1902, 10, No. 1, pp. 475ff.

LUX, Joseph August, 'Kunstschau Wien 1908'. In: *Deutsche Kunst und Dekoration*, Darmstadt 1908/09, 23, no. 1, pp. 33-61

MATTENKLOTT, Gert, 'Figurenwerfen. Versuch über Klimts Zeichnungen'. In:*Gustav Klimt Zeichnungen* (exhibition catalogue). Hanover 1984, pp. 27-35. – This essay by an expert in German literature is one of the most readable attempts to describe and analyse the 'solitary dialogues' of Klimt's erotic drawings and the relationship between the viewer and the drawings.

NEBEHAY, Christian M. (ed.), *Gustav Klimt Dokumentation*, Vienna 1969. – Even though this large volume is in many ways vague and out of date due to more recent and more precise statements, and although it is rather too complex in structure, it is still indispensable because of its extensive quotations of sources on Klimt's life and work.

NEBEHAY, Christian M., *Gustav Klimt, Sein Leben nach zeitgenössischen Berichten und Quellen*, Munich 1976

NEBEHAY, Christian M., *Gustav Klimt. Das Skizzenbuch aus dem Besitz von Sonja Knips*, Vienna 1987

NOVOTNY, Fritz, 'Zu Gustav Klimts *Schubert am Klavier*'. In:*Mitteilungen der Österreichischen Galerie*, Salzburg 1963, 7, No. 51, pp. 90ff.

NOVOTNY, Fritz/DOBAI, Johannes, *Gustav Klimt*, Salzburg 1967. – First and still indispensable catalogue raisonné of Klimt's paintings and monumental paintings, with an extensive bibliography.

PIRCHAN, Emil, *Gustav Klimt. Ein Künstler aus Wien*, Vienna/Leipzig 1942,²1956

ROGOFF, Irit, 'Gustav Klimt: A Bridgehead to Modernism'. In:*Intellectuals and the Future in the Habsburg Empire*. London 1987, pp. 29ff.

SCHORSKE, Carl, *Wien – Geist und Gesellschaft im Fin-de-siècle*, Frankfurt 1982. – The chapter on Klimt is one of the most readable contributions to the cultural and historical understanding of Klimt's life and work. Together with Werner Hofmann's book of 1970, Schorske's contribution is the only one which attempts a consistent interpretation of some important works (such as the Faculty Paintings) and the 'crisis of the liberal ego' in a social, cultural and historical context.

STEFANO, Eva di, 'Die zweigesichtige Mutter'. In: Wolfgang Pircher (ed.), *Début eines Jahrhunderts. Essays zur Wiener Moderne*, Vienna 1985, pp. 109-126

STROBL, Alice, *Gustav Klimt. Zeichnungen und Gemälde*, Salzburg 1962,²1965,²1968

STROBL, Alice, 'Zu den Fakultätsbildern von Gustav Klimt'. In:*Albertina-Studien*, Vienna 1964, issue 2, vol. 4, pp. 138-169

STROBL, Alice, 'Gustav Klimt in der Kritik seiner Zeit'. In:*Weltkunst*, No. 9, 46th year, 1976, pp. 845-855

STROBL, Alice, *Gustav Klimt. Die Zeichnungen*. Vol. I: 1878-1903, Salzburg 1980. Vol. II: 1904-1912, Salzburg 1982. Vol. III: 1912-1918, Salzburg 1984- oeuvre catalogue of all available drawings.

VARNEDOE, Kirk, *Wien 1900. Kunst, Architektur und Design*, Cologne 1987

VERGO, Peter, 'Gustav Klimt's Beethoven Frieze'. In: *The Burlington Magazine*, 115, 1973, pp. 109-113

VERGO, Peter, 'Gustav Klimts *Philosophie* und das Programm der Universitätgemälde'. In:*Mitteilungen der Österreichischen Galerie*, 22/23, 1978/79, pp. 69-100

Wien 1870-1930. Traum und Wirklichkeit (exhibition catalogue), Salzburg/Vienna 1984

Wien um 1900 (exhibition catalogue), Vienna 1964

WORBS, Michael, *Nervenkunst. Literatur und Psychoanalyse im Wien der Jahrhundertwende*. Frankfurt 1983.

WUNBERG, Gotthard (ed.), *Die Wiener Moderne. Literatur, Kunst und Musik zwischen 1890 und 1910*, Stuttgart 1981

ZAUNSCHIRM, Thomas, *Gustav Klimt – Margarethe Stonborough-Wittgenstein. Ein österreichisches Schicksal*. Frankfurt 1987. – This study, which analyses a single painting, explains the background story of the portrait and the contradictions between the real role of the lady portrayed and Klimt's rather stylized portrait.

The publisher would like to express his gratitude to all museums, galleries, collectors,
archives and photographers for their help in providing photographic material.
Whenever possible, we have quoted the location and owner of each work, together
with its title. We would also like to thank the following persons and institutions:
Galerie Welz, Salzburg (pp. 16, 17, 18, 47, 52, 58, 76, 83, 85, 87, 89, 90, 94, 121, 143,
174, 175, 186, 187, 204, 209, 221, 224); Artothek, Planegg (pp. 2, 13, 34,
48, 55, 108, 109, 113, 114, 117, 122, 137, 141, 142, 176, 181, 184, 185, 200, 205, 215,
218, 229); Foto Fürböck, Graz/Austria (p. 197); Photobusiness Meyer, Leopoldsdorf/
Vienna (pp. 28–31); the photographers Hans Wiesenhofer, Vienna (pp. 22–27, 96–99)
and Hans Riha, Vienna (pp. 106–7) and Ernst und Sohn, Publishers, Berlin (p. 154).